A Short History of Ancient Egypt

From Predynastic to Roman Times

T. G. H. James

A Short History of Ancient Egypt

From Predynastic to Roman Times

T. G. H. James

The Johns Hopkins University Press

Baltimore and London

For TRB from CAR, with love

© Librairie du Liban *Publishers* 1995
All rights reserved. First published 1995

Johns Hopkins Paperbacks edition, 1998
2 4 6 8 9 7 5 3 1

The Johns Hopkins University Press
2715 North Charles Street
Baltimore, Maryland 21218-4363
The Johns Hopkins Press Ltd., London
www.press.jhu.edu

Library of Congress Catalog Card Number 97-76105
ISBN 0-8018-5933-6 (pbk.)

Designed by Caroline Reeves.
Edited by Camilla Reid.
Cartography by European Map Graphics Ltd.
Colour reproduction by Spectrum Colour.

All photographs in this book were taken by the author, except where
otherwise stated. Grateful acknowledgement is made to T. G. H. James for
permission to use his transparencies in this work.

A catalog record for this book is available from the British Library.

A Short History of Ancient Egypt

From Predynastic to Roman Times

Introduction

In this outline of ancient Egyptian history particular attention has been paid to ideas and general movements. Because of the uneven survival of material remains, including written sources over three thousand years, Egyptian history is somewhat fragmented. Even when evidence seems to be plentiful, as in the reign of Akhenaten (the Amarna Period), it may be repetitious and not entirely comprehensive.

Nevertheless, Egypt has been studied in greater depth than any other ancient pre-classical culture; this is largely due to the country's multitude of monuments and the fact that it possessed, at a certain level, a literate society. The revelation of the humanity of the ancient Egyptians has made the study of their history one of endless fascination. And there seems to be no end to what may be discovered. Every year brings its crop of new historical information. The sources are often unexpected: professional archaeologists are the most painstaking and usually the most reliable; illicit diggers are the most unpredictable, but often dramatically successful; public works – the digging of an irrigation ditch, for example – can often yield significant surprises.

In consequence the overall picture is a varied one. Although it is unlikely that Egyptian history will ever be written on the scale of Greek and Roman history, historians of ancient Egypt will not be deterred from doing what they can with the limited evidence at their disposal. There is great opportunity for interpretation, much scope for imaginative reconstruction and dangerous freedom for invention. All the more need, therefore, for the exercise of restraint and a strict adherence to sound historical principles. Something of this last ethic has supported the writing of this book.

Since the hieroglyphic script provides the key to ancient Egypt, each chapter is introduced by a short hieroglyphic sentence, drawn or adapted from a text appropriate to what follows (translated on pp.156-9). Each chapter is also accompanied by a map pertinent to the period dealt with in the chapter and by short statements to explain the sequence of periods and to list the kings by dynasties.

As the title of the book makes clear, this is not by any means an expansive history of the country. May it therefore be a stimulus for the reader to explore further in more comprehensive histories and specialised studies, such as those included in the Reading List (p.160). The reader should not, however, be discouraged by discovering that royal names are often spelled in different ways by different writers. No one has yet devised a system of spelling completely acceptable to all scholars. Unfortunately there is no right way of writing these names except in hieroglyphs; and to do that could be even more confusing, as the ancient script itself is not without variation.

<div align="right">

T. G. H. James
31 August 1995

</div>

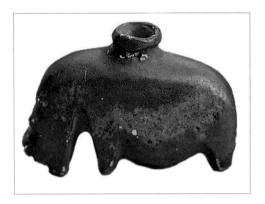

Limestone hippopotamus figurine of the
Late Predynastic Period.
Private collection; *length 6.9cm*

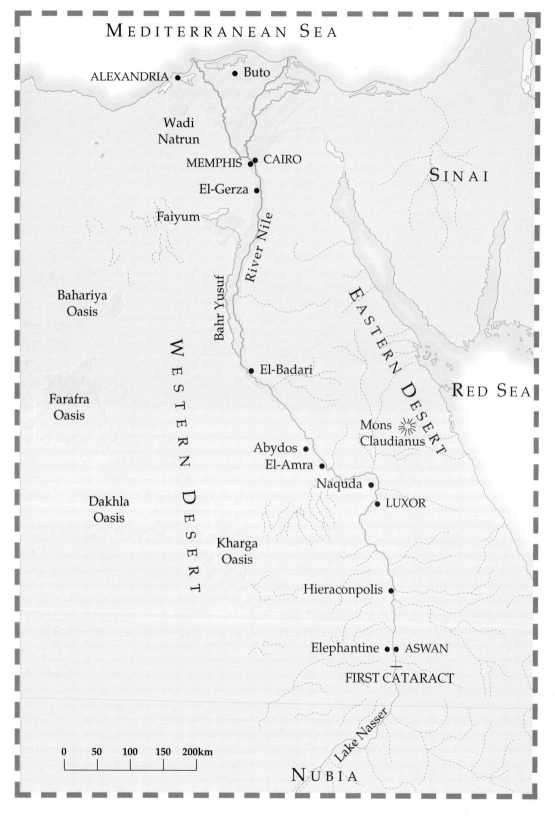

MEDITERRANEAN SEA

ALEXANDRIA

Buto

Wadi
Natrun

MEMPHIS CAIRO

SINAI

El-Gerza

Faiyum

River Nile

Bahr Yusuf

Bahariya
Oasis

WESTERN DESERT

EASTERN DESERT

RED SEA

Farafra
Oasis

El-Badari

Mons
Claudianus

Dakhla
Oasis

Abydos
El-Amra

Naquda

LUXOR

Kharga
Oasis

Hieraconpolis

Elephantine ● ● ASWAN

FIRST CATARACT

0 50 100 150 200km

Lake Nasser

NUBIA

Key

------- Desert watercourse

PREDYNASTIC CULTURES

The chronology of Egypt in the historic period is based on the dynastic series found in the history of Manetho. The cultural periods before the start of the First Dynasty in about 3100 BC are called 'predynastic'. They are mostly identified by the modern names of the places where they were first found. The discovered remains of much earlier stages in human history, termed 'palaeolithic', are similar to those found elsewhere in Africa and Europe, and cannot be regarded as being particularly Egyptian. The dates given here for the earliest times are very approximate; for the Egyptian predynastic cultures, they are more precise.

Early Palaeolithic *c*.200,000 BC
Mid-Palaeolithic *c*.100,000 BC
Late Palaeolithic *c*.10,000-7000 BC
Neolithic *c*.7000-4000 BC

The later stages of Neolithic merge into the predynastic Egyptian cultures:
Badarian *c*.4500-4000 BC
Naqada I (Amratian) *c*.4000-3500 BC
Naqada II (Gerzean) *c*.3500-3100 BC

1: The Desirable Land

Predynastic Egypt before 3100BC

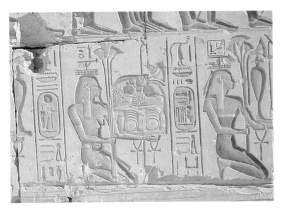

Nile deities representing the nomes (provinces) of Egypt, presenting the particular products of the various parts of the land for use in the temple of King Ramesses II at Abydos.

'Egypt is the land which the Nile in flood irrigates, and the Egyptians are those people who live downstream from the city of Elephantine and drink from that river.' These were the words, according to the Greek historian Herodotus, by which Egypt was described by the famous oracle of the god Amun in the Oasis of Siwa. As a definition it could hardly be bettered. Look at the map of modern Egypt, and you will see that the country consists of the Nile Valley running south from the Mediterranean Sea to the Sudanese border, with vast desert tracts to the east and west, together with the Sinai peninsula jutting down into the Red Sea. There are large oases in the Western Desert, important towns on the Suez Canal to the east, and valuable industrial and mining installations in both the Eastern and the Western Deserts. Even today for most people, and especially for the Egyptians themselves, Egypt is the valley of the Nile, the area irrigated by the river. The Nile no longer floods – the new High Dam just to the south of Aswan has put an end to the annual inundation – but the Egyptians still drink it, and claim, with much justice, that it provides the best water in the world.

In ancient times the land of Egypt as a well organised political unit began at Elephantine. Nubia to the south, although often occupied and administered by Egyptian officials, was never incorporated into Egypt itself. At Elephantine lies the first great cataract of the Nile, a place where the course of the river is hindered by a natural barrier of rock, where the stream is broken into many rocky channels, and where navigation is difficult and the water rough. From here to the sea the flow of the river for most of the year is placid and uninterrupted for 750 miles. It was in this last stretch of the river that the effect of the annual inundation was most beneficial. Here, over the centuries, the alluvial deposits built up on both sides of the river, extending sometimes only a few yards to the east or the west, but elsewhere forming a fertile strip ten miles or more wide.

In distant antiquity how inviting this strange land of Egypt must have seemed; so rich and fertile, so different from the harsh, inhospitable desert. It was, and is, so desirable chiefly because the Nile made it thus. The river is ever-present, with enough water to irrigate the land and to quench the thirst. It rains occasionally in winter time, especially in the north of the country; in the south rainstorms are rare and never welcomed. It is small wonder that some of the earliest settlements in which man displayed forms of organised existence were established in the Nile Valley.

'The gift of the river' was what Egypt was called in ancient times, but it was a gift that had to be renewed each year, for without the flood (which was at its height by mid-August) the land would die. Very occasionally the river would fail, or would rise inadequately and flood only part of the cultivated area. Then there would be a year of 'low Nile', and it would signal poor crops and shortages. A series of low Niles would result in famine. On the other hand, if the Nile rose exceptionally, there was the danger

The Nile at Aswan, at the northern head of the First Cataract, the point at which the land of Egypt began in antiquity.

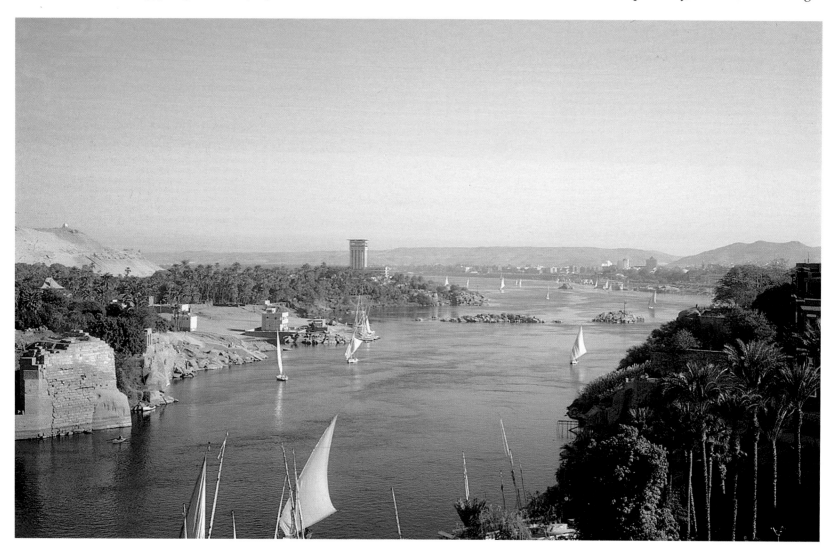

View from Siheil Island in the middle of the First Cataract, showing the rocky, broken-up nature of the Nile stream during most of the year.

that damage would be done to buildings and even to livestock, which would normally be moved well out of reach of the usual inundation.

When the waters subsided in late September and the Nile again flowed between its banks, the agricultural year began. Once the fields had been reinstated, the land boundaries re-established, and the canals and ditches cleared, ploughing and sowing could start. Very little preparation was needed for the land. The new layer of Nile mud, rich with organic deposits, was a natural fertiliser which had been spread everywhere. There was no need for a field to lie fallow, no need for crops to rotate. Seed could be sown directly, and in a normal year the farmer could wait with little anxiety for the crop to grow and ripen. Where it was possible, and needed, a little watering might be carried out, but for the most part the crops were left to flourish on their own until the spring when the harvest was gathered. After the harvest the fields could lie dormant until the waters of the Nile rose once again to perform their life-giving service to the land.

The ease with which crops could be raised in Egypt was probably the principal reason why some of the earliest agricultural communities developed by the Nile. On the edges of the Delta, in Middle Egypt, and around the shores of the great lake in the

The mythical source of the Nile, as shown in a relief in the Temple of Isis at Philae in the Roman Period. On the left Hapy, the Nile-in-inundation deity, sits in a rocky cavern pouring out the waters of the flood.

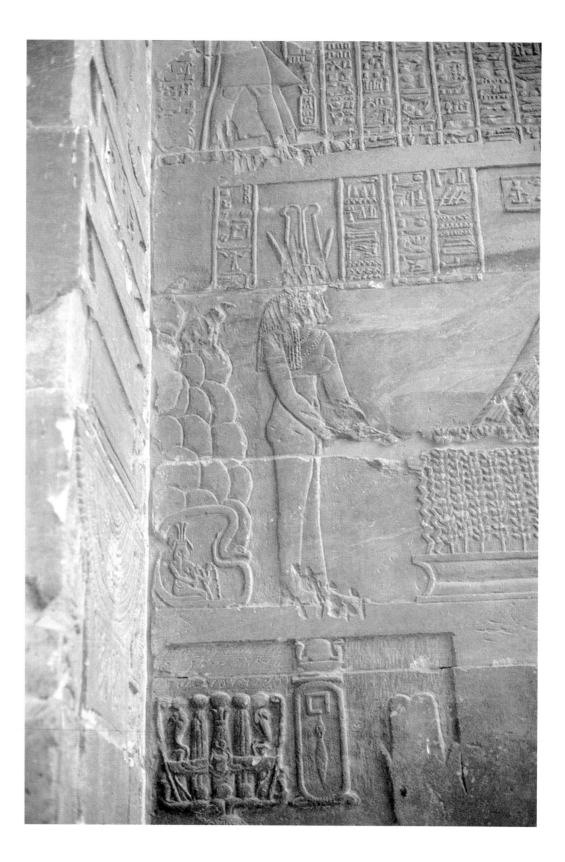

Faiyum, to the west of the main valley of the Nile, archaeologists have found the vestiges of Neolithic villages which provide very good evidence that cereal crops were grown more than 6,000 years ago. The settled way of life which the growing of crops demanded was quickly adopted throughout the Nile Valley in its northern reaches, and man rapidly learned how to make use of the wealth of resources offered to him by the fertile land and its neighbouring desert regions. In the centuries before the emergence of Egypt as a unified kingdom, the busy communities which populated the Nile Valley discovered manufacturing processes and developed ways of thought about themselves and the natural wonders which formed the simple strands from which the complex of Egyptian religious beliefs evolved.

'Predynastic' is the term usually used to describe the period before the union of Upper and Lower Egypt in about 3100BC. Elsewhere, such an early period, unilluminated by written records, would be called 'prehistoric'. 'Predynastic' is used in the case of Egypt because the historical period which followed is called 'dynastic', as will be explained later. Immediately before the unification of Egypt, the character of the culture of the country was generally the same in Upper (southern) and Lower (northern) Egypt (the Delta), but further back in time, more marked differences can be distinguished between the ways in which people lived and the things that they made in the two parts of the country. What precisely determined the division of the land in those early times was a combination of cultural differences still not fully understood. But the division was fundamental, and remained important in Egyptian minds throughout the whole dynastic period which followed unification. The division lay at about the level of modern Cairo.

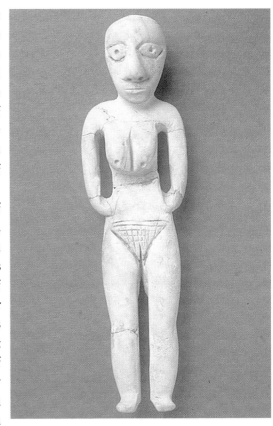

Ivory figure of a woman, one of the earliest human representations surviving from Badarian times.
British Museum *(EA 59648); height 14cm*

The first important discovery of an early culture was made by Sir Flinders Petrie at Naqada in Upper Egypt. At first he did not recognise its true age and character, but later, when similar sites were found elsewhere, he used the names of two of these places, El-Amra and El-Gerza, to particularise the early and late stages of predynastic culture: he talked of the Amratian and Gerzean Periods. Subsequent discoveries at other sites have shown that his distinctions were not as clearly localised as he thought; and, for practical reasons chiefly, archaeologists now prefer to call the two periods Naqada I and Naqada II. An earlier cultural stage preceding the Naqada I Period was identified in the 1920s at a place called El-Badari in Middle Egypt (that part of the Nile Valley lying between the Faiyum and Abydos). Here were found traces of people who had already learned how to work many kinds of materials, including copper.

Of all the objects made by these early Badarians, the finest and most typical were their pots. Once again the Nile provided the material. Its sticky black mud was available throughout the country. Moreover, it was easy to work and robust enough to maintain large and open shapes. When it was baked it became bright red in colour. Being a coarse material, it yielded rather coarse pottery, but the early potters discovered that by polishing the shaped vessels when they were sun-dried, but before they were baked, a smooth, very pleasing burnished surface could be produced.

Mons Claudianus in the Eastern Desert of Egypt, exploited for its grey granite, particularly in Ptolemaic and Roman times. The terrain is typical of the region – the source of much of the fine stone used throughout antiquity.

They also found a process by which, in the course of baking, they could carbonise the top of the pot, ending up with a red pot with a black top. This unusual type of pottery became to some extent a characteristic product of the Nile Valley, and it was often made in later periods, although chiefly by rather primitive groups.

Pottery is, in fact, the most distinctive product of all the predynastic cultures, and Petrie used it to construct a system of dating based on an observed sequence of development in styles and shapes. The pottery of the Naqada I and II Periods reveals a distinct difference in traditions between Upper and Lower Egypt which can only be partly explained by temporal development. In Upper Egypt particularly, the pottery

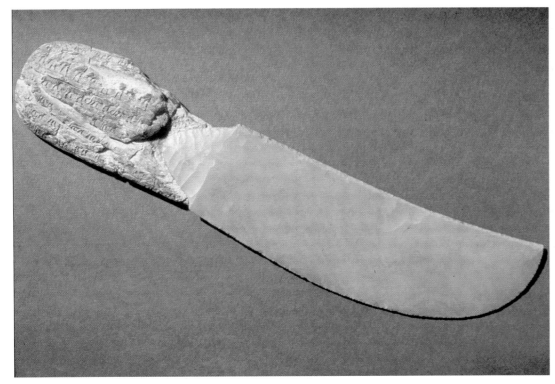

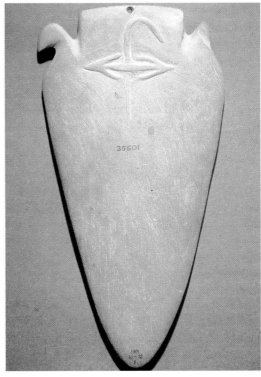

tradition of the Naqada I Period seems to be continued into the Naqada II Period, and this continuity can be seen in other material remains found in typical burials of the region. The people who produced these objects seem to have been firmly rooted in the land, devoted to a native culture which was fairly simple. In Lower Egypt, on the other hand, different forces were apparently at work, resulting in a less homogeneous culture, and forming communities with more highly developed tastes and accomplishments. The material manifestations of their life suggest that in the Eastern Delta at least, there were cultural contacts with Palestine, for example in the development of certain pottery forms. The extent of foreign influence, which some scholars would inflate into large-scale invasions from the east, remains an open question.

Graves in Middle and Lower Egypt also contained much richer material than contemporary Upper Egyptian graves. Objects found in great profusion reveal what skills had been fostered, and to what extent the way was being prepared for the great cultural explosion which would accompany the political unification of the two parts of the land. In the craft of the potter, for example, the Naqada II people discovered that far finer wares could be made from the greyish clay found in some of the desert valleys which ran down to the Nile from the east. This clay was of a very smooth texture, and it baked to a light buff colour which took decoration well. On some pots, scenes with boats and human figures were drawn, often including strange standards supporting emblems, which may have been the predynastic equivalents of the nome (provincial) standards of later times.

Left: The Pitt-Rivers knife; a fine example of a ripple-flaked, serrated, flint knife of the late Predynastic Period, fitted with an ivory handle (possibly not its original handle) carved with parallel rows of animals.
British Museum *(EA 68512); length 24cm*

Above: Slate palette decorated with bird heads at the top, and bearing in low relief carving a device which seems to incorporate a sign of uncertain identity, later associated with the god Min; from El-Amra, of Naqada II date.
British Museum *(EA 35501); height 29.5cm*

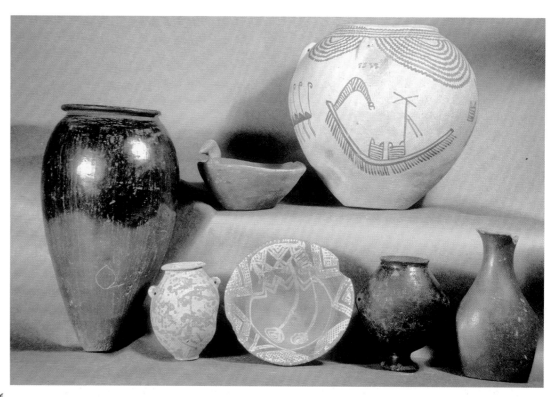

A collection of predynastic pottery of the Naqada I and Naqada II Periods, ranging in date from c.4000 to c.3100BC.

Hearst Museum, University of California, Berkeley

The Eastern Desert was also the source of the fine stones which were much used at this time for the manufacture of vessels of superb quality. In working on these stones the predynastic Egyptians learned how to shape very hard materials using tools of the simplest kinds. This was the kind of knowledge which would serve the Egyptians well when the time came to quarry granite and to shape massive architectural elements by patient pounding and abrasion.

On a smaller scale they made eye-paint palettes out of schist, a hard slaty stone; many were in the form of birds and animals. The perceptive way in which the various creatures were depicted shows how carefully the artists observed their subjects, and how skilled they were in reproducing what they saw in a hard medium. The Egyptians always observed nature with sympathy and humour.

It has already been suggested that the early inhabitants of Egypt, although rooted in the fertile valley of the Nile, were not unacquainted with the vast desert areas which lay to the east and the west. The Nile Valley provided a settled agricultural existence in which peaceful pursuits could be developed. The deserts, on the other hand, offered a challenge; they were places where unknown dangers lurked, but where valuable things could be found, particularly fine stones and metal ores. At first the collection of desirable materials was conducted on a modest scale, and it is unlikely that serious quarrying or mining was practised until the surface pickings were exhausted. Copper was available in the form of easily worked ore that had to be smelted, but the necessary skills for the extraction of the metal were not well developed until the very end of the Predynastic Period. During the

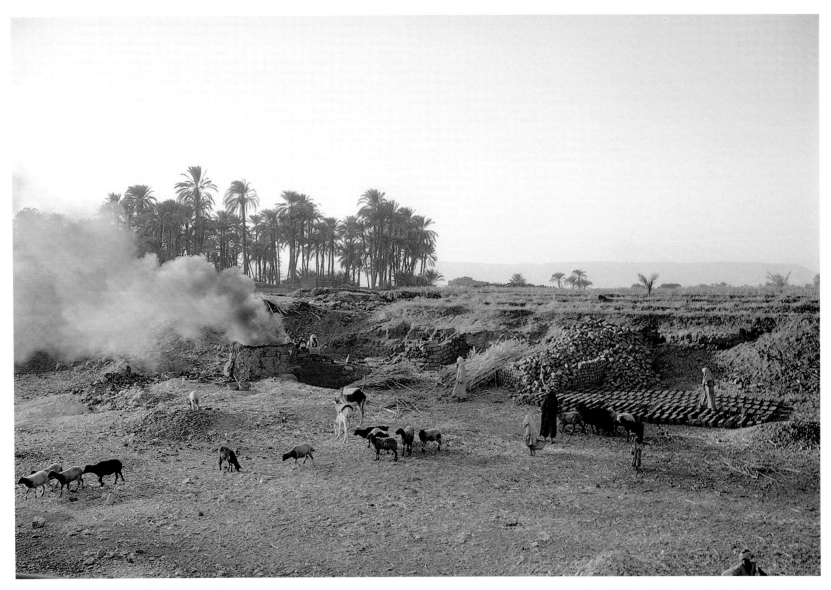

Predynastic Period, therefore, copper was used mostly for valuable ornaments and small tools which were themselves of great intrinsic worth. In the same way, gold was to be found in the Eastern Desert, and it was more easily recoverable than copper. From the first it was undoubtedly regarded as a precious metal, and was used for jewellery and embellishments, being too soft for more practical purposes.

There is some evidence that the Eastern Desert had much more vegetation in predynastic times, and that it was the haunt of a great deal of game. In historical times hunting was regularly enjoyed in the rocky valleys leading eastwards from the Nile, chiefly, no doubt, for the excitement of the chase. Hunting in the Nile Valley, however, was an activity with a different emphasis. In early times the land from Elephantine to the Mediterranean Sea was very sparsely populated. Large tracts were untamed by man,

Modern brick-making on the banks of the Nile at Dendera in Middle Egypt. Ancient mud-bricks, made from Nile mud with added chaff or straw, were formed individually as they are today, but were not baked.

undrained and marshy, where many kinds of predatory creature lurked, presenting constant threats to the villagers, their animals and their crops. The wide-spreading Delta, which offered the best opportunities for large-scale cultivation and stock-raising, was also the most difficult region to tame. It was naturally wetter than the rest of the valley, it was severed by several branches of the Nile (probably three for most of antiquity), and it received a regular rainfall in winter. Here the hippopotamus and the crocodile flourished, the former being the destroyer of crops and the latter the destroyer of man and cattle. Both creatures in later times were regarded as manifestations of certain gods, and it is probable that they were revered as such in predynastic times.

Falcon-headed Horus, identified with the living king, engages in the harpooning of his rival and brother, Seth, here shown as a hippopotamus of diminished size, in a relief in the Ptolemaic temple of Horus at Edfu; c.100BC.

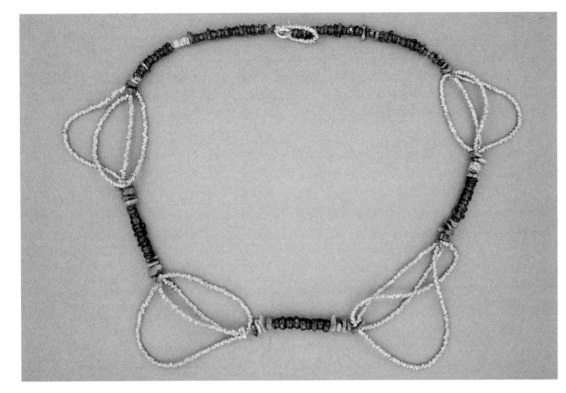

Diadem of turquoise, garnet, malachite and gold beads. It was found, still attached to the head of a woman, in a grave of the Naqada II Period at Abydos.

British Museum (EA37532); length 31.2cm

The hunting of the hippopotamus was later seen as a kind of religious rite, the slaying of Seth, the hostile god. By the religious dramatisation of a necessary activity the Egyptians were no doubt able to satisfy their scruples in attacking a deity. Some very early pottery vessels bear representations of the slaying of the hippopotamus, and as identifiable scenes are rare on such pottery it is reasonable to infer that no ordinary hunt was being portrayed.

Much of the information which we possess about the predynastic Egyptians is so slight that deductions from it concerning their thoughts and beliefs are very uncertain. Not much is even known about their physical appearance, while attempts to determine their ethnic character remain very tentative. But it is now generally thought that at the time of the unification of the land the race was already very mixed, containing strains which stemmed both from Asia and Africa. The evidence of the language spoken in dynastic Egypt in the earliest times shows that the process of fusion between Hamitic (African) and Semitic (Asiatic) peoples must have taken place over a very long period of time. It is, however, impossible to point to positive signs of how the Asiatic element arrived. In the century or so before the beginning of the First Dynasty, certain artistic and material innovations appeared in Egypt which suggest positive links with Asia; examples are the cylinder seal, certain distinctive decorative designs, and particular methods of construction with mud-brick. At this time there may well have been very strong cultural connections with the east, but to what extent they contributed to the political developments of the period will probably never be known.

Black steatite cylinder seal with incised designs, including fish, which suggest a Mesopotamian origin or influence, although the piece seems to have an Egyptian provenance.

British Museum *(EA 65859); length 3.1cm*

Very little can be said with certainty about the political situation in Egypt during the last century before unification. Mention has already been made of tribal standards on pottery, probably representing the banners of small states which made up the territorial patchwork of the country. The crowns which, throughout Egyptian history, indicated sovereignty over Upper and Lower Egypt also occur. The red crown, ⳩, was the characteristic symbol of the Lower Egyptian king, while ⳩, the white crown, was worn by the king of Upper Egypt.

It seems likely that groups of small states in the north and in the south formed themselves into two opposing unions under powerful chiefs whose capital cities were Buto in the Delta and Hieraconpolis in Upper Egypt. Being a land of length and scarcely any breadth, except in the Delta, Egypt was always difficult to rule as a united state. Local interests worked for disunity; the existence of the Nile argued for unity. The rule of a single person was the ideal, but it had to be strong rule to hold together the extremities of a most awkwardly shaped land.

The level of culture in Middle and Lower Egypt seems to have been better developed than in Upper Egypt, but it does not seem to have followed that the north was better organised militarily or more aggressive than the south. The scenes on some important carved objects, mace-heads and large ceremonial slate palettes, found at Hieraconpolis and other places in Upper Egypt, provide hints of the struggle which probably continued over many years. As representative objects of the Upper Egyptian union, these mace-heads and palettes possibly give a false impression of the superiority of the south over the north, of whose capabilities there has survived no tangible evidence of comparable value. But it was the south which was eventually to gain the victory.

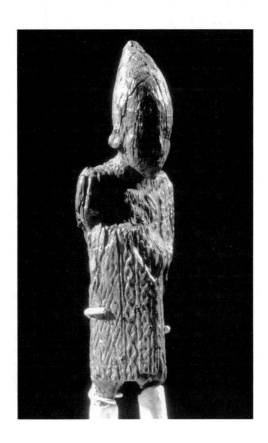

Ivory figure of a king wearing the white crown of Upper Egypt and a Sed-*festival cloak with lozenge pattern. First or Second Dynasty; from Abydos.*

British Museum *(EA37996); height 8.8cm*

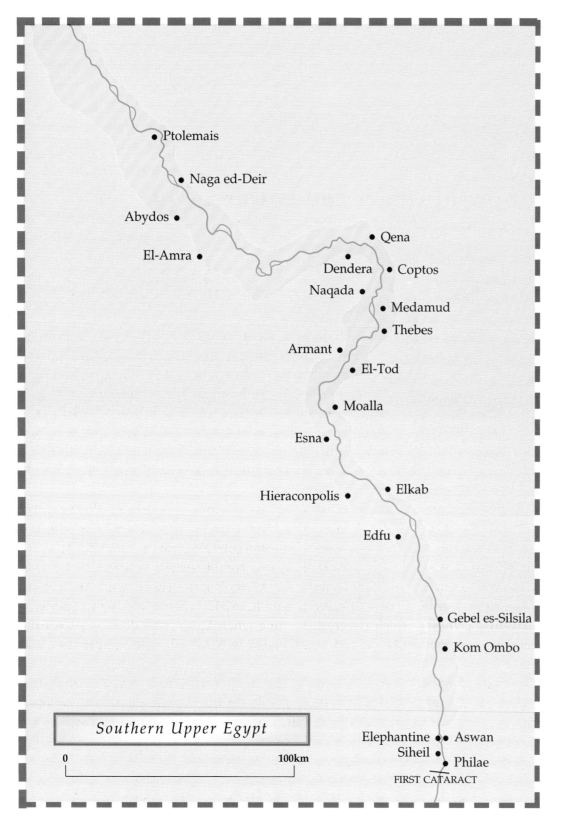

Southern Upper Egypt

0 100km

FIRST CATARACT

THE EARLY DYNASTIC PERIOD

The unification of Egypt by Menes (Narmer) marked the start of the Dynastic Period in Egypt, which lasted until the conquest of the country by Alexander the Great in 332BC. Although Menes is said to have founded the city of Memphis as a new capital for the whole land of Egypt, the political focus initially remained in Upper Egypt, moving to the north in the course of the Second Dynasty. The Early Dynastic Period, sometimes called the Archaic Period, covers the first two Manethonian dynasties.

Note: Dates at this early time are only approximate, and reign lengths uncertain.

Dynasty I *c.*3100-2890BC
Narmer (?Menes)
Aha
Djer
Djet
Den
Anedjib
Semerkhet
Qaa

Dynasty II *c.*2890-2686BC
Hetepsekhemwy
Raneb
Nynetjer
Peribsen
Khasekhem (Khasekhemwy)

2: King of Upper and Lower Egypt
Dynasties I and II, 3100–2686BC

According to tradition and some ancient records, the first king of a united Egypt was called Menes. Apart from recording the length of his reign, all Manetho could find to say about him was that he was carried off by a hippopotamus and perished. Manetho may not have known very much about Menes, but as he wrote almost 3,000 years after Menes lived, this is not surprising. Manetho was an Egyptian priest who composed a history of Egypt from priestly records in the third century BC. No complete version of this history has survived, but summaries were incorporated into the work of later writers which, happily, have been preserved.

Manetho organised the ancient lists of kings into houses, or dynasties as he called them, and this dynastic framework, although not wholly reproducing the historical sequence as it is now understood, has become too convenient to be put aside. The First Dynasty began with the reign of the king who completed the unification of Upper and Lower Egypt; the Thirtieth Dynasty – Manetho's last – ended with the death of the last native-born Egyptian king, Nectanebo II, in 343BC. Some later writers added a Thirty-first Dynasty which covered the time when Egypt was dominated for the second time by Persian kings, and which ended in 332BC when Alexander the Great entered Egypt.

The name Menes or Men, given to the first king of the First Dynasty by Manetho, by Herodotus, and by the Egyptian king-lists set up in temples during the New Kingdom, does not occur with any certainty on any objects that can be dated to the period when he lived. Who then was Menes? The names of several early rulers involved in the struggle for unity have been preserved. One of these, known as King Scorpion because he wrote his name with the hieroglyph of a scorpion, is shown in scenes on the best preserved of the ceremonial mace-heads from Hieraconpolis.

Above: Limestone ceremonial mace-head from Hieraconpolis. The relief scenes appear to show episodes in the struggle between the North and South. Here the king named Scorpion opens a canal, or is engaged in some other act connected with irrigation.

Ashmolean Museum, Oxford *(E.3632); height 32.5cm*

Right: Ceremonial schist palette of Narmer from Hieraconpolis. Here he is shown as King of Upper Egypt, smiting an enemy, and accompanied by his sandal-bearer and the falcon (Horus) leading the marshy Delta, symbolically represented, by the nose.

Cairo Museum *(14716); height 63.5cm*

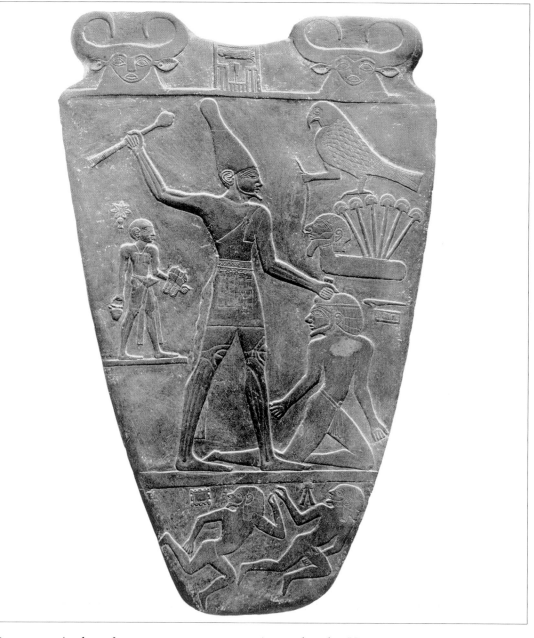

One scene is thought to commemorate a victory by the Upper Egyptian nomes over the peoples of the desert and possibly the Delta.

Another king, called Narmer, is known from a number of objects, the most important of which by far is a great slate palette carved with scenes which seem clearly to refer to the final conquest of Lower Egypt by the King of Upper Egypt. On one side Narmer, wearing the crown of Upper Egypt, is shown braining a defeated enemy. On the other, wearing the Lower Egyptian crown, he is shown going forth to inspect his slain enemies, beheaded and laid out in rows. It would seem to be an unusually fortunate

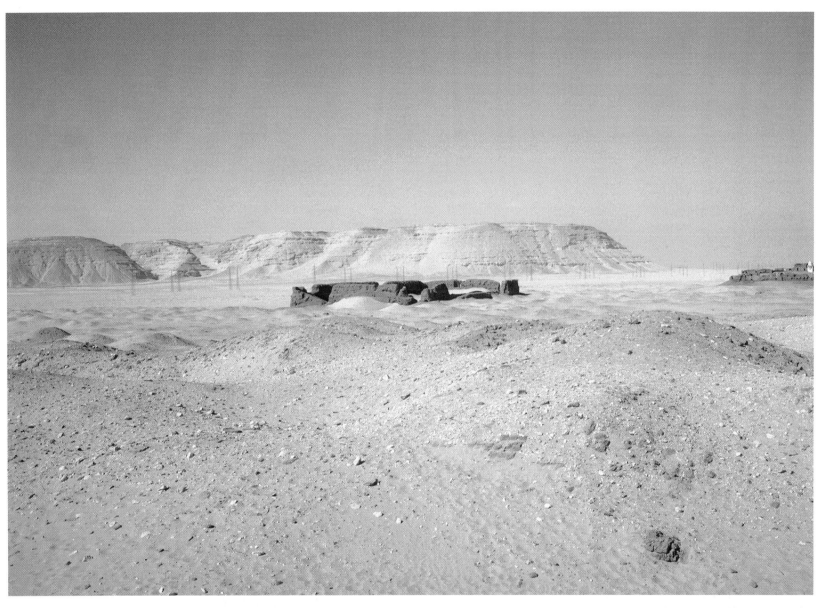

The northern end of the great Abydos necropolis with two Early-Dynastic mud-brick enclosures, probably ritual structures associated with the early royal tombs lying to the west. The enclosure on the right now contains a small village and Coptic monastery.

piece of luck that has ensured the survival of such an explicit document illustrating the final stages in the struggle between Upper and Lower Egypt. Nevertheless, the accepted interpretations of the scenes are very probable, and there is good reason for thinking that the credit for uniting the whole of Egypt belongs to Narmer. He might therefore be the historical person later to be named Menes.

The moment of unification, which is commonly believed to have happened in about 3100BC, was a critical point in the history of Egypt. Everything seemed to happen at the same time. Political unity was accompanied by a reorganisation of internal administration; a new approach to the perennial problems of river-control and irrigation could then be instituted for the benefit of the whole land. Meanwhile, Egyptian artists,

Site of Memphis, founded by King Menes, the most important city in Egypt for three thousand years. The area is now covered with villages and palm groves. The visible remains here are of the temple of Ptah of New-kingdom date.

as if overnight, developed new ways of depicting things, and established many of the conventions which were to characterise Egyptian art for the next 3,000 years. Above all, the Egyptian bureaucrats learned how to write. The earliest writings, trivial though they are, occur at the very period of unification. It is therefore true to say that the historical period in Egypt begins at the same time as the Dynastic Period. And that is why 'predynastic' is for Egypt coincidental with 'prehistoric'.

Success seemed to accompany everything that was attempted in this new age. Egypt had discovered its identity as a nation. For the future, undertakings and achievements were set in a national context, and they were correspondingly greater in conception and in result than ever before. The extraordinary change from the parochial to the national was

embodied in the person of the king. As far as can be determined from admittedly inadequate records, the victory of the south over the north did not lead to despotic domination of the latter by the former. Egypt was not ruled thereafter by the Upper Egyptian king, but by one who associated himself equally with both parts of the country. From the reign of Den, fifth ruler of the First Dynasty, the king was shown wearing a double crown incorporating the old individual white and red crowns, and he used as a title a designation which linked him with the south and the north; he was 'one belonging to the sedge [Upper Egypt] and the bee [Lower Egypt] '.

The most important royal name, however, associated the king with the god Horus, the falcon deity of the city of Hieraconpolis in Upper Egypt. There were also falcon deities worshipped in the Delta, so that the identification of the king with a falcon deity was a further act (perhaps unconscious) by which unity was confirmed in the land. The use of religious means to secure political ends was a constant feature of official policy throughout Egyptian history.

One of the most important events in the early years of the First Dynasty was the creation of a new capital city just to the south of the point where the single stream of the Nile branched to form the Delta. Here was the junction of Upper and Lower Egypt. The site of the new city was well chosen, and it remained the most important administrative centre in Egypt continuously down to the Roman Period. In later times it was called Memphis, a name taken from that of the pyramid of Pepi I of the Sixth Dynasty; but at first it seems to have been called White Walls, probably after the great white plastered mud-brick walls which surrounded it.

Menes is traditionally credited with the foundation of White Walls. In order to make the site safe from flooding, he is also said to have built a barrage to divert the course of the river. It is impossible to check the truth of these traditions, but there can be no doubt that an important administrative centre was established in the region of Memphis at the very beginning of the First Dynasty. And on the desert escarpment to the west are the huge tombs occupied by the bodies of the great men of the period. The tombs at Saqqara consist of underground burial chambers covered by massive rectangular super-structures built of mud-brick. Such a tomb is usually called a *mastaba* (Arabic for 'bench'). Over one hundred years ago, when Saqqara was first systematically investigated by Auguste Mariette, the French archaeologist who founded the Egyptian Antiquities Service, many Old Kingdom tombs were found with stone-built rectangular superstructures which reminded his workmen of the mastabas built inside and outside village houses.

Mud-brick was the material used for these early buildings. It was employed with great skill, and the visible appearance of the massive superstructures must have been most striking, especially as at Saqqara they were placed near the edge of the desert escarpment overlooking the Nile Valley and the city of White Walls. Those built during the First Dynasty had elaborate panelled and recessed façades which probably reproduced secular structures of the period. The outer walls were faced with white

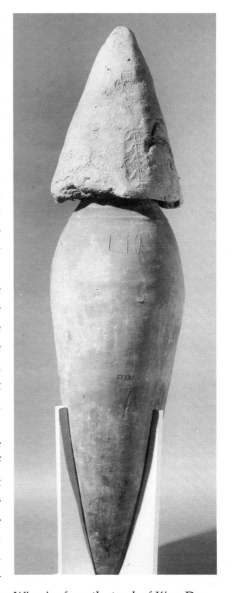

Wine jar from the tomb of King Den at Abydos. The mud stopper bears the impressions of seals with the name of Den and of his senior official Hemaka.

British Museum *(EA27737, 27741); full height 100cm*

31

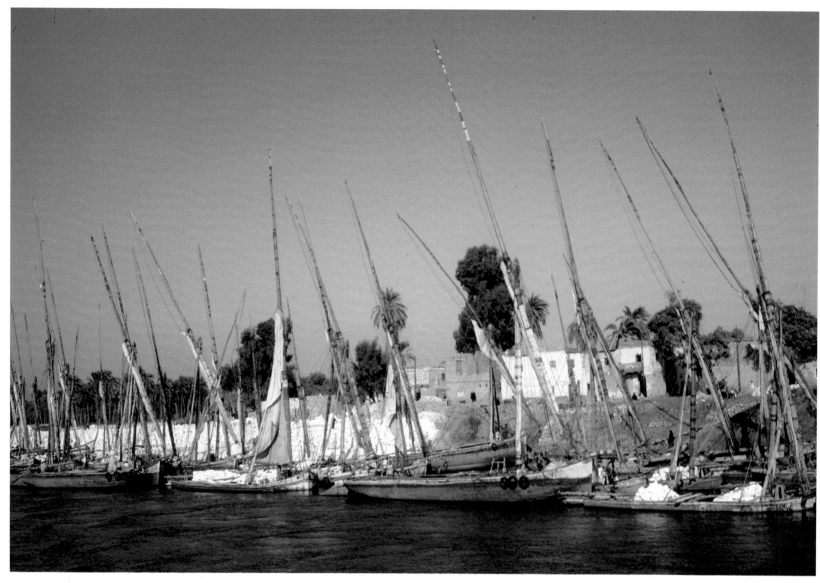

A village river-front in Middle Egypt with moored feluccas, still the cheapest and most convenient form of transport for local and cross-river traffic. In antiquity stone from quarries was conveyed long distances by river.

plaster, and, in their lower levels at least, they were painted with colourful designs representing woven mats or hangings.

Although mud-bricks are easy to mould and simple to use, they do not make a very durable medium for building, especially if they are not baked. But in a country like Egypt they are perfectly satisfactory for domestic purposes, for houses and palaces, and for official structures, which can easily be rebuilt or repaired if they suffer from the weather or the ravages of time. Indeed mud-brick was the regular building medium in Egypt, even for the great royal palaces of kings like Amenophis III of the Eighteenth Dynasty. If, however, a building was to last, it had to be built of stone, even though stone was difficult to work and hard to transport. It is therefore not surprising to find that the first use of stone for building was in early tombs – for door-jambs

and lintels, for portcullises to hinder the entry of tomb-robbers, for pavements, and for lining the walls of subterranean burial chambers.

Stone was also used for the monuments set up to mark the ownership of a tomb, and to carry the simple invocations designed to obtain the food, drink, and other necessities required in the after-life by the dead. Such monuments are usually called stelae. The finest early stelae were those set up by the royal tombs at Abydos. They carry no more than the Horus name of the king inscribed within a frame called a *serekh*, and topped by the figure of a falcon (Horus). Other stelae found in private tombs have small scenes showing the dead person seated at an offering table with texts containing lists of offerings, and the titles and name of the owner.

Taken with other pieces of evidence, these stelae provide much information about the higher-ranking Egyptians of the first two dynasties. They show, for example, that men were already using the kilts and leopard-skin tunics which important officials wore in later times, while women had discovered the attraction of the tight-fitting, low-cut dress. They sat on chairs and stools of surprisingly developed styles. The texts on the stelae show that ideas of the necessities of the after-life, known so well from later texts, were already well formulated. The titles borne by the various owners of stelae give some clues to the developing state of the Egyptian bureaucracy. Some of the smallest private stelae are well carved, but most are executed in a rather crude, untutored style. In view of the excellence of the stelae carved for royalty, and from the evidence of other carved objects in stone, wood and ivory, it is clear that first-class craftsmen, working in a rapidly expanding tradition, were already being trained in the principal centres of the country. Already the methods of representation used in scenes on royal and non-royal objects show a remarkable consistency.

In this matter, as in so much else, the ancient Egyptians demonstrated that once they were satisfied with a technique, a method, or a way of thinking, they would cling to it tenaciously. During the great formative period of the first two dynasties many characteristically Egyptian methods of doing and thinking were established.

The first hieroglyphic inscriptions, on stelae and on small objects found in tombs, are of the simplest kinds. The signs, when carefully executed, are as good as any found in later periods, but the contents of the inscriptions show that the Egyptian scribe had not yet learned how to set down complicated ideas in writing. Simple concepts and the names of objects were easy: a jar could carry the word describing its contents; a cylinder seal could bear a royal name, the name of an official, and even the name of the estate which produced the wine in the sealed vessel; a small ivory plaque could show the king named Den striking a prostrate Asiatic with a mace, accompanied by four signs usually translated as 'the first time of smiting the East (or Easterners)'. This last group expresses about as complicated an idea as was within the capacity of the early scribes.

Beside the pictorial hieroglyphic script there developed a cursive, less detailed script which is now called 'hieratic' – a very misleading term for this kind of writing. The Greeks used 'hieratic' (which means 'priestly') to describe the cursive script employed

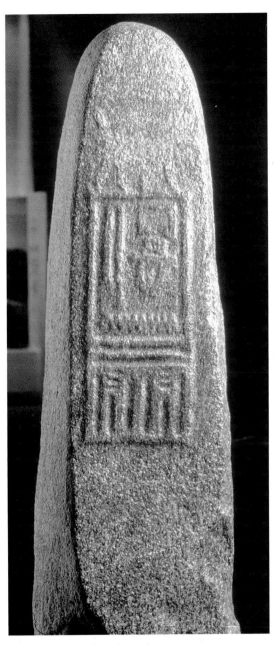

Granite stela with one smooth surface bearing the name of the King Peribsen of the Second Dynasty; from Abydos. The name is placed in a serekh, *topped by the unidentified animal of Seth instead of the more usual falcon of Horus.*
British Museum *(EA35597); height 113.5cm*

33

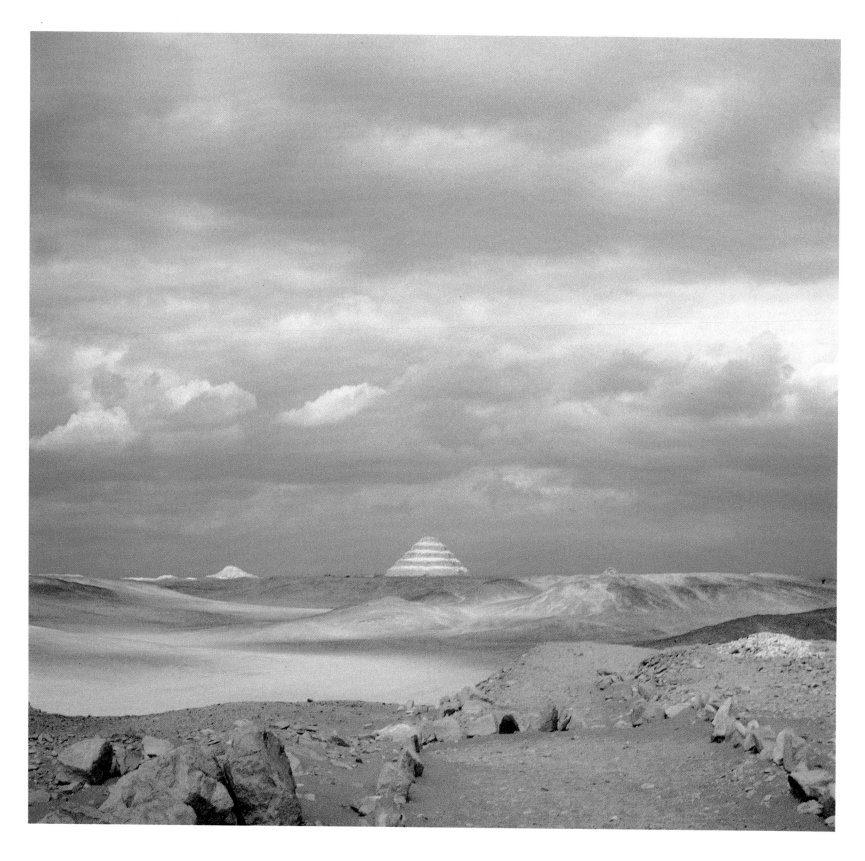

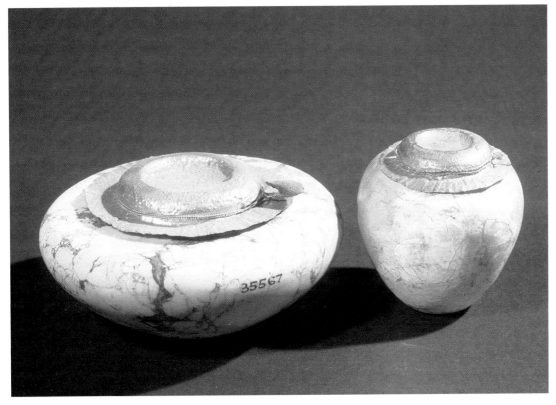

Left: Dolomite vessels with gold lids from the tomb of Khasekhemwy of the Second Dynasty at Abydos. Gold wire secured the lids, and in one case a small mud sealing is also preserved.
British Museum *(EA35567, 35568); heights 5cm, 5.7cm*

Opposite: View over the Old Kingdom necropolis of Saqqara; in the centre is the Step Pyramid of King Djoser.

in later times almost exclusively for religious texts written on papyrus. The word 'hieratic' was then adopted by early Egyptologists to describe all Egyptian cursive scripts (except 'demotic', as we shall learn later) used in earlier periods for non-formal, mostly non-religious, purposes. Such cursive scripts were chiefly executed with a brush, not a chisel, and the earliest examples are very close in form to their hieroglyphic originals.

Some of the objects found in the tombs of the early dynasties suggest that the Egyptians were not wholly isolated from the world outside Egypt. Curiosity drove Egyptians abroad to find out what was happening elsewhere, and to obtain exotic products not available at home. Contacts with Mesopotamia are implicit in many aspects of Egyptian life at the beginning of the Dynastic Period – in language, writing, building materials and methods, and designs. In technology too it is possible that techniques like the working of copper were also learned from Western Asia.

Small objects of elephant ivory and ebony point to trade with the lands to the south, through which contact could be made with equatorial Africa. Djer, third king of the First Dynasty, may have sent a conquering force into Nubia; Khasekhem, the penultimate king of the Second Dynasty also found it necessary to conduct a southern campaign, about which no details have survived. The campaign by Den against the Easterners, mentioned above, may refer to an operation against the inhabitants of Sinai. A reference to this or to a similar campaign may be contained in an

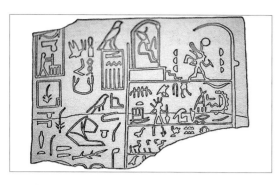

Ebony jar label from the tomb of King Den at Abydos. It carries the name of the king and of his official Hemaka, and a scene showing the king wearing the double crown, and engaged in a ceremony, part of the Sed.
British Museum *(EA32650); width 8cm*

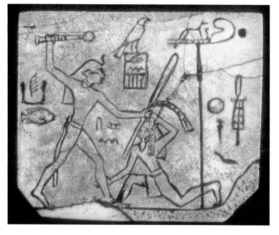

Ivory label for a pair of sandals, from Abydos. King Den is shown smiting an enemy with a text apparently saying 'First time of smiting the East (or Easterners)'.
British Museum *(EA55586); width 5.4cm*

entry on the Palermo Stone which records the smiting of the tribesmen (possibly the desert Bedouin) by a First-Dynasty king. This Palermo Stone is a fragment of a great annalistic inscription supposedly set up in the Fifth Dynasty (but possibly of much later date), recording the reigns of the kings of Egypt, the years being identified by important events such as foreign expeditions and major constructions.

One of the most fruitful areas of exploration was the Levant, the Eastern Mediterranean coast-lands. Typically Syrian oil jars have been found in Early-dynastic tombs, while Egyptian objects of the same period have been excavated at Byblos in the Lebanon. The absence of good timber in Egypt drove the Egyptians to seek it from the Lebanon, and the clear evidence of its transport to Egypt is provided by the remains of great baulks of roofing timbers from coniferous trees found in the tombs of Abydos and Saqqara.

Although the unification of Egypt by Narmer/Menes marked the beginning of a brilliant period of cultural advancement, it is unlikely that it put an immediate end to political tensions within the country. It must be supposed that the principal task of the early kings was to hold the country together. Aha, the successor of Narmer, appears to have devoted much of his energies to consolidation, and the foundation by him of a temple dedicated to Neith, the goddess of Saïs in the Delta, may have been an act consciously aimed at pleasing the Lower Egyptians. Anedjib, the successor of Den, adopted a new title consisting of two falcons on perches, which probably identified him with the two lords, Horus and Seth, and thus equally with Upper and Lower Egypt. Both Semerkhet and Qaa, the last kings of the First Dynasty, reveal some animosity towards predecessors, causing their names to be erased and replaced by their own; but the reasons for such actions are not known. The change from the First to the Second Dynasty was apparently effected without serious internal trouble.

Similarly, the early reigns of the Second Dynasty appear to have passed in relative peace. Later in the dynasty, a king named Peribsen may not have been of the true line. His name was written in a *serekh* surmounted not by the Horus falcon but by the Seth animal, which may indicate that he had led some kind of revolt, promoting the cult of Seth in opposition to the traditional royal adherence to Horus. Khasekhem, his successor, certainly engaged in great military activities. Representations on the bases of two statuettes of the king refer to victories in the north (presumably the Delta) in which large numbers of the enemy were slain. The last king of the Second Dynasty is listed as Khasekhemwy, who was possibly the same Khasekhem with his name modified by the addition of the suffix *-wy*, indicating duality. The change may have been part of a policy of reconciliation between north and south (the dual kingdom). His name was written in a *serekh* surmounted by both the Horus falcon and the Seth animal.

The victories of Khasekhem and the conciliatory policies of Khasekhemwy (whether they were two persons or one) had the effect of finally consolidating the political and cultural advances of the two early dynasties. In the entries on the Palermo Stone recording Khasekhemwy's last years, great works are mentioned, including the

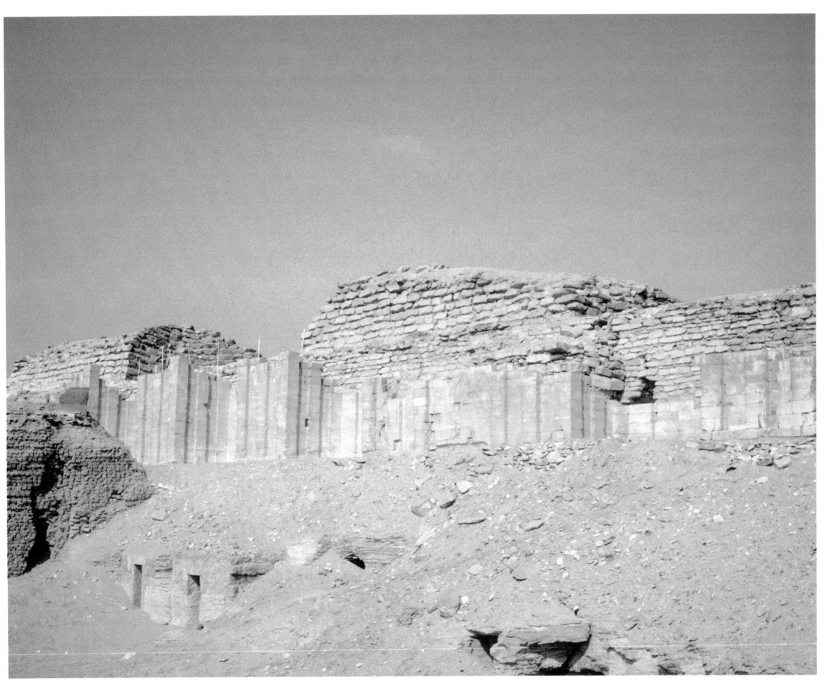

Part of the enclosure wall of the Step Pyramid complex at Saqqara. In its panelling, here made of fine Tura limestone, it seems to reproduce for eternity the less permanent white-washed mud-brick walls of early Memphis (White Walls).

Limestone seated statue of an official of the early dynasties, said to come from Abusir; it is uninscribed. The subject wears a cloak and has a head somewhat out of proportion to the body. The eyes were originally inlaid, possibly with crystal.

Egyptian Museum, Berlin *(21839); height 42.5cm*

construction of a stone temple. The country was now ready for noble achievements, and such were initiated by Djoser, the founder or second king of the Third Dynasty, and son or son-in-law of Khasekhemwy. With the help of Imhotep, his most senior official, he mustered the technical abilities and artistic skills of his people, and produced the first significant Egyptian building constructed wholly of stone, the Step Pyramid at Saqqara. Set in a vast enclosure surrounded by walls of fine limestone masonry, perhaps reproducing White Walls itself, it demonstrated unequivocally that Egyptian civilization had come of age.

*Hieroglyph of a frog on a basket from the stela
of Wepemnofret (see p.51).*

Hearst Museum, Berkeley

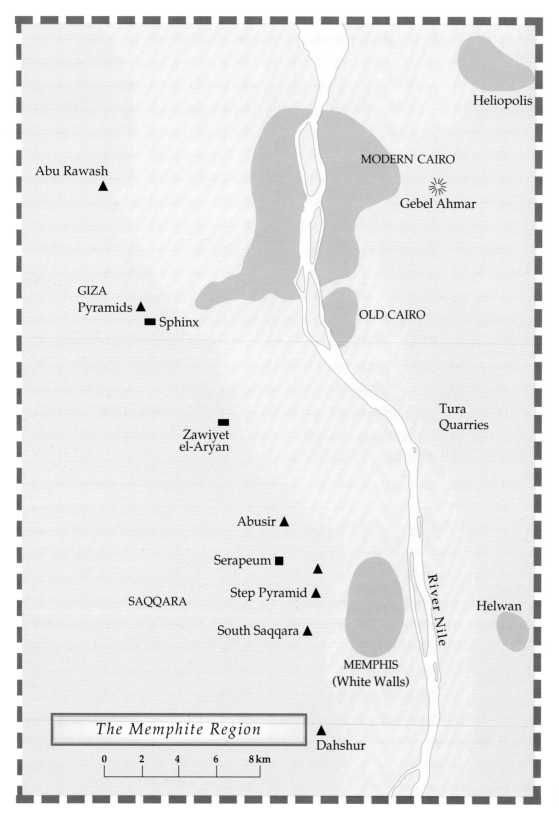

The Memphite Region

0 2 4 6 8 km

Heliopolis

MODERN CAIRO

Gebel Ahmar

Abu Rawash ▲

GIZA
Pyramids ▲
■ Sphinx

OLD CAIRO

Tura
Quarries

Zawiyet
el-Aryan ■

Abusir ▲

Serapeum ■
▲

Step Pyramid ▲

SAQQARA

South Saqqara ▲

Helwan

MEMPHIS
(White Walls)

River Nile

Dahshur ▲

THE OLD KINGDOM

The Old Kingdom was the time when the Egyptian idea of kingship was fully developed and visually proclaimed through great works. It was the Pyramid Age *par excellence*. At the same time Egyptian state religion, centred on the king, progressed from simple beginnings into a powerful ritual system based on the cult of the sun-god Re in Heliopolis. Memphis was now the political and cultural centre of Egypt.

Note: In the dynastic lists below selected names only are given; dates are uncertain.

Dynasty III *c.*2686-2613 BC
Djoser (Netjerykhet)
Sekhemkhet
Huni

Dynasty IV *c.*2613-2494 BC
Sneferu
Cheops (Khufu)
Chephren (Khaefre)
Mycerinus (Menkaure)

Dynasty V *c.*2494-2345 BC
Userkaf
Sahure
Neferirkare
Nyuserre
Djedkare Isesi
Unas

Key

☐ Limit of built-up area

Unfinished limestone statue of King Djoser in the Step Pyramid complex at Saqqara.

3: Majesty and Power

Dynasties III–V, 2686–2345BC

Between the formative years of the first two dynasties and the power-charged years of the Fourth Dynasty there came a testing time, lasting almost a century, in which the kings of the Third Dynasty expanded the horizons of achievement and made possible the remarkable era of the Old Kingdom which was to follow. The outstanding reign of this dynasty was that of Djoser, and the most crucial, tangible testimony of this reign is the Step Pyramid.

The man to whom the greatest credit for this building is usually given was Imhotep. Scarcely anything is known of his life and career from contemporary records, but his reputation was preserved and fostered by later generations, and he was numbered among the select band of clever men to whom the collected wisdom of Egypt came to be attributed. In very late times he became the object of a cult, and was identified with Asclepius, the Greek god of medicine. What precisely his position was at Djoser's court is uncertain. He carried titles which indicate that he was an official of high status and authority. He was not of royal blood, and he did not have the title which, from the time of the Old Kingdom, was carried by the chief royal officer, usually translated as 'vizier'.

Imhotep's triumph, the Step Pyramid, in addition to being the first great stone building in Egypt, serves also as a mirror reflecting the Egypt of the Third Dynasty. From the details of the architectural elements of the many smaller buildings contained within the pyramid enclosure, much can be learned of contemporary secular building, and possibly of the structures within the great palace complex down in the valley at White Walls. Engaged columns imitate in stone the reed-bundle supports used in buildings of mud-brick; half-opened doors in fine masonry reproduce wooden doors; stone ceilings are ribbed in imitation of palm-log roofs.

For the internal bulk of the pyramid locally quarried, poor quality limestone was employed; for the outer facings a very fine, close-grained limestone was brought from

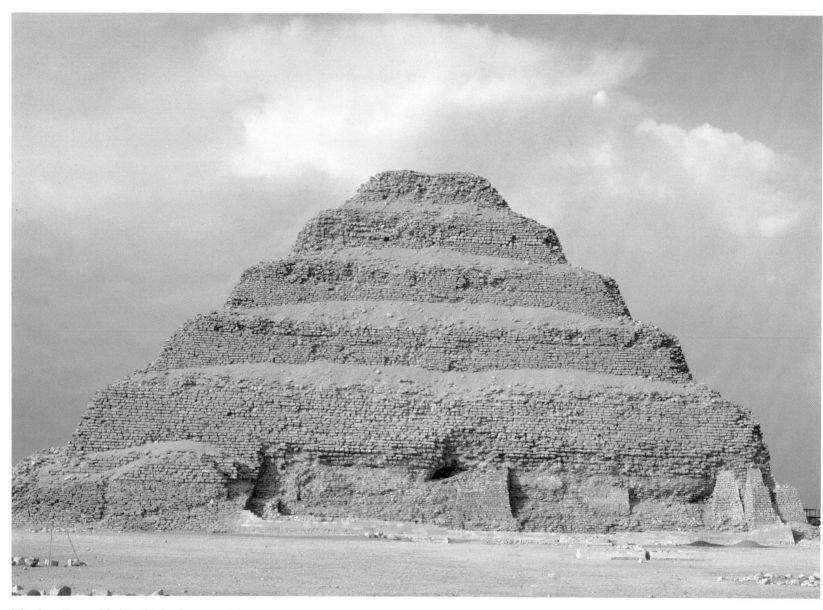

The Step Pyramid, 60m high, the central feature of the funerary complex built for King Djoser at Saqqara, overlooking the Nile Valley and Memphis. Said to be the work of the high official Imhotep, it was the first great stone building of antiquity, originally faced with a fine Tura limestone.

the Tura quarries across the Nile opposite White Walls. From a very early date the cliffs of Tura were exploited; the Egyptians had an excellent eye for stone, and a fine instinct for choosing the best. It was undoubtedly the case that the control and exploitation of quarries were in the hands of the king. Consequently, the best material was reserved for royal works, and occasionally for the monuments of those whom the king favoured. Nobles sometimes recorded in their tomb inscriptions that they owed the king for a fine piece of stone for an altar or an offering stela, or even a sarcophagus.

The shape of the Step Pyramid, apparently a series of six square mastabas set in diminishing order on top of one another, is quite unlike that of any earlier building. It may have been conceived simply as a monument of new and striking form, or as a monumental reproduction of the mound found within the superstructures of early mud-brick mastabas. It was certainly not a pyramid in the strictest sense of the word, but it was clearly the precursor of the true pyramids of the Fourth Dynasty.

Beneath the great bulk of the Step Pyramid was the burial chamber which at one time held Djoser's body, and many passages intended for the storage of funerary equipment and for the burials of members of Djoser's family. It must be assumed that some form of mummification was used to prepare the royal body for burial. From at least the First Dynasty the Egyptians had tried to discover how the bodies of the dead could be preserved in some semblance of life so that the individual could continue to enjoy earthly advantages in the after-life.

By the beginning of the Fourth Dynasty great advances in the technique of mummification had been made. A chest belonging to Hetepheres, the mother of King Cheops (Khufu), found at Giza, contains compartments designed to receive the internal organs of the dead queen, preserved in a solution of natron, the naturally occurring combination of salts used by Egyptian embalmers throughout the Dynastic Period. By this time (about 2600BC) the Egyptian embalmer had learned that it was essential to remove the internal organs if an incorruptible mummy was to be made. Although no royal mummies of the Old Kingdom have been found, it can safely be assumed that the kings would have received the very best treatment in readiness for burial and for the adventure of the after-life. For the majority of the population no special techniques for preservation were evidently available.

Preservation secured life after death, and the requirements of that life were made available to the dead Djoser in the funerary chapel built against the north side of his pyramid. Beside the chapel was a small chamber containing a life-sized statue of Djoser, the function of which was to receive the offerings on behalf of the dead king, if they could not be accepted by the mummy.

One group of buildings with an attendant court which formed part of the Step Pyramid complex reproduced the stage used in the lifetime of the king for the celebration of a festival called *Sed*. The purpose of this festival was to renew the vigour and power of the ruling monarch after he had been on the throne for an initial period of thirty years. In very early times in Egypt it is likely that thirty years may have been

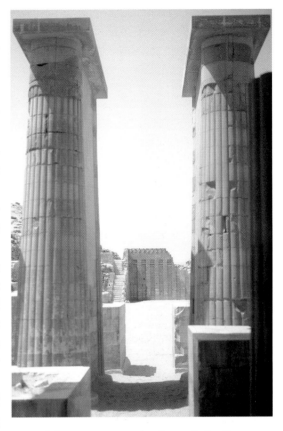

Part of the reconstructed colonnade leading from the entrance to the Step Pyramid complex to the great court. The columns, which are not free-standing, are ribbed, representing primitive supports made of reed bundles, or other natural materials.

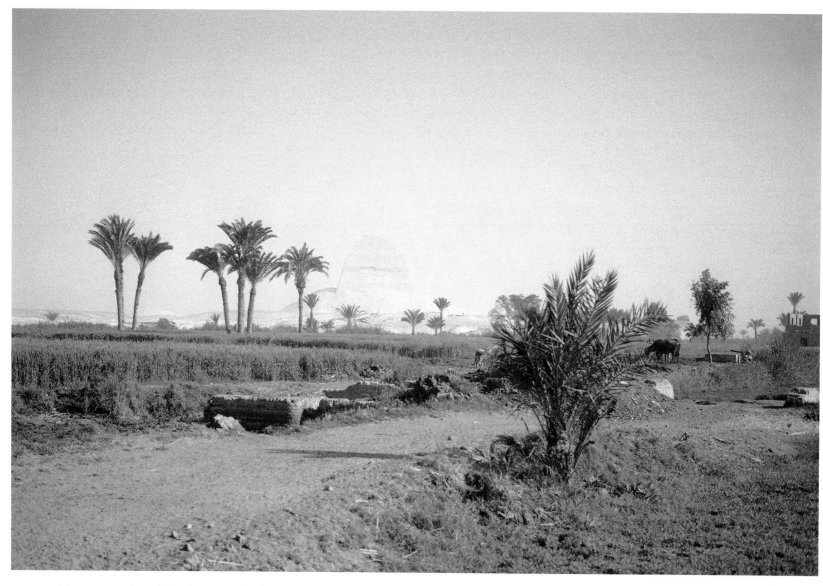

View across the cultivation towards the Maidum pyramid, built probably by King Sneferu. It represents a transitional design between step pyramids and true pyramids. Its present collapsed state is probably due to constructional weaknesses.

considered the proper term for a reign, to be followed by the ritual death of the king. This barbarous custom (if it ever existed) had already been shed, but the belief remained that after thirty years a king lost much of his power and needed revitalizing. At the *Sed* he went through what was in effect a new coronation ceremony.

In the course of the various stages of the *Sed* the king was introduced to the gods of the nomes of Upper Egypt, and then of Lower Egypt. He was then crowned with the white crown of Upper Egypt and the red crown of Lower Egypt. Further rites were concerned more specifically with the king's personal powers, and with his control over the fertility of the land.

The provision of *Sed* buildings in the Step Pyramid complex was intended to give the king the ability to renew his vital forces periodically in his posthumous existence.

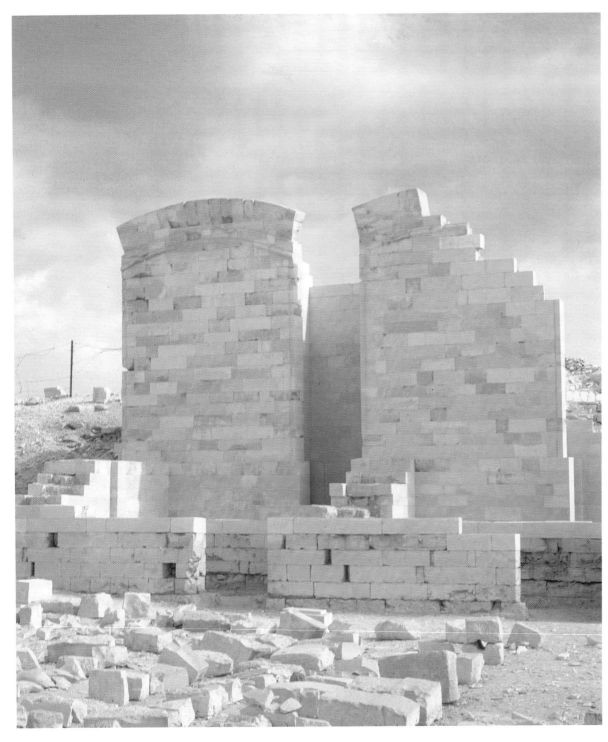

One of the reconstructed shrines facing the Sed court of the Step Pyramid complex. These dummy shrines held figures of the gods of the nomes of Egypt, to be greeted by the king during his renewal (Sed) festival, here to be enacted in his after-life.

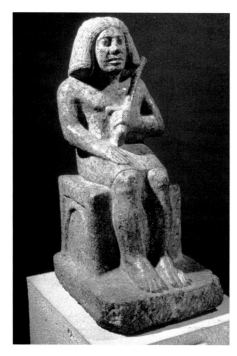

Above: Granite statue of the boat-builder Ankhwa; he is shown holding an adze; of the Third Dynasty, an early example of private sculpture in a hard stone.

British Museum (EA171); height 64cm

Right: A heavily loaded felucca under full sail making its way upstream in Middle Egypt. The prevailing wind in Egypt, blowing from the north, enables such boats to sail effectively against the current. The ancient Egyptians fully understood how to exploit the effects of wind and of river-flow.

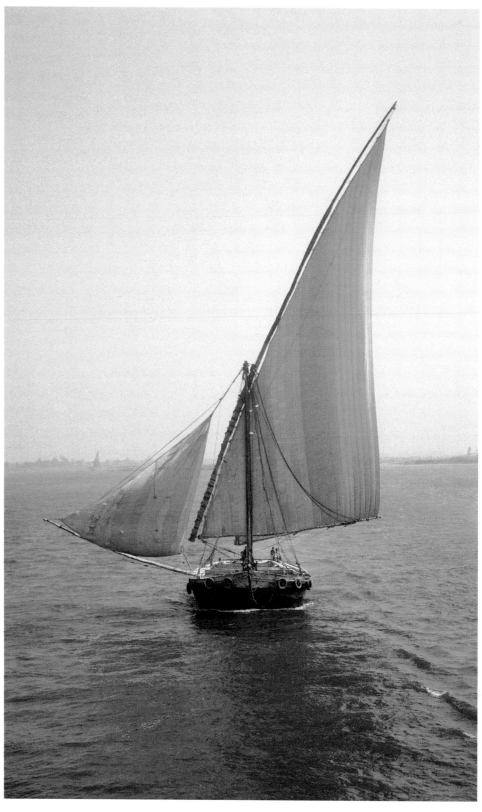

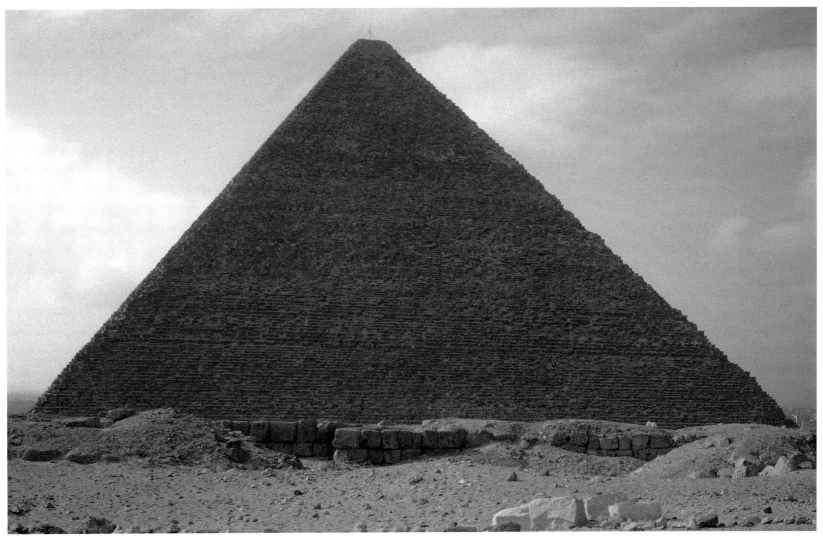

The Great Pyramid, sepulchre of King Cheops. Originally 146m high, it is constructed of local limestone. It was originally faced with fine, hard limestone from the Tura quarries, a few miles to the south, on the east side of the Nile.

This emphasis on the power of the king provides evidence of the clear realisation of the supreme position he occupied in the land. Already at the beginning of the Third Dynasty the supremacy of the Egyptian king was all-embracing. In his life he commanded all attention; in his death his tomb dominated the landscape, and served as a constant reminder of royal greatness. Nevertheless, the process whereby the king gradually secured domination over all aspects of life did not reach its zenith until the Fourth Dynasty.

Sneferu, Cheops, and their great pyramid-building successors were truly supermen. Never again was the idea of the god-king to be so clearly revealed as in their persons. Under them the highest degree of administrative centralisation was reached; all offices depended on them; all favours and honours issued from them. The royal palace was the hub and focus of the country; royal children occupied the highest positions in the land, and the nobles served as best they could, hoping to gain a crumb of advantage by

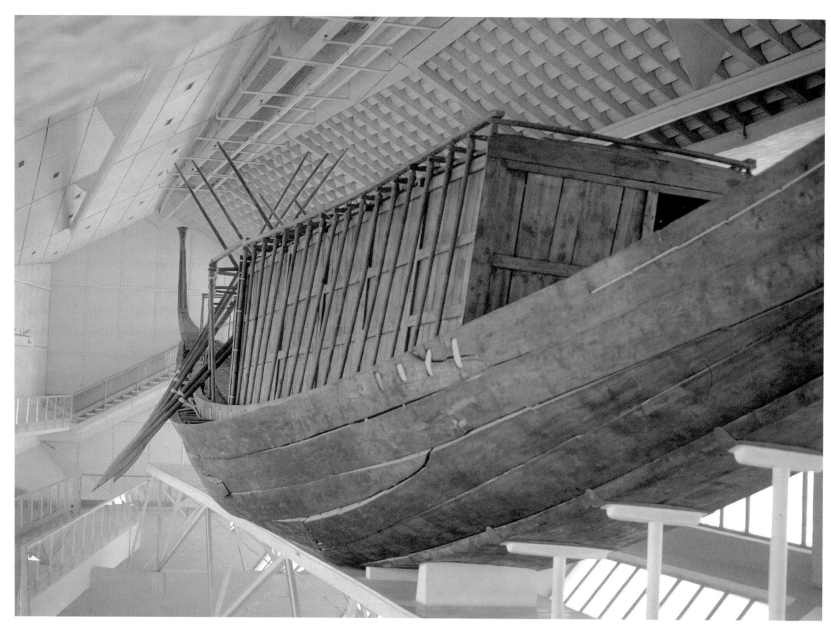

This remarkably well preserved boat was found in 1954, dismantled and marked for reconstruction, in a covered trench beside the pyramid of King Cheops. Made of wood, and held together with pegs and rope, it was intended for use by the king in his posthumous existence. It is 43.5m long.

securing royal favour. The king was the 'good god', the incarnation of divinity, the living Horus. He was the only person who could commune directly with the gods.

Nothing demonstrates the supremacy of the king better than the funerary complex of the Great Pyramid at Giza. The first true pyramid was built by Sneferu, first king of the Fourth Dynasty, at Dahshur to the south of Saqqara, in about 2600BC. His successor Cheops, however, in every way outdid him. At Giza, to the north of Saqqara, Cheops built the greatest of all the pyramids, and around it, laid out in careful rows, were the squat stone mastabas of the princes and nobles of his court, subservient and regimented even in death.

The building of the Great Pyramid itself required the most exacting organisation of labour so that the various operations could be carried forward with efficiency. Well over 2,000,000 blocks of stone were used, their average weight being two and a half tons. Quarrying by skilled labour could be carried on throughout the year, but the immense numbers of men needed for the transport of the quarried stones and for work on the pyramid could only be available during the season of inundation, when the land was flooded and inaccessible for agriculture. This season was also best for the transport of stone from the quarries. While the Nile flood covered the valley it was possible to convey the stone by barge from the quarry right to the edge of the desert escarpment on which the pyramid was being built. From the point of unloading to the construction site was a relatively short distance. The inundation, however, took place in the summer when the weather was hottest and the atmosphere most humid. The labourers may not have been slaves, but they certainly had little choice in what they did, and they must have suffered terribly.

When the king died and the proper preparation of his body had been completed, he was brought to the temple specially built on the edge of the desert to receive the mummy. The valley temple of Chephren, the builder of the second largest pyramid at Giza, is a stark building of huge granite blocks, once peopled by statues of the king, the one surviving complete example of which is now in the Cairo Museum. From here the funeral procession made its way along a slowly rising causeway to the mortuary temple built beside the pyramid, and there the final ceremonies were conducted.

Finally the body was consigned to the burial chamber in the pyramid, and the whole site was placed in the care of a body of priests whose duties for the future were to look after the mortuary cult of the king. Meanwhile, the subsidiary tombs had been prepared for the courtiers and the members of the family of the dead king, and it may be assumed that as each one died he was laid to rest in his properly allotted sepulchre.

This disposing of the king's servants after death around the grave of the king may contain an echo of the custom whereby in earlier times the dead king was accompanied to his tomb by courtiers and servants who were sacrificed to serve their master in the after-life.

If the building of massive pyramids was an indication of the power of the king, it was also a serious drain on the energies and resources of the land. The age of the great pyramids lasted for only a few reigns, the last really vast structure being built for Chephren, who also probably caused the Great Sphinx to be carved in his likeness, to act as a divine guardian of the necropolis area of Giza. Mycerinus' pyramid, the third of the Giza trio, is distinctly smaller than the other two. Never again would so much labour be expended on a royal funerary monument – never again would the prestige of the king be so great. The rapid decline may have been due to the fact that the summit of royal power had been reached in too speedy and dramatic a manner, and that in its exploitation by the all-powerful king too much was attempted in too short a time. In addition to vast building works, Sneferu and Cheops, in particular, engaged in

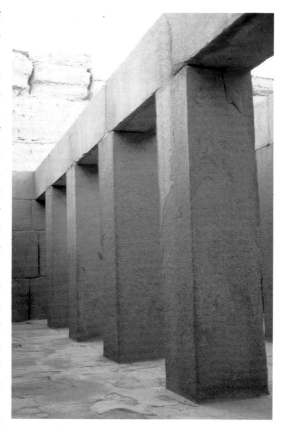

Part of the principal chamber in the Valley Temple of King Chephren at Giza, in which were performed ceremonies in which the king's body was prepared for burial. The columns are monoliths of Aswan granite, the floor is of huge slabs of Egyptian alabaster.

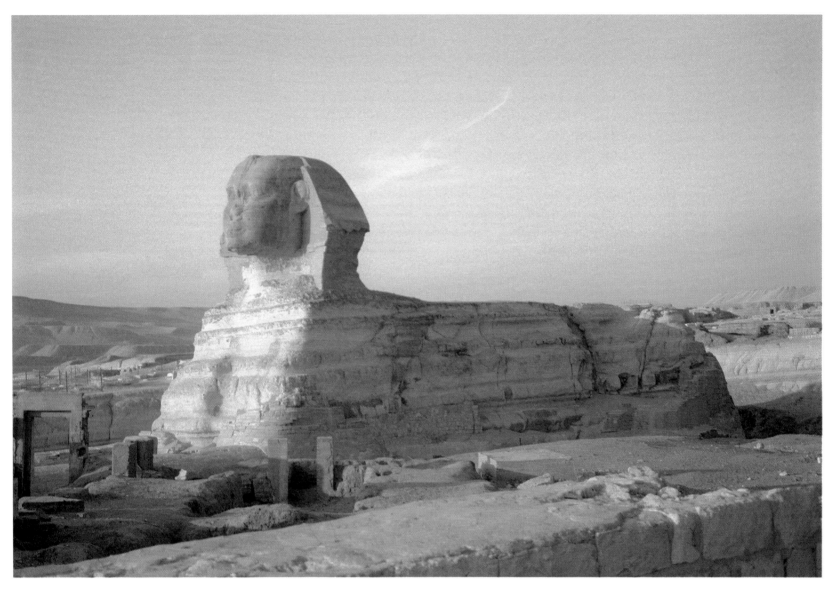

The Great Sphinx of Giza, generally considered to be part of the pyramid complex of Chephren, the head being an image of the king. The Egyptian sphinx, here seen in its earliest substantial form, with male lion body and human royal head, had a protective function, no doubt guarding the whole necropolis area.

considerable foreign adventures – in Sinai, Nubia and Libya, and overseas in Syria. The pace was too great, and the results were too little to reward the efforts of loyal courtiers. They were not even allowed to embellish their tombs beyond setting up simple limestone stelae with inscriptions invoking funerary offerings on their behalf.

Towards the end of the Fourth Dynasty matters improved. Important officials married into the royal family, and they were able to set up personal inscriptions in their tombs. In time, tombs were decorated with every kind of scene in which the life and work of the deceased occupant were reproduced. This development, which advanced rapidly throughout the Fifth Dynasty, not only showed how very much the central authority had relaxed, but also provided a wonderful stimulus to artists and craftsmen. During the Fifth Dynasty there was a spectacular burgeoning of artistic activity. Great

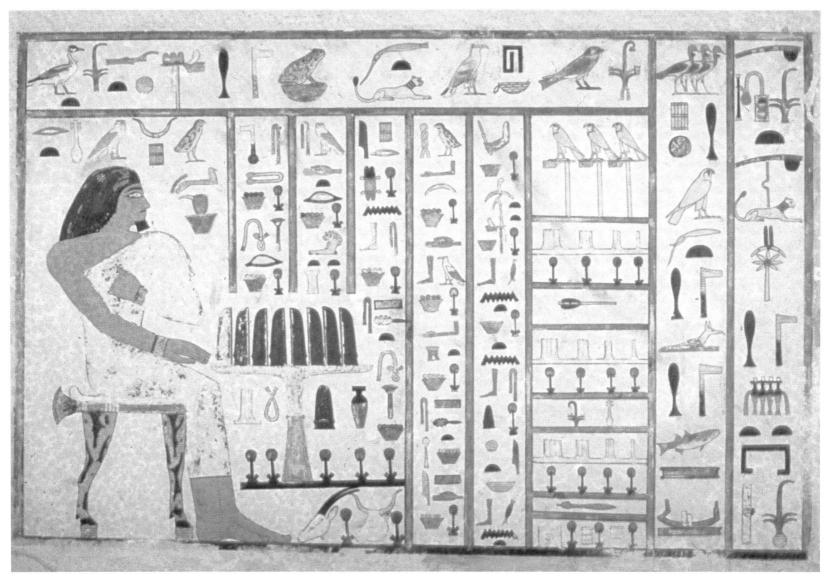

quantities of statuary were made for people in all the higher ranks of society, and their tombs contained vast expanses of finely carved, beautifully painted, low relief scenes, depicting the Egyptian countryside in all its richness and diversity. The scenes in a tomb like that of Ti at Saqqara make up a compendium of the whole of daily life. No ancient culture is so fully laid open for inspection as is Egyptian daily life of the Old Kingdom. Since the purpose of these reliefs was to recreate by magical means the environment in which the tomb-owner lived during his prime, every effort was made to make the individual episodes informative and full of detail. Here can be seen all stages in the agricultural cycle from ploughing and sowing to the binning of winnowed grain. The raising of cattle was also depicted in detail. Cattle were needed to satisfy tax demands, and ultimately for sacrifices in temples and for funerary offerings.

Limestone stela of the high official Wepemnofret of the Fourth Dynasty from Giza. He is shown wearing a leopard-skin garment and seated at a table of offerings. The superbly painted text consists principally of an enumeration of offerings.

Hearst Museum, Berkeley (6.19825); width 66cm

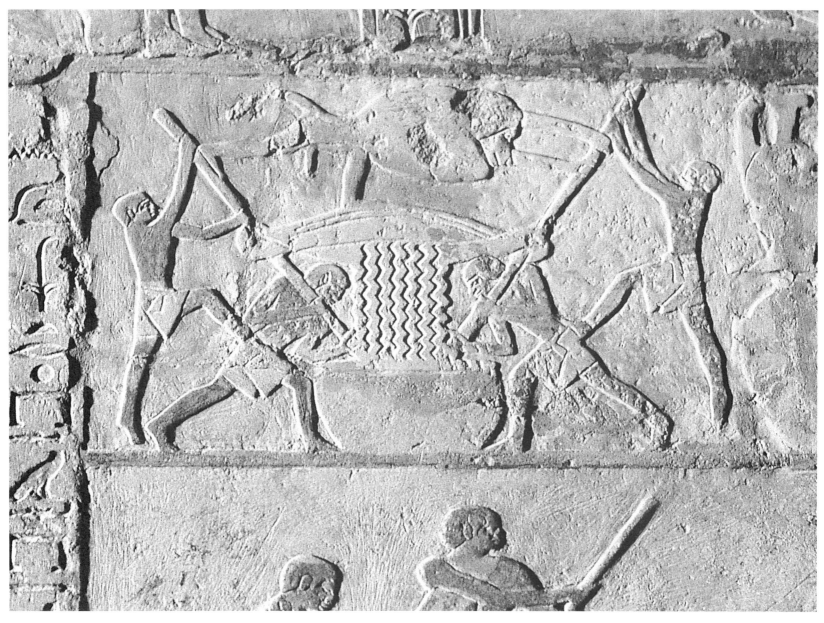

The pressing of grapes for wine from the tomb of Nefer at Saqqara; Fifth Dynasty. Men twist a long bag, probably made of coarse cloth, to express the juice which is collected in a wide-mouthed jar. The operation is assisted by the intervention of a skilled baboon.

From tomb scenes it is clear that very fine cattle were raised in the Old Kingdom; great landowners took a special pride in having their prize beasts paraded before them.

Over all activities brooded the scribe, who took note of everything. Egyptian society was excessively bureaucratic, and the strong centralised government depended on the support of loyal officials to supervise its administration throughout the land. The idea of state service of this kind was held to be honourable, and scribes, who were the civil servants of ancient Egypt, regarded themselves as an elite. They could read and write; they saw to the enforcement of the law; the great men relied on them for guidance; they did not dirty their hands or sit out in the sun. Their lot, in fact, was to be envied.

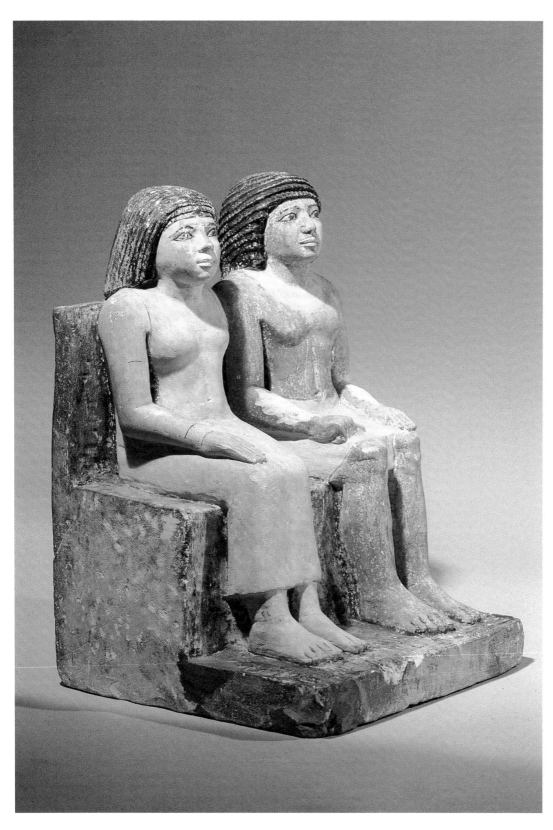

Limestone pair-statue of Katep and his wife, Hetepheres, a characteristic sculpture of the kind found in tombs of modest officials of the Fourth and Fifth Dynasties. Following Egyptian conventions, Hetepheres has yellow-painted flesh and Katep brownish-red flesh.

British Museum (EA1181); height 47.5cm

The antechamber to the burial chamber of the Pyramid of Unas at Saqqara, the first pyramid to have its subterranean rooms decorated with religious compositions drawn from the Pyramid Texts. These texts were designed principally to assist the dead king to achieve his posthumous destiny in the skies with the sun-god Re.

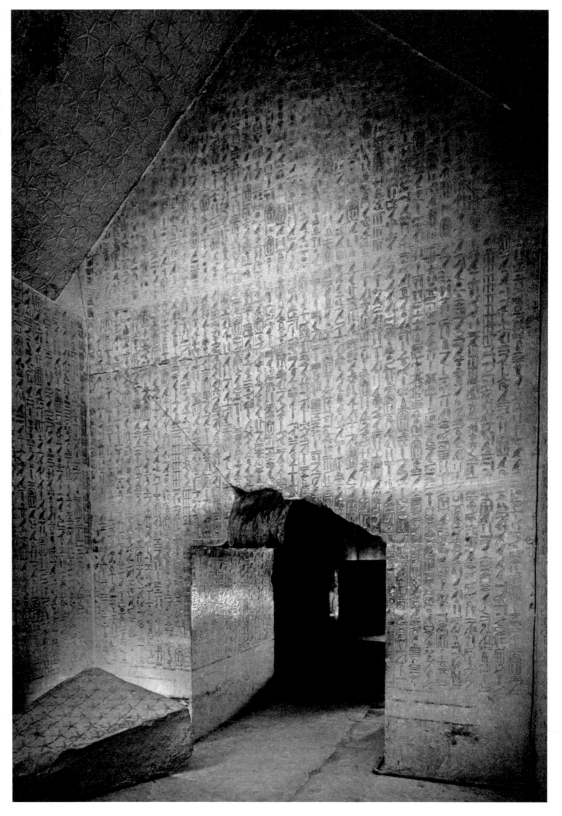

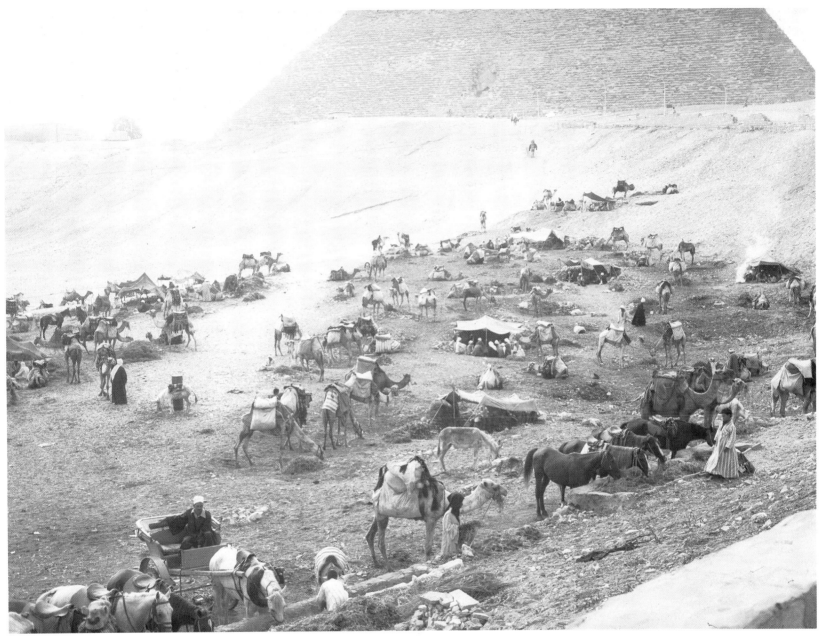

The title of scribe was proudly held by powerful nobles, and it is possible that many of them were in fact able to read and write. Great men were content to be represented as scribes. In the Old Kingdom scribal statues were among the finest products of the Egyptian sculptor. The scribe was normally shown in the act of writing on an open papyrus. This characteristic writing material was manufactured from the pith of the papyrus plant. It is probable that the first sheets of papyrus were made during the First Dynasty, but the earliest surviving examples of writing on papyrus date from the Fourth Dynasty.

The camel park below the Giza escarpment in the early morning. Brooded over by the mass of the Great Pyramid, the scene has a timeless quality, evoking the dawn gatherings of animals and traders about to set out on a desert crossing.

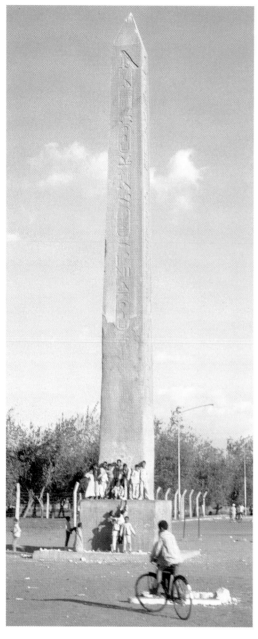

The granite obelisk of Sesostris I of the Twelfth Dynasty, the sole marker of the great temple of Re, in Heliopolis, the earliest and greatest religious centre of the Egyptians from at least the Third Dynasty. It is now submerged in a suburb of modern Cairo.

It is in a way typical of ancient Egypt that the earliest papyri bear accounts and lists, and not important dispatches or literary texts. The largest surviving early archive is concerned with the administration of a foundation set up to look after the affairs of the sun-temple of Neferirkare, the third king of the Fifth Dynasty, who lived around 2470BC. The surviving texts were mostly written in the reign of Isesi, about one hundred years later, and the survival of the foundation over this length of time demonstrates the long-term efficiency and durability of Egyptian administration. It also shows that a well-regulated organisation, very beneficial to those who were in charge of running it, was not easily dissolved.

The sun-temple was a new conception during the Fifth Dynasty. It sprang from the growing allegiance of its kings to the cult of the sun-god Re (Ra), whose principal shrine was at Heliopolis to the north-east of Memphis. According to a story preserved in a papyrus written in the times of the Hyksos, the first three kings of the Fifth Dynasty were the sons of Re and the wife of a priest of Re. This tale was undoubtedly composed to justify what must have been a violent change of dynasty – a case of religion being invoked to legalise a doubtful political act. The devotion of the Fifth-Dynasty kings to Re is, however, an historical fact. Not only did they construct great sun-temples at Abu Gurab, just to the north of Saqqara, but they also called themselves the sons of Re, a title regularly used thereafter to introduce the second cartouche of the Egyptian king's full titulary. Five names now made up this full titulary, the first of which was the Horus name written within the *serekh*; the Two-Ladies name and the Golden Horus name, (both of lesser importance, but associating the king with important deities) were followed by the two written in cartouches, the prenomen (the King of Upper and Lower Egypt name), and the nomen (Son of Re name).

In many ways the years of the Fifth Dynasty seem to have been ideal. Peace dwelt in the land; the king was secure on his throne, his authority reinforced by the new relationship with Re; foreign expeditions prospered and the administration ran smoothly. Doubt about the essential permanence of the *status quo* must have seemed unthinkable. Art flourished, and in the reliefs which adorned part of the sun-temple of Nyuserre, the sixth king of the dynasty, the life of Egypt in the three seasons of the ancient Egyptian year ('inundation', 'planting' and 'harvest') was depicted in marvellous manner. Nature was laid out in order, its bounty harvested and presented to Re. All was shown in harmony beneath the beneficent rule of Re. This was the desirable land which all Egyptians believed their country should be. For a time the ideal may have been realised.

Relief of a hedgehog in a cage; from the tomb of Mereruka
at Saqqara. Sixth Dynasty.

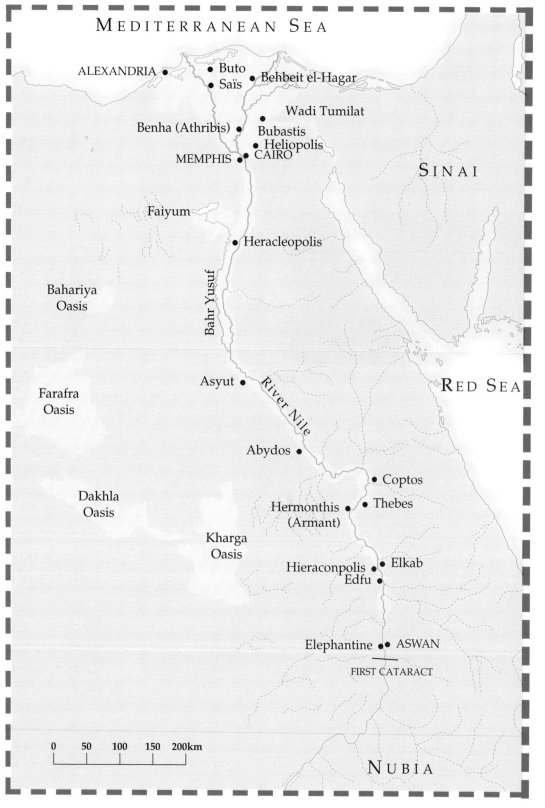

LATE OLD KINGDOM TO EARLY MIDDLE KINGDOM

The Old Kingdom régime slowly disintegrated after its last flourishing in Dynasty VI. The shadowy subsequent dynasties are collectively called the First Intermediate Period. Dynasties VII and VIII preserved something of the Memphite tradition in the north, but their insubstantial power succumbed to that wielded by local rulers at Heracleopolis (Dynasties IX and X). In the south groups of nomes eventually sided with powerful rulers in Thebes (Dynasty XI) who in due course triumphed over Heracleopolis, re-establishing a united land.

Note: In the dynastic lists below selected names only are given; and dates only when reasonably certain.

Dynasty VI *c.*2345-2181BC
Teti
Meryre Pepi I
Merenre ·
Neferkare Pepi II

Dynasties VII & VIII *c.*2181-2125BC

Dynasties IX & X *c.*2160-2025BC
Meryibre Akhtoy (Khety)
Wahkare Akhtoy (Khety)
Merikare

Dynasty XI *c.*2125-1985BC
Mentuhotpe
Sehertowy Inyotef (Antef)
Wahankh Inyotef (Antef)
Nebhepetre Mentuhotpe II *c.*2055-2004BC
Sankhkare Mentuhotpe III *c.*2004-1992BC
Nebtowyre Mentuhotpe IV *c.*1992-1982BC

Key
------- Desert watercourse

4: Awakening of Conscience
Dynasties VI–XI, 2345–1985BC

Throughout the Old Kingdom the kings of Egypt continued to build pyramids for themselves, but in size and in skill of construction those of the Fifth and Sixth Dynasties were pale shadows of the mighty monuments of the Fourth Dynasty. The idea of the pyramid may also have changed from that which had inspired the Step Pyramid and its immediate successors. It is reasonable to connect the true pyramid shape with the increasing devotion of the kings to the worship of the sun-god. Something of the ideas which may have inspired these buildings can be found in a large body of religious spells known as the *Pyramid Texts*, which first appear in the chambers within the pyramid of Unas, the last king of the Fifth Dynasty (about 2350BC). They are also found in the pyramids of the Sixth Dynasty and in a few later pyramids. Compounded of magic, ancient myths, funerary incantations, and ritual formulae, they provide a confusing, apparently inconsistent, mélange of information, from which almost anything can be proved about the nature of the kingship of Egypt.

It would be a great mistake to consider the *Pyramid Texts* as an organised body of religious literature. They were not for reading by, or for the enlightenment of, ordinary Egyptians. They were intended solely for the king, to assist him after death to achieve his divine destiny. Some of the oldest strands go back to very early times when barbarous customs were, it seems, commonplace in the exercise of royal power. Most of the texts, however, are more esoteric, and two principal religious traditions can be detected – one involving the sun-god Re, and the other concerning Osiris, a relative newcomer in the Egyptian pantheon.

An examination of these traditions as they occur in the *Pyramid Texts* leads to a better understanding of why the apparently unassailable strength of the Egyptian monarchy began to weaken towards the end of the Old Kingdom. The worship of the sun and the identification of the king as the son of Re were perfectly natural in a land like Egypt

The fine preliminary drawings of piled offerings – fruit, vegetables, bread, slaughtered animals, joints of meat – part of the generous provision for Mereruka, vizier of King Teti in the burial chamber of his tomb at Saqqara. Sixth Dynasty.

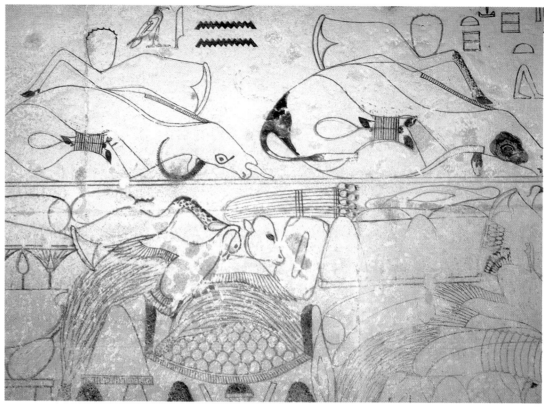

where the sun shone every day, bringing heat, light and happiness to all. It was natural that after death the king should travel to join his father in the heavens. Ordinary mortals, however, while worshipping the sun and appreciating the benefits it bestowed, would find it difficult to see how they could share in the destiny which was by tradition reserved for the king alone. Sun-worship was royal and remote. On the other hand, the cult of Osiris had its roots in the earth, and was much more comprehensible and accessible for ordinary people. The myth of Osiris assumes that there actually was a king called Osiris who fell victim to his brother Seth. Osiris was slain, his body recovered by Isis, his wife, and stolen again by Seth. To destroy Osiris' power for ever, Seth cut up the body and scattered the pieces throughout Egypt. Isis then travelled the length and breadth of the country with her sister Nephthys, collecting the pieces, reconstituting the body, and conceiving by it a child who was eventually born as Horus.

Osiris, the martyr, became the king of the dead, inhabiting an underworld remote from the abode of the sun-god. He was earthbound. The king in death was also identified with Osiris, just as in life he had been identified with Horus. In death he passed to the realm of Osiris and there enjoyed an after-life which was very different from his separate destiny with Re. The apparently different royal fates with the two deities co-existed without any attempt at reconciliation. In this Osirian fate the ordinary Egyptian could see a possibility of participation for himself. In the sufferings and resurrection of Osiris lay hope for all.

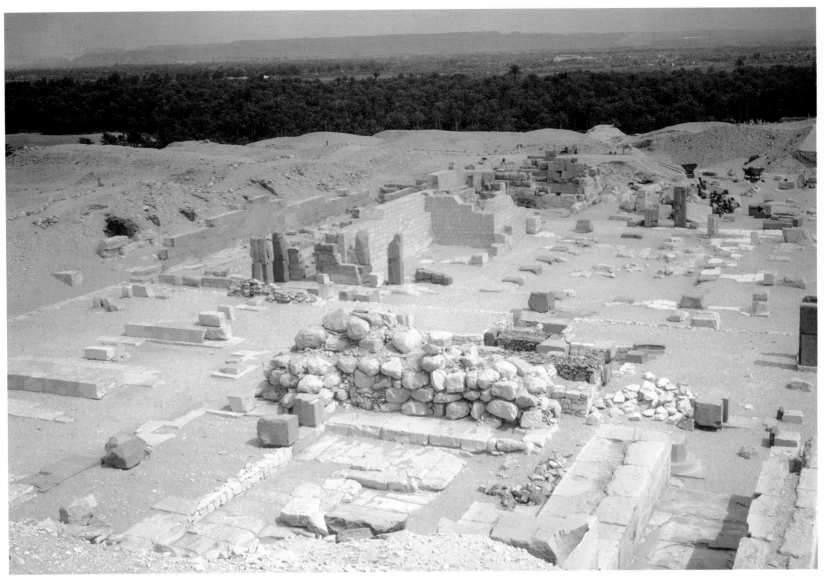

The seeds of disintegration which resulted in the collapse of central government in Egypt during the First Intermediate Period, which followed the Sixth Dynasty, may be detected in many developments of thought and practice. As they emerged it is likely that some of these developments were viewed as progressive, although some of them were undoubtedly unplanned, like the evolution of people's ideas about their relationships with the gods and with the king. The myth of royal supremacy and divinity necessarily had less effect when the evident mortality of individual kings was linked to the down-to-earth conception of the Osirian after-life. Other developments seem to have resulted, as far as we can judge from the somewhat inexplicit evidence, from positive policy on the part of the king to give his nobles greater independence. By the end of the Fifth Dynasty the latter were no longer tied so tightly to the court in death as much as in life.

From the pyramid of King Pepi I of the Sixth Dynasty at South Saqqara, looking down to the remains of the temple used chiefly for the renewal of rituals on behalf of the dead king after his burial.

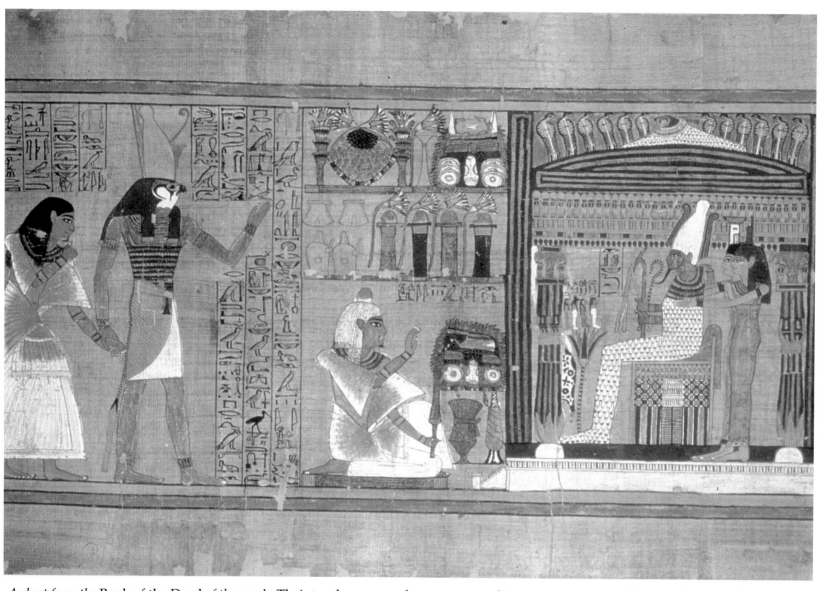

A sheet from the Book of the Dead *of the royal scribe Ani. This 'book', derived in part from the* Pyramid Texts, *was funerary in purpose, but with the emphasis on Osiris rather than Re. Here Ani is conducted by Horus into the presence of Osiris after he has been judged. Early Nineteenth Dynasty.*

British Museum *(EA10470); height 38cm*

Their tombs were no longer arranged in neat rows around the royal pyramid. The tombs themselves were individual constructions, their size and decoration depending on the importance of their owners. Personal details creep into the inscriptions set up in nobles' tombs; it is clear that they too seek after death something of the good life which formerly was reserved for the king. During the Sixth Dynasty the tombs of the nobles provide even more evidence of the liberating process.

The kings of this dynasty were far more active than their predecessors in affairs of all kinds. There is much evidence of building throughout the land; expeditions were sent regularly to Sinai; Nubian connections were developed. In particular, a new trade-link was forged with a distant land called Punt, which could only be reached by a long sea voyage. From Punt – probably Somaliland – exotic products such as ivory, ebony,

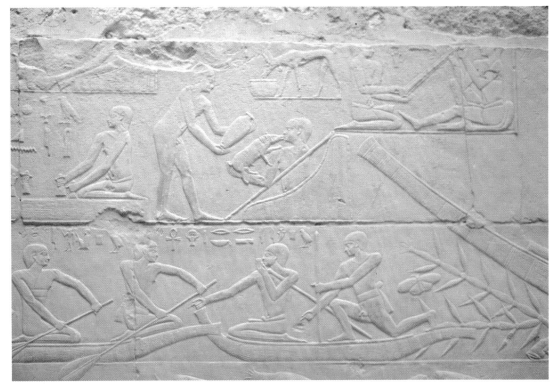

Relief from the mastaba chapel of Kagemni, vizier of Egypt in the early Sixth Dynasty which contains some of the finest depictions of agricultural and domestic activities of the period. Here a boating encounter in the marshes occupies the lower register; above in the centre is a unique representation of a man apparently suckling a small dog.

leopard skins, incense, gold and apes could be obtained. These otherwise reached Egypt along the difficult overland routes from equatorial Africa. The accounts of the expeditions promoted by the Sixth-Dynasty kings are mostly preserved in the biographical inscriptions in the tombs of the nobles who were in charge of the forces engaged. What is especially interesting is that their tombs are often to be found not in the royal cemeteries, but in or near the provincial centres where they exercised power on behalf of the king.

The nomes of Egypt were the regional districts or provinces which made up the country. In the Old Kingdom there were twenty-two in Upper Egypt and about seventeen in Lower Egypt. Provincial governors are usually called nomarchs, a term first found in Herodotus. By the time of the Fifth Dynasty power in the nomes was concentrated into the hands of specific families who provided the nomarchs in hereditary succession. The nomarch not only administered the nome on behalf of the king, dispensing justice and collecting taxes; he also organised the local militia, superintended shrines, and supervised flood-control and the maintenance of canals. The nomarch was indeed a feudal baron, administering his own domain and promoting his own interests. Here lay the source of future trouble. For the time, however, the system operated reasonably well.

One of the most instructive of provincial careers of which something is known is that of a man named Weni who proudly recorded his life-history on a stela set up in his tomb at Abydos. He achieved his first important appointment under Teti, the first king of the

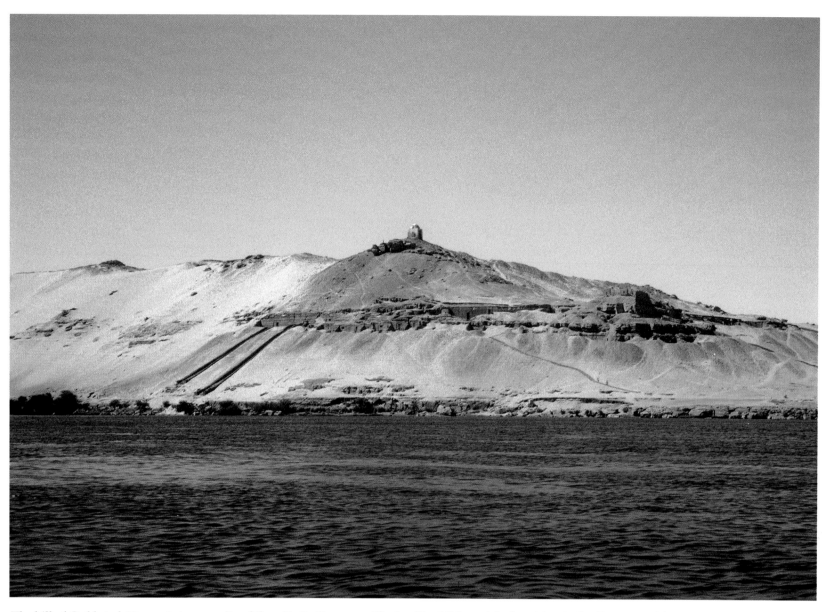

The hill of Qubbet el-Hawa at Aswan, site of the burial places of the local nobles of the Old and Middle Kingdoms. Some of the tombs were approached from the river by steep stairs, two of which can be seen on the left.

Sixth Dynasty. Under Pepi I he added to his civil offices, and he was eventually put in charge of large forces sent to deal with troublesome incursions by Asiatics and Bedouin on Egypt's north-eastern boundary. Under Merenre, Pepi's successor, Weni, by now an old man, was appointed Governor of Upper Egypt. In this position, and on behalf of the king, he made several exacting expeditions to quarries to obtain stone for royal monuments, and he supervised the cutting of five channels through the rocks of the First Cataract to facilitate navigation on the Nile.

The governorship of Upper Egypt was usually held by the nomarch of Elephantine, undoubtedly the most influential baron during the Sixth Dynasty. He was frequently put in charge of general administration in Upper Egypt, and he organised expeditions

into Nubia. The success of Egyptian trade with the south depended greatly on the goodwill of Nubian tribes, and a measure of a governor's success was the vigour with which he could persuade these tribes to co-operate. Under Merenre and Pepi II the most energetic royal officer was Harkhuf, nomarch of Elephantine. When Pepi II became king as a very young child, Harkhuf consolidated his position by bringing back from his first Nubian expedition of the new reign a dancing dwarf as a special gift for the king. In his tomb inscription he records the letter Pepi sent him expressing his delight at the gift; his comments on the letter display a fine mixture of pride and ingratiation.

From the scenes in nobles' tombs of the Sixth Dynasty not only is a picture of growing independence obtained, but also many indications of the improvement in the

The many layers of the city which flourished on the Island of Elephantine at Aswan from the beginning of the Dynastic Period; most importantly from about 2400BC to 1900BC when the local nobles acted for the king in Nubian matters.

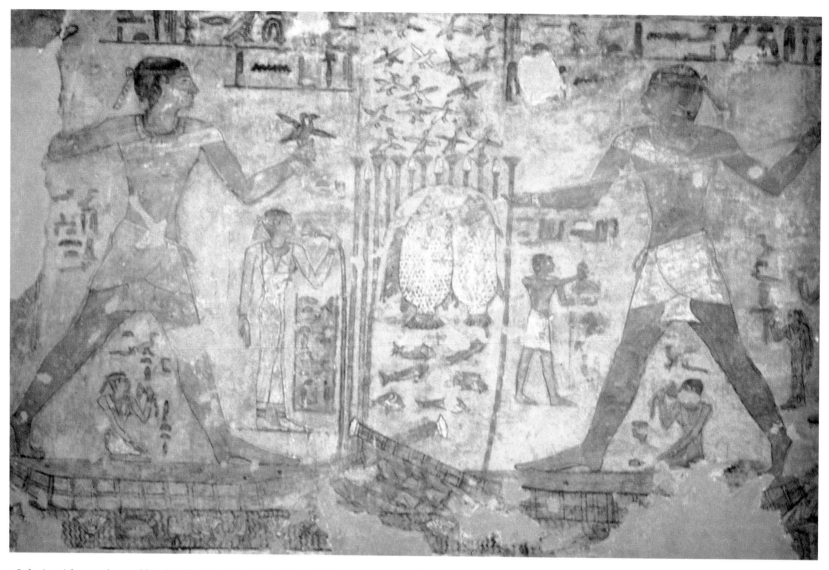

Sabni, with members of his family, hunting fish and fowl in the marshes. He was Governor of Upper Egypt and nomarch of Elephantine in the reign of Pepi II. The paintings in this tomb and others at Qubbet el-Hawa are distinctly provincial, but have great charm.

life of the peasant. In the scenes of the multifarious activities on the estates of the nobles most of the people depicted are peasants. They are rarely named, but their actions are accompanied by short label texts which reproduce what were no doubt thought to be characteristic comments. They shout instructions at each other; they hurl insults and make ribald remarks. These peasants are not downtrodden serfs, and it may reasonably be assumed that the free-and-easy ways they display in the tomb-scenes reflect the true state of affairs to be found in the fields of the nobles' estates. If they fail to perform their duties they can expect a beating, and in some scenes miscreants, often tax-defaulters, are shown being brought for summary justice. Yet the nobles boasted that in administering justice they saw to it that no one was wrongfully convicted, and that fair hearings were given to those with complaints. Justice truly was becoming accessible to people of all classes, at least in principle.

Such concern for justice would scarcely have been shown by a noble of the Fourth Dynasty, and certainly not by his divine master, the king. But much had happened since those autocratic days. Pepi II ruled Egypt for more than ninety years, and at the close of his reign (about 2180BC) the weakness of the central government must have been readily apparent. The state of anarchy into which the country relapsed at the end of the Sixth Dynasty lasted for about 130 years.

This twilight age, generally known as the First Intermediate Period, was not, however, wholly a period of setback and loss. During this time of national depression new ways of thought developed, much heart-searching was done; texts composed at this time suggest that ordinary Egyptians were, perhaps for the first time, becoming conscious of the religious dimension of life. Nearly one thousand years had passed since Menes had secured the unification of Upper and Lower Egypt, and during the whole of this long period the divine monarchy had suffered only small checks to its all-pervading authority. When the breakdown eventually came it must have seemed as if eternal order had been shattered.

A semi-philosophical composition, *Admonitions of an Egyptian Sage*, is thought to describe conditions during this time. It paints a picture of desolation and bewilderment. Men are frightened to conduct business unarmed; tombs are violated; family relationships have broken down; the rich have lost their wealth; the powerful have lost their power; the poor man flourishes; servants pay no attention to their masters and are not afraid to answer back; men are punished unjustly; the laws of the land are flouted openly. All Egypt is said to be in disintegration, and, with the breakdown of law and order, there come poor harvests, food shortages, and all the concomitants of anarchy. No doubt there is much exaggeration in this text, but evidence from other sources shows that the period was indeed very disturbed.

The mood of introspection which affected some Egyptians during the First Intermediate Period, and which surely sprang from the dissolution of long-established ways of life and thought, is exemplified by another literary composition called *Dialogue of a Pessimist with his Soul*. A man brought close to despair by his unhappy circumstances is prevented from committing suicide only by the persuasive arguments of his soul, which is presented as having a separate existence.

Linked with this mood of pessimism concerning present life and prospects after death was a development of a feeling of personal involvement in the fate of humanity. The idea of retribution, which can be seen emerging in some tomb inscriptions of the Sixth Dynasty, now assumes moral overtones. People began to think of the rightness of their actions in terms of justification before the divine King Osiris in the underworld after death. Much of this awareness of the moral dimension in life was due to the wide acceptance of the beliefs connected with Osiris. As the king had identified himself in death with Osiris, so could anyone else who could show that he was worthy of the Osirian destiny. If, after having the record of his life examined for flaws, he were acceptable, he could expect life eternal in the after-world. Towards the end of the First

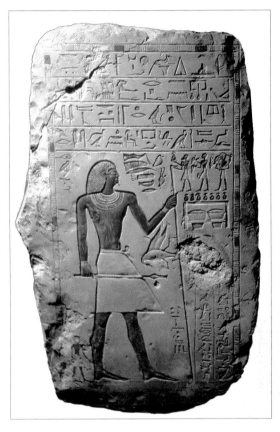

Limestone stela of Tjeby, from Naga ed-Deir a few miles to the north of Abydos, a burial ground of the local high officials of the First Intermediate Period. Tjeby receives offerings, represented in a somewhat gauche style typical of the place and period.

Hearst Museum, Berkeley (N3765)

Limestone inscription of the high official Tjetji, from Thebes. At the bottom he is shown receiving offerings. The long biographical text above records Tjetji's service under kings of the early Eleventh Dynasty. At this time, as he records, the Theban 'monarchs' controlled all Egypt from Aswan in the south to Thinis (the region of Naga ed-Deir) in the north.

British Museum *(EA614); height 152cm*

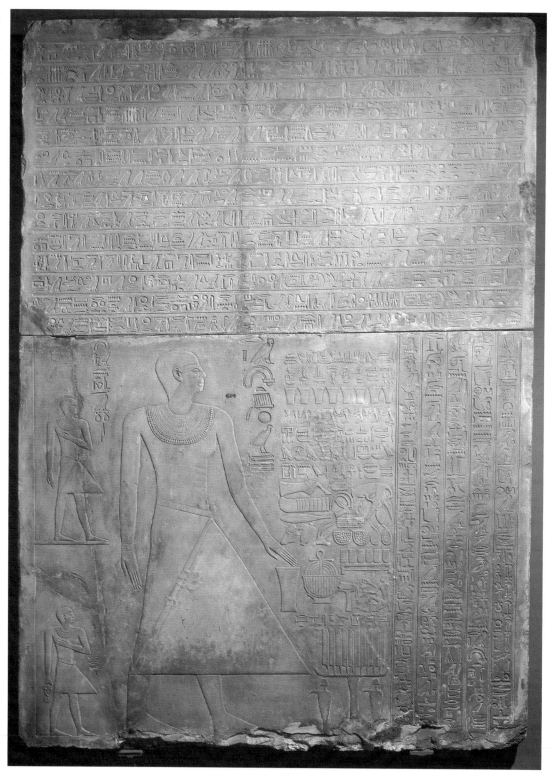

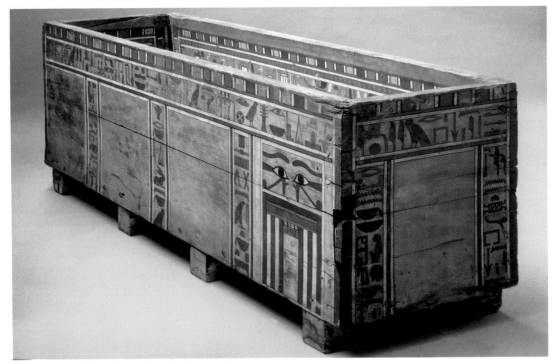

Outer wooden coffin of the physician Seni, from El-Bersha in Middle Egypt. Such coffins, with texts in brightly-coloured hieroglyphs, and with Coffin Texts *in black ink hieratic on the inside, commonly formed the chief item of tomb equipment of important officials in the Eleventh and Twelfth Dynasties.*

British Museum *(EA30842); length 216cm*

Intermediate Period people who could afford them had coffins which were inscribed lavishly with spells derived in many cases from the old collection of *Pyramid Texts*. In their new form, adapted for the use of non-royal persons, they are called *Coffin Texts*. Their prime function was to secure the welfare of the owner of the coffin in the after-life.

There are great gaps in what is known of political events in Egypt during the First Intermediate Period. When the provincial nobles took advantage of the weakness of the central authority, a confused situation seemed to develop. But the country did not apparently revert entirely to a fragmented condition, and may never have been in as bad a state as was described in the *Admonitions of an Egyptian Sage*. Nevertheless, central control had gone, and the general situation was probably further complicated by incursions of marauding tribesmen from Libya and the east. The little known dynasties, numbered Seven and Eight by Manetho, are not wholly without historical substance, and the latter apparently exercised some control from Memphis as far south as Coptos. Slowly stability returned as coalitions of nomes were gradually built up under the leadership of strong barons.

The first coalition to achieve real power was led by the nomarchs of Heracleopolis, the twentieth nome of Upper Egypt, who established a régime which promised ultimately to achieve the reunification of Egypt. The royal titles were first re-assumed in about 2160BC by the nomarch called Akhtoy (Khety). He and his successors, the 'kings' of the Ninth and Tenth Dynasties, extended their authority through most of Lower and Middle Egypt. In time they re-established Memphis as the capital, and some of their number were buried at Saqqara.

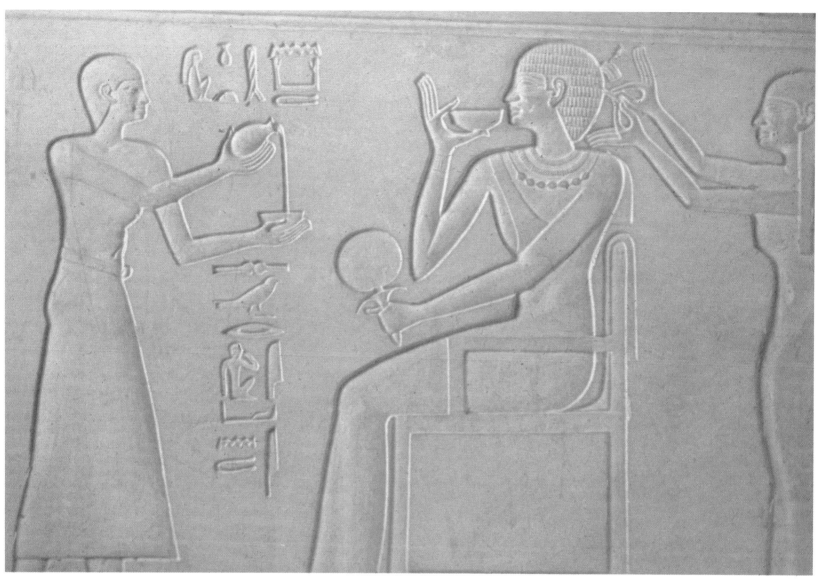

Carved scene on the limestone sarcophagus of Kawit, one of the consorts of King Mentuhotpe II of the Eleventh Dynasty; from Deir el-Bahri. Kawit has her hair dressed while she drinks a cup of beer, her attendant encouraging her to drink another.

Cairo Museum *(47397); height of scene 38cm*

Although the Heracleopolitan kings may have for a time exercised partial influence in the south, their tenuous rule was challenged by the nomarchs of certain of the stronger Upper Egyptian nomes, particularly Edfu and Thebes. There seems to have been a fair amount of inter-nome feuding before the rulers of Thebes emerged as the most powerful in the south. The rise of Thebes had been recent and fast. It had become the capital of the fourth Upper Egyptian nome at the expense of the old nome capital of Hermonthis (Armant). The dissolution of central government at the end of the Old Kingdom had provided the Theban nobles with the opportunity to expand their territory. In about 2130BC the inevitable clash with the forces of Heracleopolis led to open warfare under a Theban nomarch called Mentuhotpe. His son, Inyotef (Antef), openly assumed the royal titles, placed his names in cartouches, and then chose as a new prenomen Sehertowy,

Life by a canal in Upper Egypt. Canals were as important in ancient times as they are today, and when possible they were maintained on a national basis. When the system failed dire results followed, with water shortages and even famine.

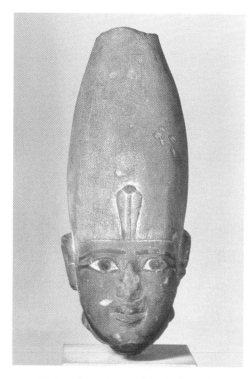

Painted sandstone head of Nebhepetre Mentuhotpe II 'the one who unites the Two Lands', the reunifier of Egypt in the Eleventh Dynasty. From Deir el-Bahri. The king is shown as a strong, uncompromising monarch.

British Museum *(EA720); height 38cm*

'the one who pacifies the Two Lands'. Later ages credited Mentuhotpe and Inyotef with being the first kings of the Eleventh Dynasty, but nearly one hundred years were to pass before the Theban line succeeded finally in overcoming the power of Heracleopolis.

The reunification of Upper and Lower Egypt was ultimately achieved by another Theban 'king', named Mentuhotpe, whose prenomen was Nebhepetre, between about 2050 and 2040BC. In triumph Nebhepetre took a new and significant Horus name, Smatowy, 'the one who unites the Two Lands'. It was an important moment. The terrible times of inter-nome warfare, national disintegration, foreign infiltration, and social turmoil were at last over.

Many remarks in the inscriptions in tombs of local dignitaries of the First Intermediate Period suggest that the lack of co-ordination of flood-control, canal-maintenance, and other inter-nome activities, had brought about famine. In those parts of the country where successful agriculture depended on the careful administration of water economy, the effects of the breakdown had been disastrous. Under the new Theban régime the re-establishment of agriculture based on national flood-control was one of the priorities. The political settlement by conquest secured allegiance; a well-organised countryside with good harvests promoted confidence. The rapid establishment of both by the kings of the Eleventh Dynasty was soon reflected in a burst of building activity, a revival of expeditions to obtain raw materials from Nubia, Sinai and Asia, and a renaissance of art which owed much in matters of style and tradition to Memphis of the Old Kingdom. Trust in the new régime was confirmed. From the time of reunification under Mentuhotpe II, Nebheptre (Smatowy), the Middle Kingdom may be deemed to have commenced.

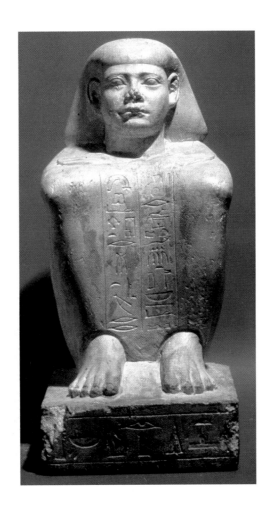

Limestone block statue of Sihathor, from his
niche stela (see p.83).
British Museum; *height 44.5cm*

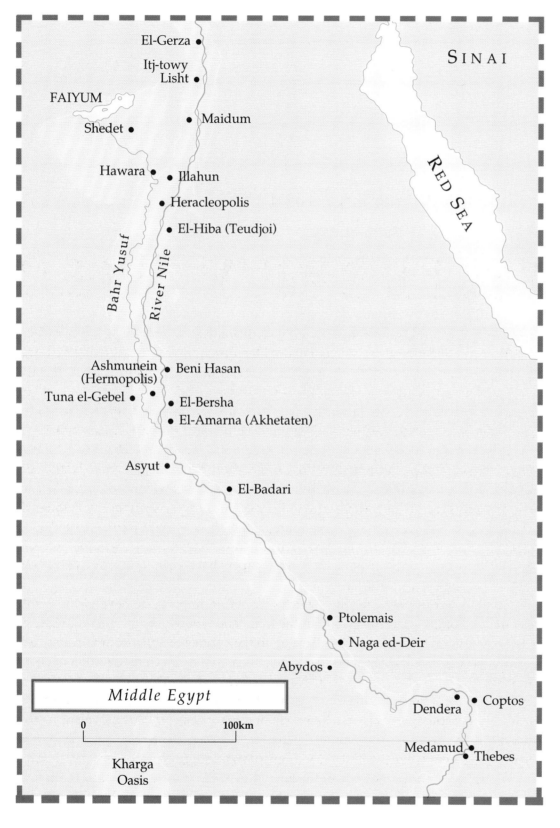

El-Gerza

SINAI

Itj-towy
Lisht

FAIYUM

Shedet

Maidum

RED SEA

Hawara

Illahun

Heracleopolis

El-Hiba (Teudjoi)

Bahr Yusuf

River Nile

Ashmunein
(Hermopolis)

Beni Hasan

Tuna el-Gebel

El-Bersha

El-Amarna (Akhetaten)

Asyut

El-Badari

Ptolemais

Naga ed-Deir

Abydos

Coptos

Middle Egypt

Dendera

0 100km

Medamud

Thebes

Kharga
Oasis

THE MIDDLE KINGDOM

The Twelfth Dynasty was central to the time of settled government known as the Middle Kingdom, which may be extended back into late Dynasty XI (the time of reunification) and forward into Dynasty XIII. Royal power was generally as great as at the height of the Old Kingdom, but the earlier feudal society had been significantly eroded; high offices formerly held by members of the royal family were now exercised by non-royal professional bureaucrats who ran Egypt more like a business than a family. For this period greater certainty can be achieved in dating through the use of astronomical data and by correspondences with datings from elsewhere in the Near East.

Note: The dates of some reigns overlap due to the use of co-regency to ensure royal succession.

Dynasty XII *c.*1985-1795BC
Sehetepibre Ammenemes I *c.*1985-1955BC
Kheperkare Sesostris I *c.*1965-1920BC
Nubkhaure Ammenemes II *c.*1922-1878BC
Khakheperre Sesostris II *c.*1880-1874BC
Khakaure Sesostris III *c.*1874-1855BC
Nymaatre Ammenemes III *c.*1854-1808BC
Maakherure Ammenemes IV *c.*1808-1799BC
Sobkkare Sobkneferu *c.*1799-1795BC

Part of a letter on papyrus of the early Middle Kingdom. It is a private document addressed by a farmer, Hekanakhte, to members of his family, in which domestic and farm matters are discussed.

Metropolitan Museum of Art *(22.3.516); height 28cm*

5: Achievement of Maturity
Dynasty XII, 1985–1795BC

A small window is opened on the lives of some very ordinary Egyptians by a collection of papyrus documents written during the early years of the Middle Kingdom, possibly in the reign of Sankhkare Mentuhotpe III, the penultimate king of the Eleventh Dynasty. Some of the documents are letters, and some are accounts, and they are all concerned with the affairs of a man called Hekanakhte who farmed land in the Theban area. By no estimate can Hekanakhte be considered to have been an important person, yet he still found it possible to send letters to his family when he was separated from it. He did not write the letters himself, but probably employed a professional scribe; it is not known whether or not he could read the written results. Writing was commonly used for everyday affairs and domestic matters in Egypt, certainly from the beginning of the Middle Kingdom, but the ability to read and write was probably limited to a small part of the Egyptian population only. In addition to letters and accounts, many private papers have been found, including wills and other non-official legal documents.

Hekanakhte wrote about matters which were of no importance beyond his family circle: the care of his estate, the height of the inundation, how ploughing should best be carried out, what rations were to be allocated to the various members of the household. He gave instructions about the renting of land and about the effective collection of debts. It emerges that a length of cloth or a quantity of copper or of grain could be used as payment of a lease, that debts were assessed in terms of grain, but that emmer-corn was worth only two-thirds of barley, while a small measure of oil was equivalent to two measures of barley. Here the system of barter can be seen working in practice, for no monetary system in the strictest sense was known in Egypt until very much later. True coinage was not introduced until the end of the Dynastic Period, in the fourth century BC. The old barter system seems cumbersome to us, but it worked well in its time.

Limestone shrine made in the reign of King Sesostris I as a resting place for the sacred boat of Amon-Re of Karnak when carried in procession. It has been reconstructed from blocks used as the filling of the Third Pylon at Karnak (see also p.78)

Another indication of how people behaved in a barter economy, when prices could be fixed only in terms of certain acceptable commodities, is provided by Hekanakhte's precise specification of the corn-measure that was to be used when quantities owed to him were collected. Only by using your own corn-measure could you be sure of retrieving in full what you were owed. The standardisation of measures was necessarily an important factor in the proper functioning of trade between different parts of the country and with foreign merchants. There is reason to believe that responsibility for weights and measures lay in the hands of the nomarchs, and that a general standard was provided in the great cities in Upper and Lower Egypt. Details of how the system worked are unfortunately not known, but it is interesting to see how a problem of this kind was solved by one small farmer.

The wealth of domestic detail made known by documents on papyrus and stone from the time of the Middle Kingdom provides a particularly intimate picture of some aspects of life at that time. Royalty was no less divine than it had been in the Old Kingdom , but it did not behave as divinely as in former times. Greater opportunities were offered

to non-royal people to own property, conduct business and, in general, live independent lives. Something of a middle class emerged in Egypt during the Twelfth Dynasty, and a touch of cosiness creeps into the picture of daily life. The advantages enjoyed by ordinary people depended on the opportunities offered by the expansion of the economy, and this expansion was the result of policies pursued by the kings of the Twelfth Dynasty.

Early morning at Beni Hasan. The welcoming delegation await the arrival of tourists to lead them from the river to the Middle Kingdom tombs of the local nomarchs, visible in the cliffs in the distance.

Ammenemes (Amenemhat), the first king of the dynasty, had served as vizier under Mentuhotpe IV, the last king of the Eleventh Dynasty. In about 1985BC he seized power and initiated a line of kings which ruled Egypt for 200 years. It was a period of mature achievement, of steady advances. Art was brilliant, sculpture in particular being

One of the pillars in the reconstructed shrine of Sesostris I at Karnak. The king is shown, followed by his spirit (ka), making offering to Amon-Re assimilated to Min, a fertility deity of Coptos. The carving of the scene and texts is of the highest quality.

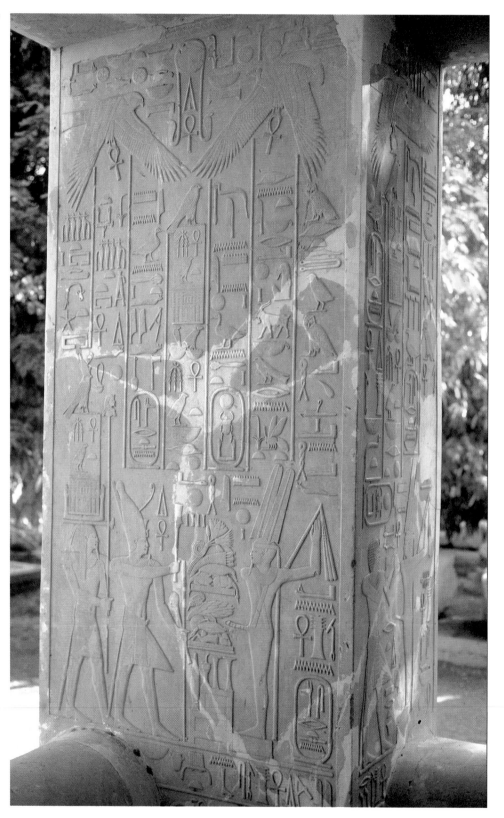

characterised by a sensitivity and realism which had previously been lacking. At the same time the Egyptian language reached maturity as a flexible instrument of spoken and written communication. Literature flourished, and in addition to works of imagination, many writings of a more practical nature were set down for the first time. The scribe's services were in greater demand than ever before.

The duties of the scribes were greatly increased by the proliferation of paperwork engendered by the new administrative system built up by the kings of the Twelfth Dynasty. One consequence of the troubles of the First Intermediate Period, and of the struggles which took place before the reunification, was the disappearance of several powerful families of barons. Although the earlier kings of the dynasty felt obliged to respect the old nomarchic system, both for political reasons and for the sake of continuity of administration, they were well aware of the inherent dangers in the system.

At first, royal policy was aimed at binding the nomarchs closely to the interests of the throne, and a court very similar to that which flourished at the height of the Old Kingdom was re-established. For more effective control over the whole country the royal residence was moved north to a new site about twenty miles south of Memphis, and the new capital was called Itj-towy, 'Who seizes the Two Lands'. It lay on the boundary of Upper and Lower Egypt, and was better placed for administration than Thebes. Here the new nobles and new officials gathered, and when the kings died their adherents were buried around the royal pyramids.

Away from the capital, in the nomes, the bad habits of the later Old Kingdom began to show themselves again. The barons once more built up their local courts and behaved with great independence. They fostered their interests by making convenient marriages with the daughters of neighbouring nomarchs; they undertook large-scale works, had great statues made to boost their own importance; and in death they were laid to rest in imposing rock-cut tombs. The scale of their activities was nothing like as great as that of their royal masters, but in these activities could be detected the seeds of future trouble.

The crisis appears to have come to a head in the reign of Sesostris (Senusret) III, in about 1850BC. It is not known precisely what happened, but abruptly the nomarchs no longer figure in the inscriptions, and the series of great tombs in the provincial cemeteries ceases. Presumably the old system of provincial administration was dissolved throughout Egypt by a single act, or series of acts, at about the same time. It was replaced by new arrangements whereby the country was divided into three departments, Lower Egypt, Middle Egypt (i.e. northern Upper Egypt), and southern Upper Egypt. High officials appointed by the king and answering to the vizier, the highest officer in the land, were in charge of these departments. Their administrative offices were set up in the capital, and from there all provincial affairs were administered. In consequence the civil service was greatly inflated. It was wholly dependent on the vizier who had now become a very important person.

The area to be administered was further enlarged by the steps taken during the Twelfth Dynasty to improve the irrigation and agriculture of the Faiyum. This district of

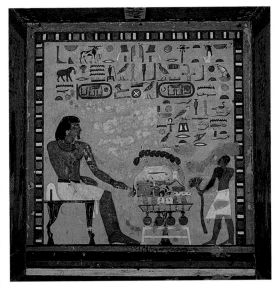

Painted stela in the tomb of Sirenput II, in the hill of Qubbet el-Hawa, Aswan. Sirenput, named here Nubkhaure-nakhte, was one of the last recorded nomarchs of the southern region; he receives offerings from his son. Reign of Ammenemes II.

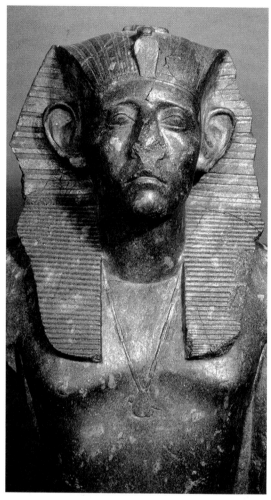

Above: Upper part of a life-size granite statue of King Sesostris III; from Deir el-Bahri. It is one of the most realistic royal representations from ancient Egypt.

British Museum *(EA680); height 122cm*

Right: Part of the Abydos sacred area used during the Middle Kingdom for the erection of cenotaphs by officials who wished, along with their families, to be associated in death with the hallowed burial place of Osiris, and the festivals celebrating the god's martyrdom.

low-lying land to the west of the Nile Valley, at the level of Itj-towy, contained a vast lake watered by an arm of the Nile. Since remote antiquity people had lived on the shores of this lake, but the possibilities of the whole area had never been exploited. Sesostris II built a barrage to control the inflow of water from the Nile, and by a new network of dykes and canals the area of cultivable land was greatly increased.

Under Ammenemes III the process of recovery was extended, and the Faiyum became a monument to that king's administration. The great building which he constructed beside his pyramid at Hawara, on the eastern edge of the Faiyum, served principally as a temple, but it may also have housed a massive administrative complex. (Known to classical writers as The Labyrinth, it has now completely disappeared as a recognisable structure.) Ammenemes III also enlarged the capital city of the Faiyum, Shedet, which henceforth became a significant provincial centre.

Another act of the Twelfth-Dynasty kings, which was later to have profound results, was the elevation of the god Amun to the position of principal state god. In origin Amun was a rather unimportant member of a company of eight deities, the centre of whose worship was Hermopolis in Middle Egypt. His cult was introduced into Thebes during the First Intermediate Period, and he was adopted by the Twelfth-Dynasty kings, probably because their predecessors of the Eleventh Dynasty had been devoted to Month, the old Theban nome god. Amun soon came to be associated with the sun-god Re, and as Amon-Re he was installed in Karnak and designated King of the Gods. In this form he was to become the great imperial god of the New Kingdom, under whose

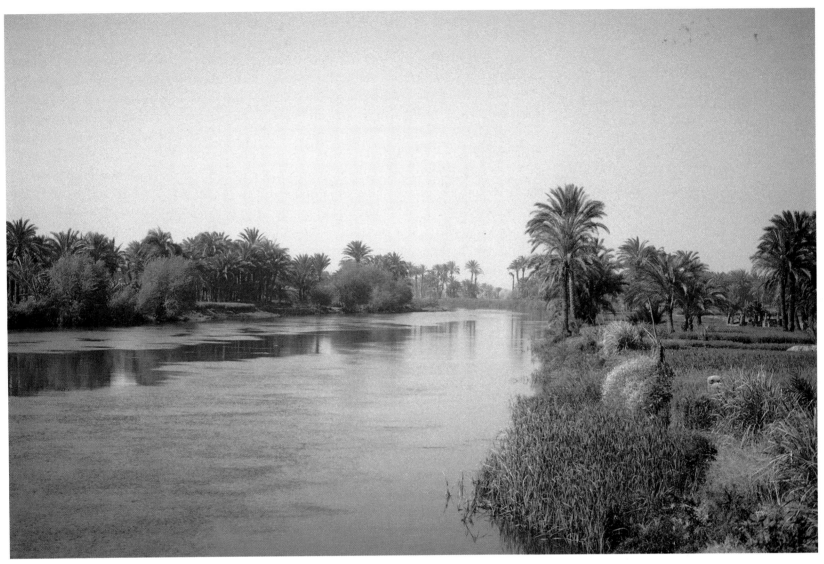

protection foreign conquests were made, and to whose temples were brought the tributary gifts of conquered nations.

Amun was not essentially a funerary god, and he entered into the prayers of the dead only as a powerful agent interceding on their behalf for mortuary benefits. During the Middle Kingdom Osiris became pre-eminently the god of the after-life, and all men and women sought, if they could, to participate in his kingdom. A practice which developed during this period was the symbolic pilgrimage to Abydos, the legendary burial-place of the god. Someone, buried elsewhere in Egypt, could erect a small memorial monument, a cenotaph, at Abydos with a stela bearing a text in which funerary advantages were sought for the *ka*, or spirit of the deceased. In this way association with the holy place could be established and posthumous benefit acquired, by proxy, through the stela.

The Bahr Yusuf, an important off-shoot of the Nile, flowing from just north of Asyut to the Faiyum depression. The water flow into the Faiyum was regulated and improved by the kings of the Twelfth Dynasty.

Head of a colossal granite statue of King Ammenemes III of the Twelfth Dynasty; probably from Memphis, but found at Bubastis in the Delta, to which it had been taken and then usurped by Osorkon II of the Twenty-second Dynasty (c.874-850BC).
British Museum *(EA1063); height 79cm*

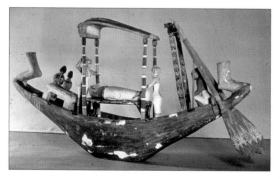

Painted wooden boat from a Middle Kingdom tomb, symbolically conveying the mummy of the deceased owner (unknown) on the pilgrimage to Abydos.
British Museum *(EA9524); length 66.7cm*

The pilgrimage to Abydos was also represented in some tombs by the presence of model boats loaded with mummies and mourners. Many tombs from the late Old Kingdom up to the Middle Kingdom were furnished with models; some were purely funerary, but most of them showed domestic and agricultural activities. They served the same purpose as the reliefs and painted scenes found in other tombs. The models are often very fine, the carving is skilful, and the detail intricate. They are nearly always very informative, for they show in three dimensions activities which are often hard to interpret in the two-dimensional representations on tomb walls.

Among the fine paintings which show similar activities in the Twelfth-Dynasty tomb of Khnumhotpe, a nomarch of the Oryx nome at Beni Hasan, one scene is of special interest. It indicates the arrival in the nome of a group of Asiatic nomads dressed in very colourful garments. An inscription states that their business is the bringing of eye-paint, and the visit is dated to the sixth year of Sesostris II, which would be about 1875BC. An actual visit by the Bedouin seems to be the subject, and while it must have been rather unusual to command such interest, it also indicates how trade was expanding at this time.

The kings of the Twelfth Dynasty were very active in developing contacts with foreign countries, and the chief reason, apart from the simple demands of border peace and security, was trade. As ever, the objects of trade were mostly commodities which might enhance the quality of life for the ruling classes. In matters of food and clothes Egypt was capable of providing all that might be needed for its people, but there were certain materials which had to be obtained from abroad if the country were to behave as a great sovereign state. In particular, precious and non-precious metals and timber were sought.

From the start of the Twelfth Dynasty positive steps were taken to re-establish a foothold in Nubia. At first the probes southwards met with some resistance from the local inhabitants who had, no doubt, come to believe that trouble from the north was a thing of the past. By the reign of Sesostris I, however, the scale of Egyptian activity had markedly increased. Garrisons were set up in the region of the Second Cataract, south of what is now the Egyptian–Sudanese border. Trading posts were established much further south, and quarries and mines deep in the Nubian deserts were exploited for gold, diorite and amethysts.

After a period of relative calm, when the fruits of the early campaigns were enjoyed, further strong action had to be taken by Sesostris III. In a series of punitive campaigns he reinforced Egypt's authority in Nubia by constructing a chain of forts in the Second Cataract region. Extremely well sited, these forts were fine examples of military building. Sadly they are now all lost beneath the waters of Lake Nasser.

Linked with this system of forts was a frontier organisation for the regulation of trade and immigration. Copies of dispatches of a somewhat later date, sent from the fortress commander at Semna in the Second Cataract to officials in Thebes, show how seriously the frontier duties were carried out. The Egyptian presence clearly brought a degree of stability to the whole area, and it was not necessary, so it seems, to set the

Statue of Sihathor, royal treasurer under King Ammenemes II of the Twelfth Dynasty, set in a small niche; from the cenotaph of Sihathor at Abydos. This is one of the earliest examples of the block statue, a peculiarly Egyptian form.

British Museum *(EA569, 570); overall height 112cm*

The temple area of El-Tod, south of Luxor, cult-centre of Month, principal Theban god before the advent of Amun. Here was found a collection of silver vessels, mostly of Syrian type, part of the temple treasure in the Twelfth Dynasty.

frontier further south. Generally good relations with the native Nubian Kingdom of Kerma to the south, straddling the Third Cataract, facilitated trade with regions further south. It is likely that any caravans travelling from equatorial Africa headed to Kerma. The 250 miles between Kerma and the nearest Egyptian military posts were barren and inhospitable, and therefore probably presented little obstacle to regular communication.

Fortifications were also used in the north of Egypt in the Twelfth Dynasty to deter marauding bands of Asiatics and tribesmen from entering the Delta in the casual way to which they had become accustomed during the preceding century. Ammenemes I built a barrier called 'Walls of the Ruler' in the Wadi Tumilat, the natural approach to Egypt

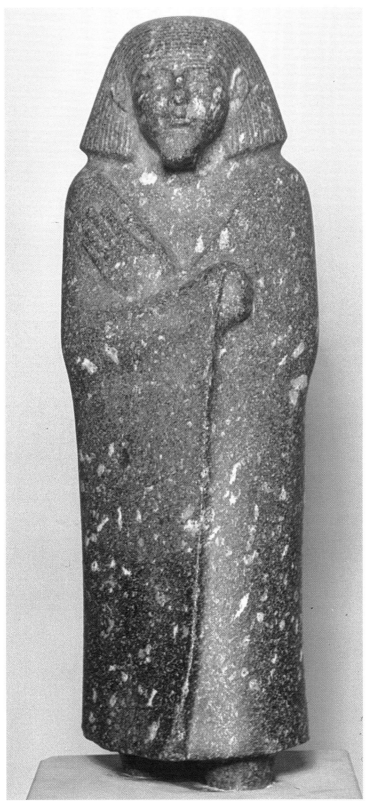

Granite uninscribed figure of an official wearing an all-enveloping cloak, under which the bodily forms are subtly suggested. Late Twelfth Dynasty; said to come from Benha in the Delta.

British Museum *(EA1237); height 63.5cm*

A pendant incorporating in the design the prenomen, Khakheperre, of King Sesostris II of the Twelfth Dynasty. It is in the form of a winged scarab, the inlaid decoration being made up of carnelian, lapis-lazuli and green felspar, set in electrum.

British Museum *(EA54460); width 3.5cm*

from the east. He and his successors were obliged from time to time to conduct short, sharp, campaigns against infiltrators from the east, but it never seemed a part of Egyptian policy at this time to wage open warfare for the acquisition of territory in this easterly direction.

It is, however, clear that there were constant comings and goings of Egyptians and Asiatics for the purposes of trade and diplomatic contacts. Excavation of many sites in Palestine and Syria has produced evidence of the presence in those countries of Egyptians during the Middle Kingdom. Furthermore, the evidence is not of a military kind, for the contacts were peaceful. The coastal towns of Byblos in the Lebanon and Ugarit in Syria were much frequented by Egyptian sea-going vessels, and the return cargoes to Egypt in the Twelfth Dynasty consisted not only of timber, but also of metals which were not readily available in Egypt.

Two metals which the Egyptians badly needed were silver and tin. The former was required for precious objects, jewellery and temple furniture, but it was not easy to obtain by mining in Egypt. It was imported, therefore, chiefly from Asia Minor. The importance of this source for silver is indicated by the extraordinary collection of silver vessels of Asiatic workmanship found in a Twelfth-Dynasty deposit at El-Tod to the south of Thebes. Much of it appears to have been scrap metal, for recycling. Tin, on the other hand, was needed for the manufacture of bronze, an alloy of copper and tin which was infinitely superior to simple copper as an efficient material. Tools and weapons of bronze were essential for an up-to-date economy, and in this respect Egypt had lagged far behind Asia. Bronze did not become common in Egypt until the late Twelfth Dynasty.

Regular expeditions were sent under royal patronage to visit the turquoise mines of Sinai (especially exploited under Ammenemes III), the important quarries throughout the Eastern Desert, the distant land of Punt, the oases in the Western Desert, and Libya. Trade also started with the Aegean world, for objects of Minoan origin have been found in Egypt, and Egyptian objects dating from the Twelfth Dynasty in Crete. In spite of all these contacts with foreign lands and peoples, the Egyptians, dwelling in what was still virtually an isolated country, retained a profound suspicion of foreigners, and considered them to be bringers of trouble.

The success of the kings of the Twelfth Dynasty in maintaining consistent policies both at home and abroad for 200 years was partly due to the practice of co-regency which was introduced by Ammenemes I. In the twentieth year of his reign, being already an elderly man, he took his eldest son, Sesostris, as partner on the throne, and thereafter the young regent assumed responsibility for the more active aspects of policy. In this way Ammenemes hoped to make certain the succession for Sesostris and avoid the kind of situation in which he himself must have seized the throne. His fears were fully justified, for he was assassinated while Sesostris was returning from an expedition to Libya. The lesson was clear, and for the rest of the dynasty a new practice emerged; the succession was ensured by the appointment of the crown prince as co-regent.

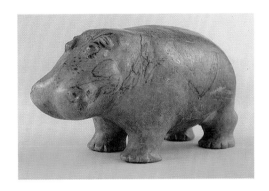

Faience figure of a hippopotamus decorated
with marsh plants.
British Museum (EA35004); *length 19cm*

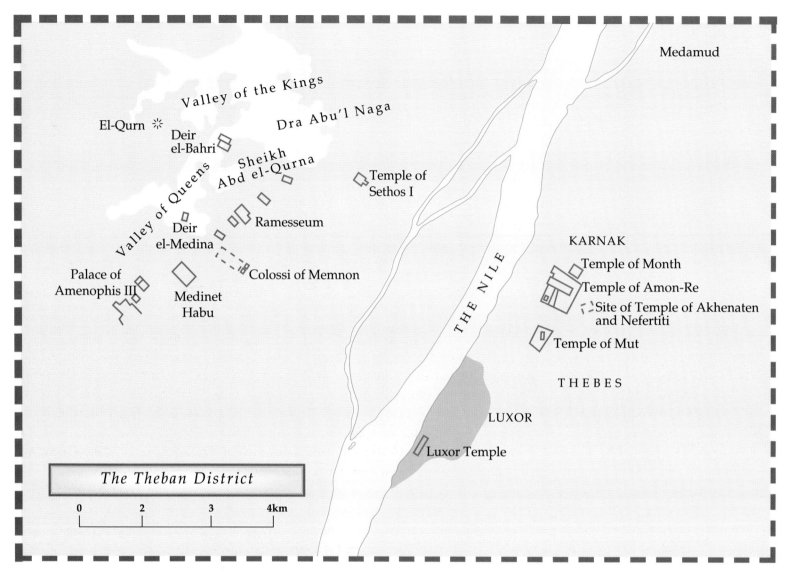

The Theban District

0 2 3 4km

Second Intermediate Period To The Early New Kingdom

The names of the kings assigned for this period following Dynasty XII in the Turin King List amount to many dozens, some of which can be linked with names on inscribed monuments; most seem to be quite ephemeral. The kings of Dynasty XIV were obscure princelings in the Delta. Those of Dynasty XV were Hyksos, Asiatics settled in the Delta, and Dynasty XVI, Hyksos vassals. This confused time is known as the Second Intermediate Period. When the native rulers of Dynasty XVII at Thebes defeated and expelled the Hyksos, unity in Egypt was again restored. Then followed Dynasty XVIII, and so began the New Kingdom.

Note: In the dynastic lists below selected names only are given up to the end of Dynasty XVII.

Dynasty XIII *c.*1795-1650BC
Sekhemre-sewadjtowy Sobkhotpe III
Khasekhemre Neferhotep

Dynasty XIV *c.*1750-1650BC

Dynasty XV *c.*1650-1550BC
Seuserenre Khyan
Aauserre Apophis

Dynasty XVI *c.*1650-1550BC

Dynasty XVII *c.*1650-1550BC
Sekhemre-wadjkhau Sobkemsaf I
Nubkheperre Inyotef
Seqenenre Taa
Kamose

Early Dynasty XVIII *c.*1550-1458BC
Amosis *c.*1550-1525BC
Amenophis I *c.*1525-1504BC
Tuthmosis I *c.*1504-1492BC
Tuthmosis II *c.*1492-1479BC
Hatshepsut *c.* 1479-1458BC

6: Breakdown and Recovery

Dynasties XIII–XVIII (to Hatshepsut), 1795–1458BC

Four official scarabs of the late Middle Kingdom with the names and titles of their owners: (right to left) overseer of the Mentjiu (Bedouin), Sonb; hall-keeper of the Great House (palace), Werneb; god's seal-bearer of the shrine of Anubis, Sobkankh; hall-keeper, Heryshef-hotpe; all officers of modest rank.

British Museum (*EA40725, 66728, 66737, 30548*);
lengths 2.4-2.6cm

The last ruler of the Twelfth Dynasty was a queen, Sobkneferu, whose presence on the throne suggests that the powerful line of Ammenemes and Sesostris had finally failed to produce a male heir. What happened after her death is not known, but formerly it used to be assumed that Egypt once more relapsed into a condition of anarchy as it had done after the Sixth Dynasty. But things in 1795BC were very different from what they had been in 2181BC. The general tendency towards the collapse of central authority was altogether lacking in the later period. There were no vulture barons waiting to feast on the dismembered body of Egypt.

The fate of the royal house remains a mystery. The Thirteenth Dynasty is credited with sixty kings by Manetho, and this number is supported by the Turin King List, a papyrus document written in the Nineteenth Dynasty. Many of the names of these kings are known from other sources, and it has been supposed that some enjoyed only very short reigns, while others may have reigned only locally in the Delta. On the other hand, it has been well established that the strong administration set up by the kings of the Twelfth Dynasty continued to function with efficiency for many decades after the end of that dynasty. The names that recur in inscriptions and written documents of this period are those of high officials like the viziers Ankhu and Iymeru, who clearly controlled the country during many reigns. The period from the end of the Thirteenth Dynasty until the end of the Seventeenth Dynasty is usually called the Second Intermediate Period. Only in this name, however, can the time be likened to the First Intermediate Period.

For some years after the end of the Twelfth Dynasty the royal residence remained at Itj-towy, and from there the country was administered by a well-organised civil service. It was a period of rampant bureaucracy. From this time, more than any other, there have survived large numbers of scarabs bearing the titles and names of officials in charge of government departments and offices. A scarab inscribed with an official's name and

Holiday-makers in the festival marking the end of Ramadan, the month of fasting, at Tuna el-Gebel in Middle Egypt; a joyful occasion with picnics and visits to graves of relatives – the kind of popular celebration which accompanied the great religious festivals in ancient Egypt.

title was used like a signet ring to stamp official documents. The number and variety of examples that have survived dramatically emphasise the ramifications of the bureaucratic system.

Extensive documents written in official hieratic, which had by now become a very cursive script, very different from the hieroglyphic, provide many details of how the land was organised. The system was apparently all-pervasive. In addition to the office of the vizier, which had supreme authority in running the country, there were special departments in charge of the treasury and of the management of labour. The latter, a sort of Ministry of Public Employment, dealt with the conscription and allocation of labour required for official projects, which included not only the recurrent works resulting from the annual inundation, but also fortifications, roads, port facilities, and anything else

required by the central administration. This department had close links with the well-established prison system, for the inmates of prisons provided a useful recruitment to the ranks of forced labour gangs. Because conscripted service was unpleasant, it was not uncommon for a man to abscond to avoid the call-up. He was then declared a fugitive and liable to serve a prison sentence. Once caught he was immediately available for use by the labour department, when his terms of service would be infinitely more disagreeable than if he had accepted his call-up in the first place.

At a lower level in the administration there were lesser officials, reporters and district councillors, based in the towns and in the countryside. They were probably responsible ultimately for the assessment and collection of taxes, for which they were answerable both to the Treasury and to the Office of Fields, a kind of Department of Agriculture.

Papyrus groves along the river Ciane in Sicily, of a kind no longer seen in modern Egypt. Papyrus was used not only for writing material, but also for ropes, sandals, etc. The plant was introduced into Sicily in Ptolemaic times.

Colossal granite royal sculpture standing before the Seventh Pylon of the Karnak Temple. The two seated figures are of kings of the Thirteenth Dynasty, one an unspecified Sobkhotpe. The two on the left are of Tuthmosis III, usurped by Ramesses II; that on the right, Amenophis II.

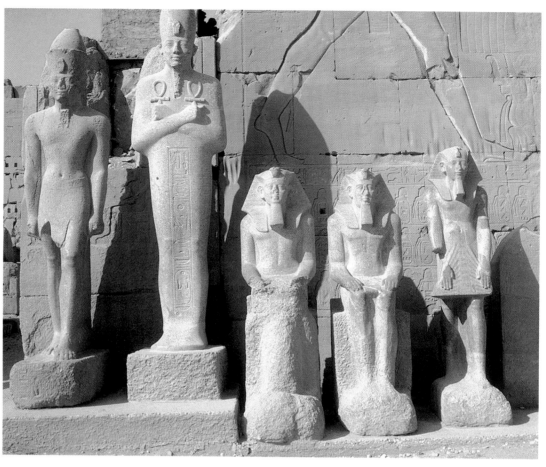

These officials had in fact taken over the duties formerly carried out by the nomarchs, but unlike the nomarchs their allegiance was not local but national.

A papyrus of this period in The Brooklyn Museum contains on its reverse side a long list of people who were transferred by legal process from the estate of a man to that of his wife, in the reign of King Sobkhotpe III in the mid-Thirteenth Dynasty. The named people, ninety-five in number, were all servants of a single household, and of these forty-five were Asiatics. They were treated on paper as part of the household property, to be dealt with like a piece of land or a measure of barley. Some of those who were native-born Egyptians were undoubtedly free-born, and had lost their freedom for various reasons. They may in some cases have been allocated to the householder by the department in charge of forced labour. The Asiatics, on the other hand, were probably in servitude for life. The fact that there were forty-five Asiatics in one Upper Egyptian household suggests that there was a very large number of Asiatics in the whole of Egypt at that time.

Other foreigners whose presence in Egypt became very noticeable during the Second Intermediate Period were the Medjay Nubians, whose homeland was in Lower Nubia. They were employed by the Egyptians as mercenary troops, providing a necessary

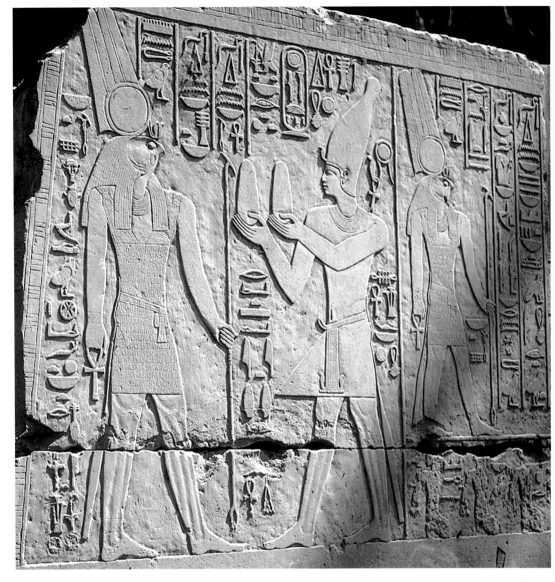

Part of a monumental doorway from the Temple of Month at Medamud, now in the open-air museum at Karnak. Here King Sekhemre-wadjkhau Sobkemsaf I of the early Seventeenth Dynasty offers loaves to falcon-headed Month 'Lord of Thebes, visiting Madu (Medamud)'.

stiffening for the ranks of the unwarlike native Egyptian levies. They seem to have established, or been established in, garrisons throughout Upper Egypt. A few generations later they were more closely assimilated into Egyptian society, but they remained a distinctive element in the population, being used for militia and police work.

Warfare became a very serious business during the Second Intermediate Period, and the Medjay were to find themselves much needed. Trade contacts between Egypt and Western Asia revealed to Asiatics the advantages of life in Egypt. Immigrants trickled steadily into the Delta and even into Upper Egypt. Many were craftsmen, in particular metal workers, and their skills were welcomed. In addition to individuals and families, larger groups seem to have seized the opportunity of entering Egypt, and over the years powerful tribal communities were built up, especially in the Eastern Delta. Their leaders

Above: Two gold spacer bars decorated with recumbent cats, parts of an elaborate piece of jewellery; inscribed for the Seventeenth Dynasty king, Nubkheperre Inyotef, and his wife Sobkemsaf.

British Museum *(EA57699, 57700); length of bases 3cm*

Right: The Carnarvon Tablet, a writing tablet found at Thebes, inscribed in hieratic with a text outlining the early stages of the confrontation between the Theban rulers and the Hyksos. It seems to be a copy of a monumental text dated in the third year of Kamose, last king of the Seventeenth Dynasty.

Cairo Museum *(41790); length 43.1cm*

were called in Egyptian *hikau-khasut*, 'chieftains of foreign desert countries', and this designation became debased into the name Hyksos, used by Manetho.

According to later tradition, the Hyksos rulers were ruthless destroyers who led hordes of invading foreigners throughout Egypt, looting temples, massacring the inhabitants, overthrowing native culture, and imposing an alien régime. The truth, however, may have been very different. Although it is not known how the Hyksos seized power, or how they exercised it, there is little reason to believe that they abused it. In the first place, the assumption of control seems to have been gradual and not the result of simple invasion. By about 1720BC the Asiatics in the Eastern Delta were sufficiently organised to set up a capital at Avaris, where they initiated an official cult, the divinity of which was Seth, brother of Osiris, and traditionally a hostile deity.

A dynasty of six Hyksos rulers, the Fifteenth, began to rule in about 1650BC. The first king, named Sheshi, probably captured Memphis, and it was not long before most of Middle Egypt fell under Hyksos rule. Some evidence suggests that they ultimately exercised control even over Thebes, but, in view of the continuance of the Thirteenth Dynasty of native kings based in Thebes, it is unlikely that the Hyksos ever exercised more than a tacit sovereignty over the south. Yet they certainly had contacts with the old Middle Kingdom trading post at Kerma in Nubia, and they were able to establish friendly diplomatic relations with Nubian princes who at this time had managed to set up an independent state in Lower Nubia.

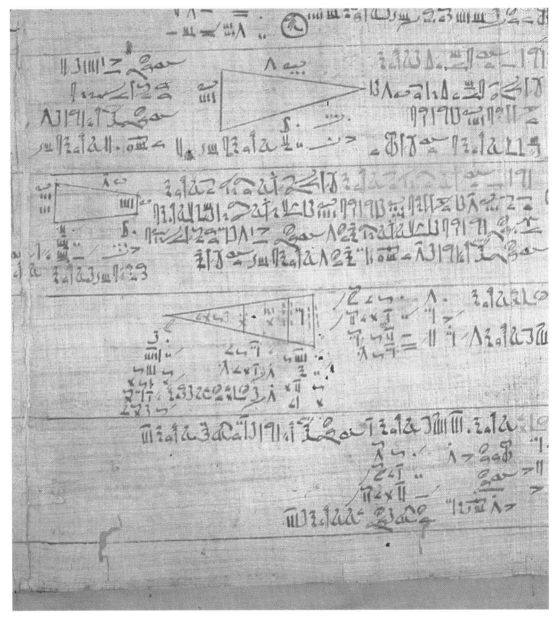

Part of the Rhind Mathematical Papyrus which contains problems with their solutions; here are the calculations of the areas of triangular pieces of land. It was written in Year 33 of the Hyksos Aauserre Apophis of the Fifteeenth Dynasty.

British Museum *(EA10057, 10058); height 32cm*

It seems that the Hyksos tried to behave like Egyptian rulers. Their god was Egyptian; they used Egyptian titles and put their names in cartouches; they built Egyptian-style buildings and appropriated Egyptian statues for their own use; they also appear to have fostered traditional Egyptian culture. It is a strange fact that some of the most interesting surviving papyrus texts were written at this time, including a long series of stories dealing with magical happenings in the Old Kingdom, the remarkable Ebers Papyrus which contains a large number of medical recipes and treatments, and the Rhind Mathematical Papyrus which was written down in the thirty-third year of the fourth Hyksos king, Apophis (Apepi) I.

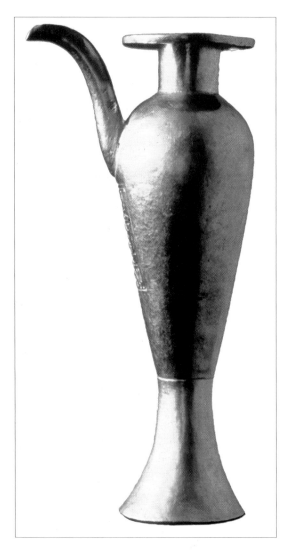

Gold ewer inscribed with the names of Amosis, first king of the Eighteenth Dynasty; found in the tomb of Psusennes I of the Twenty-first Dynasty at Tanis in the Delta, a king who lived 500 years after Amosis; possibly a royal heirloom.

Cairo Museum *(85895); height 14.6cm*

The peoples who are conveniently lumped together under the designation Hyksos do not demonstrate any distinctive national identity. They were undoubtedly Asiatic in origin, and they maintained trade links with Palestine and Syria, exploiting the opportunities offered by their control of the channels of communication with the east. Great claims have been made that it was the Hyksos who introduced into Egypt important things like the horse, chariots, bronze weapons, including certain types of sword and the composite bow. The most that can be said is that such things were undoubtedly of Asiatic origin, and may first have entered Egypt during the years of Hyksos rule.

While the kings of the Fifteenth Dynasty were installed at Avaris, a pale shadow of the Egyptian monarchy continued at Thebes, and it is likely that other ephemeral princes exercised local power in the Western Delta and elsewhere from time to time – vassals, in effect, of the Hyksos. In about 1650BC a new line of rulers assumed control at Thebes, instituting the Seventeenth Dynasty. This new line seems to have been a true dynasty with hereditary succession, an improvement on what had apparently been the haphazard line of the Thirteenth Dynasty. To begin with, however, the new kings were no more successful than their Theban predecessors in presenting a really brave front to the Hyksos.

The poverty of this attenuated Theban principality is to be seen in the meanness of the tombs of its kings, the wretched character of much of its artistic work, and in the use of poor-quality materials for important grave goods. But memories of past greatness were not wholly extinguished. As happened before in Thebes during the First Intermediate Period, the signal for positive defiance of the stronger northern power was the assumption by the Theban princes of the royal titles as Kings of Upper and Lower Egypt.

The final stage of the struggle to liberate Egypt was possibly initiated by the Theban king, Seqenenre, retaliating strongly to an imagined insult offered by Apophis, the Hyksos ruler. A story of the New Kingdom relates that Apophis objected to the harpooning of sacred hippopotamuses by the Thebans. Seqenenre took umbrage and marched his army north. The condition of Seqenenre's mummy has led some historians to claim that he was foully done to death, perhaps even in his hour of triumph on the battlefield. The truth is unknown. It was left to his successor, Kamose, to take the war right into Hyksos territory. Contemporary inscriptions record his successes, but no account tells of what happened before control passed to the hands of Kamose's younger brother, Amosis (Ahmose). To the latter fell the honour of capturing Avaris and expelling the Hyksos from Egypt.

Amosis' reign began in about 1550BC, and he very rightly has been regarded as the founder of the New Kingdom and the first king of the Eighteenth Dynasty. From this point it may be convenient to use the term Pharaoh for the Egyptian king. The word is Egyptian in origin and means 'Great House', originally the royal palace, and then in the New Kingdom, the king himself – the personification of the palace in the form of the king. It is strictly anachronistic to use Pharaoh of earlier kings.

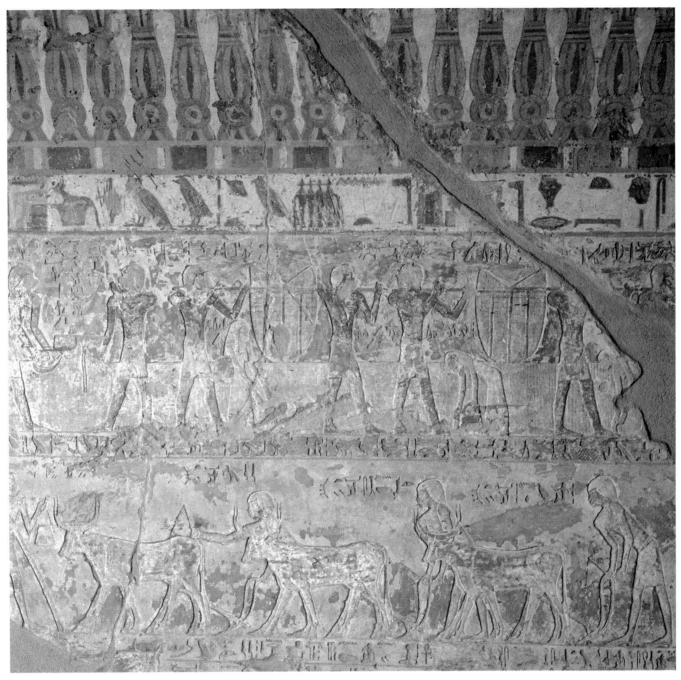

Agricultural scenes from the tomb of Renni, mayor of Elkab; early Eighteenth Dynasty. Above, harvesting of grain, and below, ploughing with cattle. The nobles of Elkab engaged actively in the campaigns to expel the Hyksos, and subsequently in Asia and Nubia.

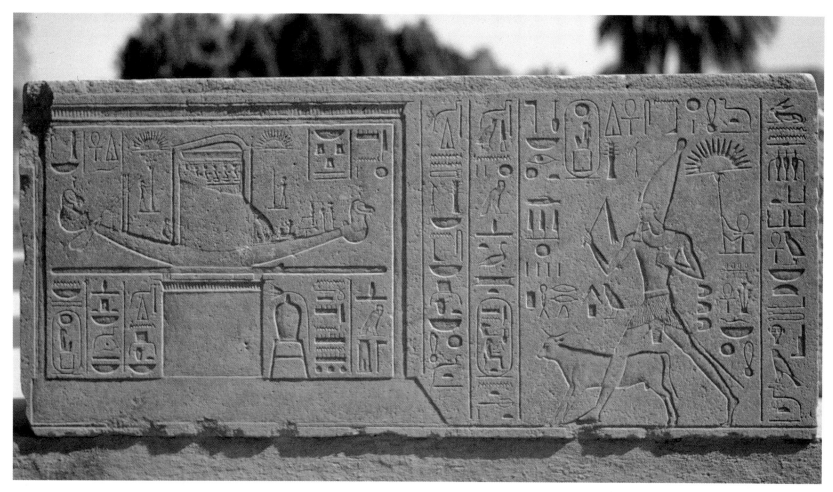

Quartzite block from the 'Red Chapel' of Hatshepsut, once part of the Karnak complex, later dismantled and used as filling in the Third Pylon of Amenophis III. Here the queen, shown as king, runs with the Apis bull to a shrine containing the divine boat of Amon-Re. Now in the open-air museum, Karnak.

One thing which the Hyksos domination of Egypt had brought home to the Egyptians was the vulnerability of the country. Apart from the Delta it was a land with no breadth but only length, and it was extremely difficult to defend against a determined invading enemy. The Pharaohs of the Eighteenth Dynasty had no mind to allow foreigners to establish themselves again in Egypt like the Hyksos, and they determined the best way of preventing this disaster was by reasserting Egyptian influence in Nubia, and by campaigning actively for the first time in Asia.

After consolidating his influence in Palestine, Amosis directed his attention principally to Nubia. He sent at least three punitive expeditions south, eliminated the upstart Prince of Kush (as the local ruler called himself), and began the restoration of the Second Cataract forts. He also instituted the office of Viceroy of Kush, who was henceforth responsible for the maintenance of Egyptian power south of Elephantine.

Under Tuthmosis I Egyptian power was extended to the Third Cataract region, and late in the reign of Tuthmosis III the town of Napata was founded almost at the Fourth Cataract – the furthest point south ever reached by the Egyptians militarily. From this outpost closer contact was obtained with tropical Africa, and there is much visual evidence

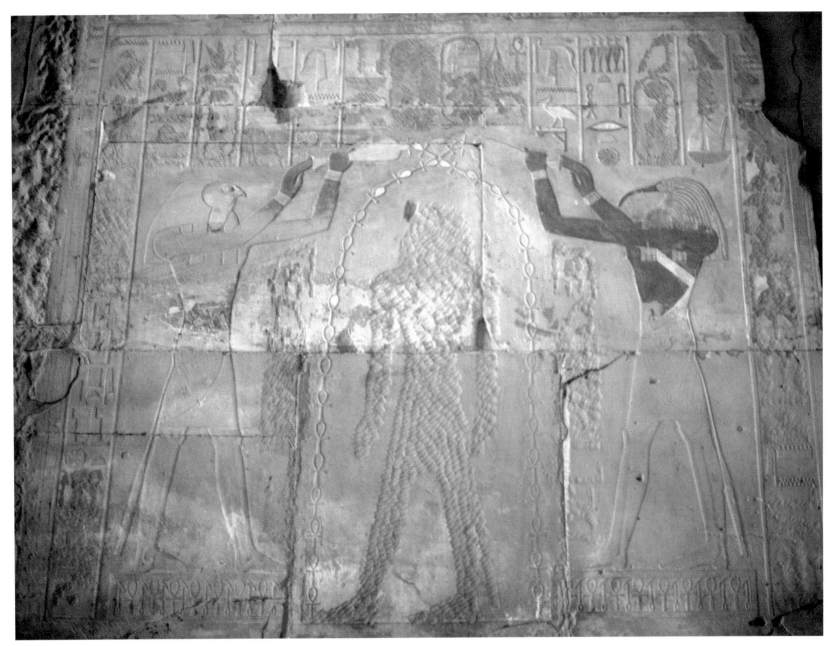

in tombs to show that from the mid-Eighteenth Dynasty the flow of exotic products into Egypt was greatly increased. Trade flourished in the settled conditions obtained by the new vigilance and under the well-organised administration of the viceroy.

The imperial character of Egyptian policy towards Asia was initiated by Tuthmosis I, who campaigned as far as the land of Naharin, and east of the river Euphrates, the realm of the King of Mitanni, and apparently established garrisons in Syria and Palestine. Authority in the newly acquired empire undoubtedly depended to a large extent on the support of client chiefs, and their loyalty in turn depended not only on the physical

A finely carved and painted scene in a room near the central sanctuary of Karnak. Hatshepsut, her name and figure carefully chiselled out in the reign of Tuthmosis III, receives lustration from the gods Horus and Thoth. The water of lustration is shown as streams of ankh *(life) signs.*

Above: Granite statue of the steward Senenmut, chief official of Hatshepsut, shown holding the Princess Neferure, daughter of the queen. The form of this sculpture is unique in Egyptian art. From Thebes.
British Museum *(EA174); height 61cm*

Opposite: The mortuary temple of Queen Hatshepsut at Deir el-Bahri. The architect, usually thought to be Senenmut, made dramatic use of the natural setting, laying out a series of rising courts with colonnades. It has been much restored.

threat of military retaliation, but also on generous practical support. A suitable present at the right time worked wonders.

In the reign of Queen Hatshepsut not enough interest was taken in Asia, and this neglect, combined with active pressure from Mitanni, brought about a revolt in Syria just about the time when Tuthmosis III regained his throne (in about 1458BC). Acting with great vigour he inflicted a crushing defeat on the rebellious Asiatics at Megiddo in one of the great battles of antiquity. This success was followed up by a series of brilliant campaigns by which he extended the Egyptian empire in Asia beyond the Euphrates and to the borders of the Hittite empire.

Meanwhile, within Egypt the imperial character of the country's image abroad was reflected in domestic prosperity and great artistic achievements. After the liberation from the Hyksos a good beginning was made in re-establishing administration on a sound footing. The court and main departments of state were centred in Thebes, but a more effective control over the whole land was obtained by the institution of a second office of vizier based in Memphis. From this base the northern vizier controlled geographically the larger and more important part of the country; it contained the towns and trading posts in direct contact by sea and land with Asia, the Aegean, and Libya. Memphis must have been a large and busy city.

By the accidents of survival and intensive excavation, however, much more is known of Thebes and of the activities of the Theban vizier and his subordinate officials. As chief official of the land the vizier was the Pharaoh's prime minister, responsible for carrying out all royal orders and policies. In theory he was responsible for every aspect of the affairs of state. In practice, he had a large staff of senior and junior officials who looked after the day-to-day running of matters, reporting finally to the vizier, and consulting him when necessary. In matters of justice there was undoubtedly a body of law, perhaps even written down in a codified manner, based partly on a kind of common law, and partly on specific enactments.

Occasionally officials other than the vizier succeeded in obtaining the favour of the ruling Pharaoh. Such was Senenmut, steward of Amun, who became the most powerful officer of Queen Hatshepsut, whose own regal position was very questionable. During the Eighteenth Dynasty the right to the throne seems to have passed through the female line. A king possessed the right to rule because he was married to the daughter of his predecessor's principal wife. Since he himself was usually the son of his predecessor, then his principal wife was his half-sister. The relationship was not wholly incestuous; the king and his principal wife had the same father but different mothers.

Hatshepsut was the daughter of Tuthmosis I and Queen Ahmes, and she by her divine royalty confirmed the regality of her husband, Tuthmosis II. When he died prematurely, leaving the young Tuthmosis III to become Pharaoh, it was quite understandable that Hatshepsut should act as regent during his minority. Not satisfied with this power she soon adopted the titles and authority of Pharaoh, put the young king aside, and ruled absolutely for almost twenty years. The visible remains and records of her reign suggest

Schist head of a monarch wearing the white crown of Upper Egypt, identified both as Queen Hatshepsut and King Tuthmosis III. The softness of the features possibly favours the female identification.

British Museum *(EA986); height 45.7cm*

that during this time Egypt's foreign activities were greatly reduced. The style and quality of her reign are typified by Hatshepsut's mortuary temple.

This temple, the outstanding architectural masterpiece of the dynasty, and as much a monument to Senenmut, its architect, as to Hatshepsut, was built in a dramatic situation, at Deir el-Bahri in the Theban Necropolis, in a great bay in the limestone cliffs. The temple consists of a series of open courts on terraces, leading up to the chapels of the deities principally honoured there, Amon-Re, Hathor and Anubis. Open colonnades on the terraces contain finely coloured scenes in exquisite low relief showing, among other things, the great expedition sent to Punt, the transport of vast granite obelisks from Aswan to Thebes, and a sequence designed to establish Hatshepsut's divine birth. Senenmut may have been well contented with his creation, but his triumph was short-lived. His disappearance from the Egyptian scene, like that of his mistress, was abrupt, and possibly violent.

Alabaster ointment vessel in the form of a standing lion;
from the Tomb of Tutankhamun.
Cairo Museum *(62114); height 60cm*

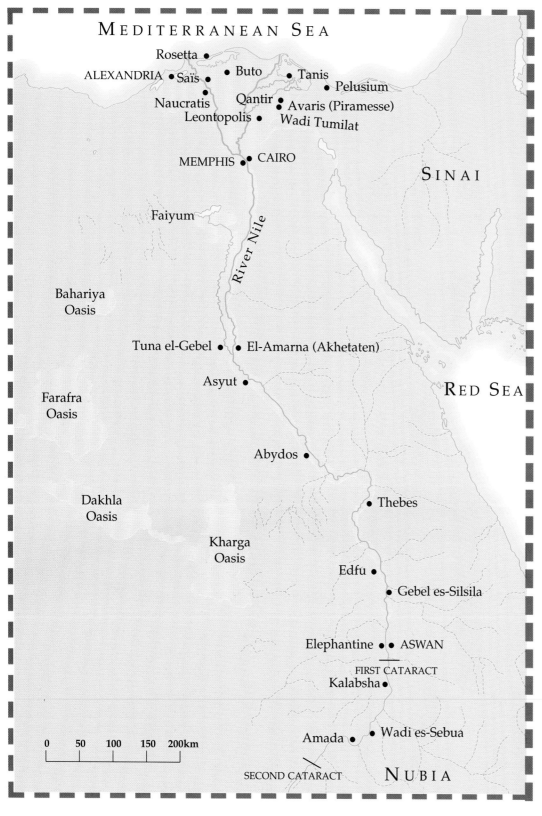

MEDITERRANEAN SEA

Rosetta
ALEXANDRIA • Saïs • Buto • Tanis
Naucratis • Qantir • Pelusium
Leontopolis • Avaris (Piramesse)
Wadi Tumilat

MEMPHIS • CAIRO

SINAI

Faiyum

Bahariya
Oasis

Tuna el-Gebel • El-Amarna (Akhetaten)

Asyut •

Farafra
Oasis

RED SEA

Abydos •

Dakhla
Oasis

Thebes

Kharga
Oasis

Edfu •
Gebel es-Silsila •

Elephantine • ASWAN
FIRST CATARACT
Kalabsha •

0 50 100 150 200km

Amada • Wadi es-Sebua

SECOND CATARACT
NUBIA

River Nile

New Kingdom To The End Of The Eighteenth Dynasty

After Hatshepsut's regency and usurpation of the monarchy, her nephew Tuthmosis III resumed his royal powers and, by vigorous policies at home and abroad, which were pursued by his successors of Dynasty XVIII, brought the country to a peak of success characterised by splendid works in architecture, sculpture, painting and the minor arts. The funerary equipment of Tutankhamun offers an indication of the dynasty's capabilities and achievement. The reign of Akhenaten – the Amarna Period – failed to secure its revolution and was subsequently viewed as a disgrace. As a result it was eliminated from the later king-lists along with those of his immediate successors, seemingly also tainted with the hated Atenism.

Note: Dates are now more certain, supported by further astronomical data and correspondences from elsewhere.

Late Dynasty XVIII *c.*1479-1295BC
Tuthmosis III *c.*1479-1425BC
Amenophis II *c.*1427-1400BC
Tuthmosis IV *c.*1400-1390BC
Amenophis III *c.*1390-1352BC
Akhenaten *c.*1352-1336BC
Neferneferuaten *c.*1338-1336BC
Tutankhamun *c.*1336-1327BC
Ay *c.*1327-1323BC
Horemheb *c.*1323-1295BC

Key
---------- Desert watercourse

7: Fruits of the Empire

Dynasty XVIII, Tuthmosis III–Horemheb, 1479–1295BC

Wooden chair with woven cord seat, its back inlaid with panels of ebony inset with ivory decoration; a typical Egyptian chair found as part of a tomb equipment in an unidentified Theban tomb of the Eighteenth Dynasty.
British Museum *(EA2480); height 62.2cm*

The ill-fated Senenmut had taken steps to ensure that he enjoyed a noble burial. Two tombs bear his name and titles, one prepared before he had attained the position of highest authority, and the other begun while he was exercising that authority. The first tomb contains scenes of the kind found in many other nobles' tombs of the mid-Eighteenth Dynasty, largely illustrating the worldly activities and surroundings of the great man, with a few episodes specifically concerned with funerary rites and the provision of suitable offerings. The second tomb was to be of a very different kind. Here the accent was on the posthumous journey of the dead man, and the tomb-walls were to be covered in part with ritual texts of a kind normally found in royal tombs. It seems as if Senenmut intended to have a semi-royal tomb for himself. He was to be disappointed, for not only was the tomb never finished, but he was apparently not buried in it.

Although Senenmut would undoubtedly have preferred his second tomb as a repository for his body, his first tomb has for us much more intrinsic interest in being a typical noble's tomb of the middle reigns of the Eighteenth Dynasty. The limestone of the Theban Necropolis is, except in a very few places, of poor quality, and not suitable for carving. Consequently the excavated tomb-walls were made smooth with plaster, and then painted, not carved. The opportunities now offered to Egyptian artists for the development of painting were enormous, and artistic skills advanced by leaps and bounds. Technically Egyptian artists had been very competent craftsmen for a very long time, but now they began to explore the possibilities of their craft, experimenting with their palette as never before, introducing new artistic conventions, adapting the old ones, and generally breaking down the rigid traditions which had shackled them for so long.

The time was coming when extraordinary things would be done in liberating Egyptian art, but already in the reign of Tuthmosis III the process of blurring the edges

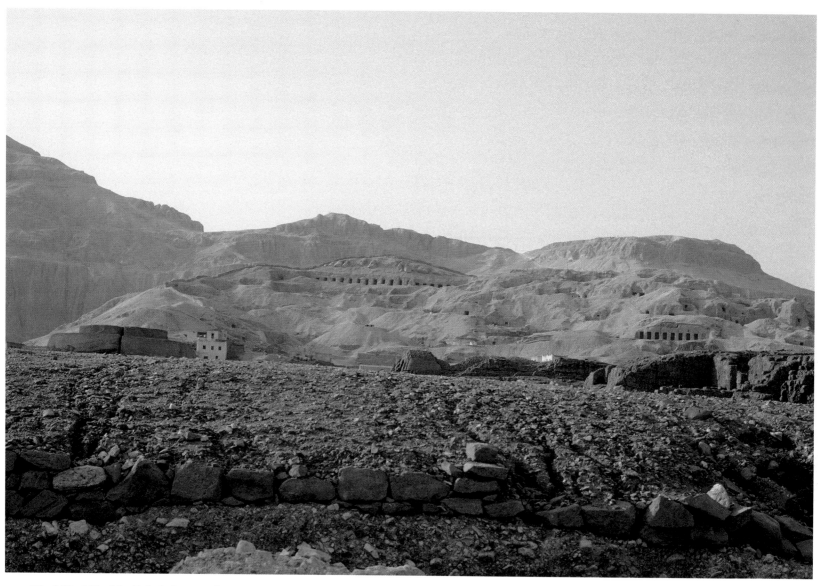

The hill of Sheikh Abd el-Qurna, the central feature of the Theban necropolis, housing many of the finest private tombs of the New Kingdom. The colonnaded façades of some of the largest tombs are clearly visible.

of the old formalism had begun. Many tomb scenes contain small sub-scenes of great realism and charm; the hard, firm outlines of earlier artists were softened; the flat areas of colour were modified by stippling and shading; the formal layout of scenes was in some cases abandoned, and in others much modified to give greater movement to figures and more life to whole compositions.

It is from the scenes in Theban tombs that much is learned about the houses and gardens of senior officials of New Kingdom Egypt. The pictorial evidence is supplemented by the actual remains of villas excavated at El-Amarna. The Egyptian house was built of mud-brick with wooden beams, door and window fittings, and occasionally with stone lintels, pillars and other internal features. It was usually a single-storey structure, but in towns it might have two or three floors. In most cases, however,

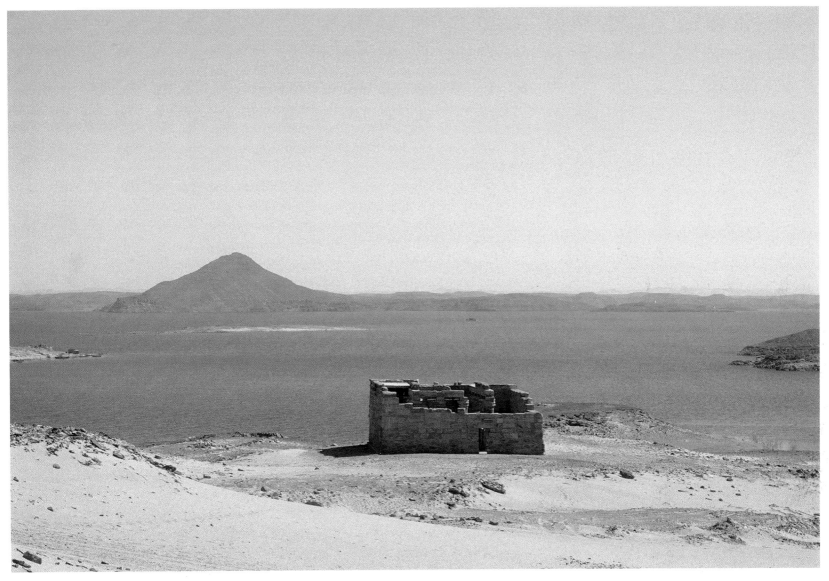

a staircase led to the roof where members of the family could sleep in very hot weather. A large house had an entrance porch, a reception area, family rooms, servants' quarters, and outbuildings. Some houses even had baths, lavatories, and rudimentary drainage.

The decoration of houses was carried out in bright colours on white plastered walls. When first excavated, the palace of Amenophis III in Thebes was sufficiently well preserved to show lively paintings of animals, birds and flowers. Furniture was well designed and comfortable; the styles used for chairs, tables and beds were mostly traditional, but New Kingdom craftsmen introduced many variations in design and decoration, which can be seen in well-preserved surviving examples.

The kinds of entertainment given in the houses of the great can also be seen in tomb scenes. The guests at a party usually sat in pairs, sharing small tables, sometimes men

The reconstructed temple of Amada by the shore of Lake Nasser. Begun in the reigns of Tuthmosis III and Amenophis II, and added to under Tuthmosis IV, it was dismantled and moved as part of the Nubian Rescue Programme in the 1960s.

Scene above a doorway in the Anubis shrine in Queen Hatshepsut's temple at Deir el-Bahri. The queen's nephew, King Tuthmosis III, offers wine to the falcon-headed necropolis deity, Sokar.

Granite relief retrieved from the filling of the Third Pylon at Karnak showing the warrior King Amenophis II demonstrating his strength and skill by shooting arrows through copper targets from his chariot at full gallop.
Luxor Museum; *width 234cm*

and women together, but frequently with the two sexes separated. Food and drink were brought by girl attendants. All kinds of fowl and roasted meat were served; vegetables and fruit in profusion were handed round in great baskets along with many varieties of bread and cakes. Beer and wine were consumed in great quantities, the former being the most common ancient Egyptian drink. Wine was probably always something of a luxury, but it was essential for a good party. Excessive drinking was not uncommon, and guests are sometimes shown drunk and even unable to contain what they had consumed.

To accompany the feasting there would be musicians, usually women, although harpists were often male and frequently blind. The oriental scene was completed by nude or semi-nude girl dancers who performed the Pharaonic equivalent of belly dances.

If the party were taking place at a villa outside the town, the guests might stroll in the enclosed garden when the evening came. A good Egyptian garden required a pool with lotus flowers, surrounded by shady trees; there would have been an arbour where one could sit in the heat of the day, and there had to be flowers. If the villa were big, there would also be a kitchen garden where fruit and vegetables for the household could be grown. Many gardens contained vines which were trained over pergolas. They were planted in troughs so that the roots could be protected and their watering carried out economically. Villa owners might grow enough grapes for their own modest purposes in this way, but the vast amounts of wine needed for palace and temple came from grapes grown on great estates in the Delta and some of the oases in the Western Desert.

The fruits of the empire, on the other hand, ripened fully during the reign of Amenophis III, after the active reigns of Amenophis II and Tuthmosis IV, who consolidated the gains of the mighty Tuthmosis III in Asia and Nubia. When Amenophis III became Pharaoh in about 1390BC, the military situation was so settled everywhere that quite small demonstrations of force by the new king were all that was necessary, as it seemed, to confirm his authority. Not only were the borders quiet, but useful acts of diplomacy in Asia had further attached the peripheral rulers to the Egyptian crown. Tuthmosis IV had married a daughter of the King of Mitanni, and Amenophis III followed his example by taking several Asiatic princesses into his harem. Among them were the daughter of the King of Mitanni and the sister of the King of Babylon.

With the necessity of foreign expeditions removed, some historians have claimed that Amenophis III settled for a quiet life of luxury and idleness. The titillating picture of life in the luxurious court of this Pharaoh is, however, almost certainly exaggerated. There was undoubtedly a higher level of comfort and opulence in the life of the great than ever before, but there is no real evidence that during the reign of Amenophis III there was a decline of moral standards and a neglect of religion and the nobler aspects of life. On the contrary, the period was evidently one of piety, even if it were of a rather ostentatious kind. Wonderful temples were built at Luxor and as part of the great Karnak complex. The king's funerary temple was greater than any previously built; unhappily it was levelled in antiquity, and all that clearly remains are two vast quartzite statues of the king, now known as the Colossi of Memnon, and the traces of great courts littered with

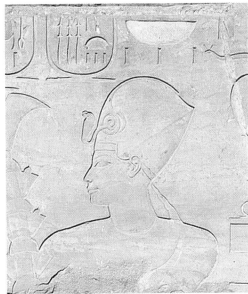

Above: Limestone sunk relief carving of the head and shoulders of King Tuthmosis IV, wearing the blue crown. From the filling in the Third Pylon at Karnak, and now in the open-air museum at Karnak.

Left: Dancing girls performing as part of the banquet entertainment in the tomb of a 'counter of grain of Amun', probably named Nebamun. From Thebes, reign of Amenophis III.

British Museum *(EA37984); height of whole fragment 61cm*

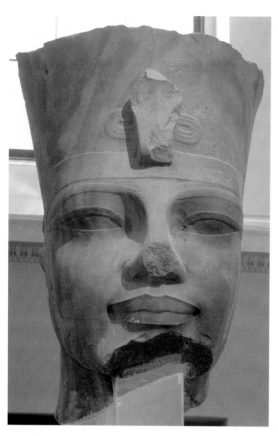

Colossal quartzite head of King Amenophis III,
from his mortuary temple in Western Thebes,
once one of the finest of such temples, but
almost wholly destroyed in antiquity.
British Museum *(EA6); height 117cm*

the shattered remains of royal sculptures. In Nubia a temple of striking beauty was built at Soleb, south of the Third Cataract; here Amenophis himself was worshipped as a god along with Amon-Re. Not far away at Sedeinga another temple was built in which his principal queen, Tiye, was similarly worshipped.

The deification of the king was an established aspect of royalty in ancient Egypt, but the idea that he might, while still alive, have a temple dedicated to him as a god was new. It was a practice much used later by Ramesses II, especially in Nubia where such temples served to magnify the Pharaoh's power and authority. The association of the Pharaoh as a god with the great Theban deity, Amon-Re, was particularly significant. In his solar form this god was more suitable than any other Egyptian god for presentation to foreigners abroad as the embodiment of Egyptian religion and majesty. The sun was universal; most of the other Egyptian gods were essentially local deities.

In his devotion to Amon-Re Amenophis III followed the example of Hatshepsut in formally establishing his claim to the throne. In his Luxor temple a series of reliefs were carved demonstrating that the king's father was actually the god. From the courtship of his mother, Queen Mutemuia, by Amon-Re, the story unfolds step by step, until the royal baby and his *ka* (spirit) are modelled by the creator god Khnum, and produced in labour by the Queen, assisted by the protective deities of birth.

The expression of religious feeling demonstrated by the great state cults, and embodied in the building of temples, should not be taken as an indication of general religious devotion. From early times the formal texts found in private tombs had occasionally contained hints of the simple pieties of people who used the traditional forms only because they had no other way of expressing their personal religious beliefs. These beliefs developed during the First Intermediate Period, when ideas of moral responsibility first became revealed in written texts, and in the Eighteenth Dynasty the moral element was enshrined in a long section of the *Book of the Dead*, a compilation of religious spells mainly designed to enable the *ba* (the manifestation of a dead person's ability to move about on earth after death) to come out of the tomb and indulge in earthly activities.

The funerary equipment of a dead person of some status usually included a copy of the *Book of the Dead*, the size of the copy depending on how much the owner could afford. Nearly all examples contain the section now numbered as Chapter 125, which deals with the judgement of the person in the underworld. The deceased undergoes an examination by forty-two assessor gods who question him on his life. He is asked if he has committed specific sins, and if he answers correctly, that is, if he denies all the charges truthfully, he is declared justified. His heart is weighed in a balance against Truth (known to the Egyptians as *Maat*), and if it fails to measure correctly in the balance it is given to a monster to be eaten. Ideas of responsibility and retribution underlie the whole of this conception of judgement; it embodies a true morality.

Maat, the divine idea of truth, meant much more in its fullest form, and it developed still further during the Eighteenth Dynasty. It contained the conception of order and

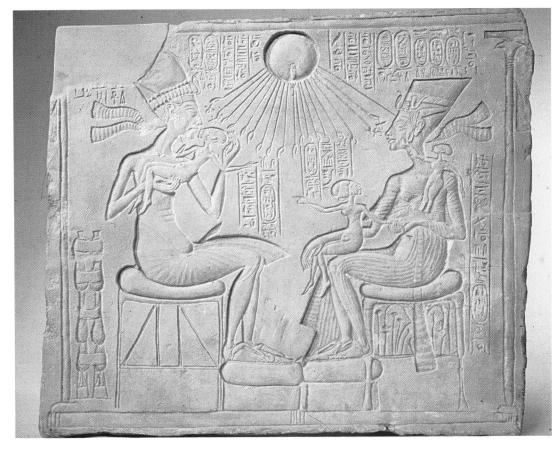

Above: Opaque glass flask, possibly for perfume, in the form of a fish. The festoon decoration was achieved by the working of coloured glass rods into the partly molten body of the flask. Found beneath the floor of a house at El-Amarna.
British Museum *(EA55193); length 14.2cm*

Left: Limestone relief, possibly from a shrine in a private house at El-Amarna, showing Akhenaten and Nefertiti relaxing with three of their daughters; a notably intimate glimpse of royalty carved in the gauche style of the early years of the king's reign.
Egyptian Museum, Berlin *(14145); height 32.5cm*

stability, the regularity of life found in the natural world which was dominated by the all-pervading sun. It seems that many thinking Egyptians began to find satisfaction for their spiritual aspirations in vague idealisations embodied in Maat, and, especially, the life-giving sun. Some tomb inscriptions set up in the reign of Amenophis III contain not only conventional prayers to Re but also finely expressed hymns addressed to the Aten, the deified sun's disc.

The cult of the Aten received a powerful boost when it was adopted by the crown-prince, Amenophis, who later changed his name to Akhenaten. His devotion was matched by that of his wife, Queen Nefertiti. They even built temples to their favoured deity near the precinct of Amon-Re at Karnak. But it seems that a concerted opposition in Thebes created such an atmosphere of hostility that Akhenaten decided to move his capital to a virgin site in Middle Egypt. The place chosen was isolated and unsullied by associations with already existing Egyptian divine cults. It was given the name Akhetaten, 'Horizon of the Aten'; today it is called El-Amarna.

The move from Thebes to Akhetaten was made in the Pharaoh's sixth year (about 1346BC), and it is possible that he left behind in Thebes his father, Amenophis III, with whom he shared the crown. (The question of a co-regency between these two kings has not yet been settled to the satisfaction of all historians of ancient Egypt.) The area of the

Boundary inscription set up in Akhenaten's sixth year, the text of which sets out the plan for the new city of Akhetaten (El-Amarna). Headless statue-groups of the royal family stand beside the main inscription. It is carved in the cliffs near the Late Period necropolis of Tuna el-Gebel.

new capital was strictly limited by Akhenaten by the establishing of boundary stelae bearing inscriptions in which he described how the site was chosen by the Aten himself, how it was not to be increased, and how it was to be a self-sufficient unit. Akhenaten declared that he would never leave the place. In this great enterprise he was helped by a group of nobles and officials who seem to have been mostly new men, unconnected with the old régime – men who were bound to Akhenaten and his revolutionary ideas by their preferment at his hands.

The new city of Akhetaten was laid out in a spacious manner, with fine palaces and villas, government offices, artisans' quarters, and, most important of all, a great temple dedicated to the Aten. Unlike the traditional Egyptian temple it was mostly open to the sky, the altars and offering tables receiving in full the life-giving rays of the sun. In essence

the cult of Atenism was a monotheism, and it did not depict the deity in human form. The sun's disc was the manifestation of the Aten, pouring down goodness on the Pharaoh and his family. It is often said that Atenism was a kind of universal religion, and that Akhenaten was the first true monotheist; but such claims are exaggerated. It may have contained the possibility of becoming a universal religion, but it was never propounded as a creed that could have application much beyond the ambit of the royal family. It was essentially a religion of adoration and wonder, in which the element of Maat was all-important. There seems to have been little moral content in its tenets; responsibility had no place in a world where everything was created and guided by the Aten.

In character the régime of Akhenaten was revolutionary, and no aspect of life seems to have been considered inviolate in its traditional form. Everything had to be changed. The compulsion to do so was overwhelming. Even in language the effect can be seen. The formal inscriptions on royal monuments had for centuries been written in a form of Egyptian which tended to be archaic in structure and vocabulary. During the short Amarna period, however, the language of formal texts clearly reflected more of what seems to have been contemporary speech. This 'freeing' of the language was matched by changes in artistic methods and style, which resulted in the production of many strange and some wonderful works of art. The emphasis on natural order in Atenism led to a radical reappraisal of how an artist should observe his subject. While the established methods of representation could not wholly be overthrown, the new way of looking at

Above: Quartzite torso of a girl, probably a daughter of Akhenaten and Nefertiti; part of a sculptural group which included the royal parents and possibly other daughters. It was excavated at El-Amarna

Petrie Museum, University College London (002); *height 16cm.*

Left: Musicians and attendants take part in the great procession marking the festival called Opet, when the gods of Karnak visited Luxor Temple. These reliefs in the Luxor Temple were begun in the reign of Tutankhamun, but completed under Horemheb.

113

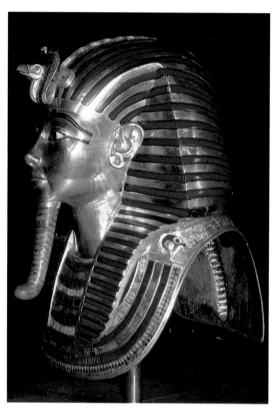

Solid gold head mask from the mummy of Tutankhamun. The piece is made of beaten sheet gold, inlaid with semi-precious stones (cornelian, lapis-lazuli, felspar, quartz), opaque glass and faience.

Cairo Museum *(60672); height 54cm*

things meant that subjects were shown as they were seen to be in reality; and not as they were supposed to appear.

The earliest surviving exercises in the new methods in sculpture and relief come from the Aten temples at Karnak, and the most unusual are colossi of Akhenaten. He is shown not as an idealised Pharaoh but as a sexless man with extraordinary bodily peculiarities. His head is quite grotesque, with elongated features, pendent jaw and distorted skull. These characteristics must have been present to some extent in the Pharaoh, but in these sculptures they seem almost to be caricatured. The contrast with the exquisitely refined and controlled art of the high years of Amenophis III is striking. It is evident that the new art was not only difficult for its practitioners, but in many cases produced by artists who were inexperienced.

As Akhenaten's reign advanced artists became more accustomed to the ideas of the new art, and clearly found it stimulating. The statues made in the royal workshops at Akhetaten have all the refinement of technique of the preceding reign, and additionally are inspired by the realism of Atenism. Among the most successful works of Amarna art were the landscapes and scenes of natural life painted on the plastered walls of the palaces at Akhetaten. In these murals the freedom from the confining conventions which governed the use of space in earlier wall decorations was wonderfully revealed. Unfortunately, only fragments of these paintings have survived.

The inward-looking life that was developed in the court at Akhetaten left little room for the grand affairs of state. Diplomatic records found at El-Amarna show how Egyptian influence in Western Asia disintegrated through lack of interest in the capital. Appeals for help from vassal rulers fell on deaf ears. Eventually, pressure from important officials like the general Horemheb, linked with a growing realisation that his régime attracted little support in Egypt, possibly forced Akhenaten towards the end of his reign to effect a reconciliation with the old order at Thebes. Neither Akhenaten, nor his eventual co-regent Neferneferuaten, who was possibly his brother Smenkhkare, or even Nefertiti, survived to clinch the reconciliation.

Tutankhamun, who succeeded, was very young; he was undoubtedly related to Akhenaten, but his parentage remains uncertain. In his short reign the old order was re-established with little difficulty. In fact, the reign of this minor monarch would require but a brief mention in the history of the Eighteenth Dynasty but for the glorious treasure found in his tomb. The extraordinary contents of the tomb do not tell us much about him or his reign, but they do provide a dazzling glimpse of the magnificence of the court of Pharaoh. Everything is marked by style and fine craftsmanship; luxury and comfort are assumed; even the vulgarity of excessive opulence is present. All this was for a youth whose reign was marked, as far as the record shows, by no great deeds.

Upper part of a blue faience shabti (deputy) figure of
King Sethos I. From Thebes.
National Trust (Kingston Lacy House); *height 8.8cm*

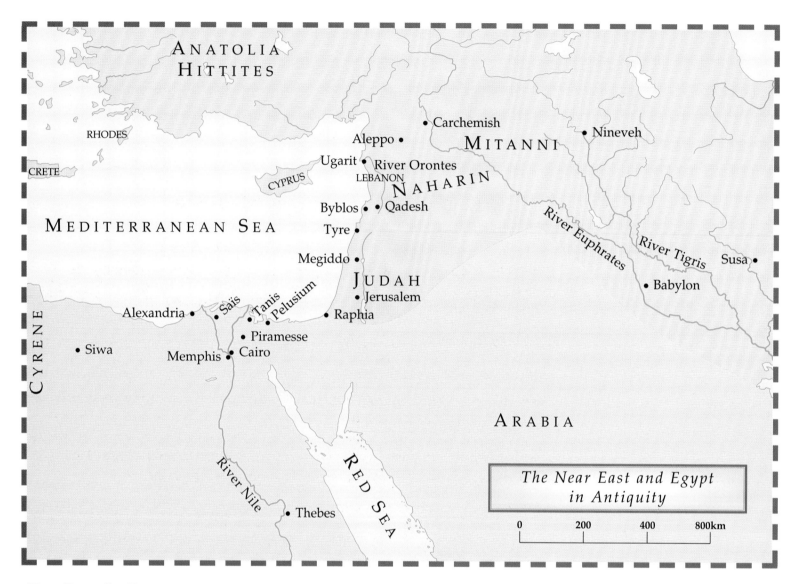

The Near East and Egypt in Antiquity

THE END OF THE NEW KINGDOM

Threats to the Egyptian empire in Asia and to Egypt itself after the start of Dynasty XIX were for a time stemmed by the so-called victory of Ramesses II at Qadesh, and more substantially by the vigorous steps taken by his successor Merneptah. More serious invasions in the reign of Ramesses III of Dynasty XX were again frustrated. A decline in Egypt's stability in late Dynasty XX resulted in a period of weakness in Dynasties XXI-XXIV, often called the Third Inter-mediate Period.

Note: In the dynastic lists below selected names only are included.

Dynasty XIX *c.*1295-1186BC
Ramesses I *c.*1295-1294BC
Sethos I *c.*1294-1279BC
Ramesses II *c.*1279-1213BC
Merneptah *c.*1213-1203BC

Dynasty XX *c.*1186-1069BC
Sethnakhte *c.*1186-1184BC
Ramesses III *c.*1184-1153BC
Ramesses IV-XI *c.*1153-1069BC

Dynasty XXI *c.*1069-945BC
Smendes *c.*1069-1043BC
Psusennes II *c.*959-715BC

Dynasty XXII *c.*945-715BC
Sheshonq I *c.*945-924BC
Takelothis II *c.*850-825BC
Sheshonq III *c.*825-773BC

Dynasties XXIII-XXIV c.818-715BC
Tefnakhte *c.*727-720BC
Bocchoris *c.*720-715BC

8: Growth of the Foreign Menace

Dynasties XIX–XX, 1295–1069BC

The stability which the Egyptian empire had enjoyed during the middle years of the Eighteenth Dynasty came to an end during the reign of Akhenaten. That preoccupied Pharaoh, however, cannot be blamed wholly for the fatal decline which then developed. Throughout Western Asia during the second half of the second millennium BC there were constant movements of peoples. It was not an area where peace could endure for long; there were always pressures. The loosely controlled Egyptian empire was bound to disintegrate unless a constant watch was kept on all neighbouring peoples, and vigorous action taken against any hostile move.

Two tombs of very important persons in the New Kingdom necropolis at Saqqara: on the right, that of the high priestly official Tia, whose wife, also Tia, was a sister of Ramesses II; on the left, that of the General Horemheb built before he became last king of the Eighteenth Dynasty.

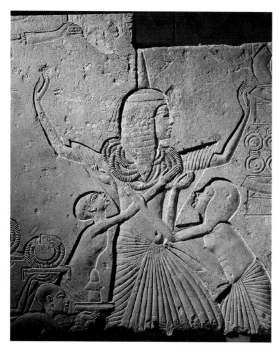

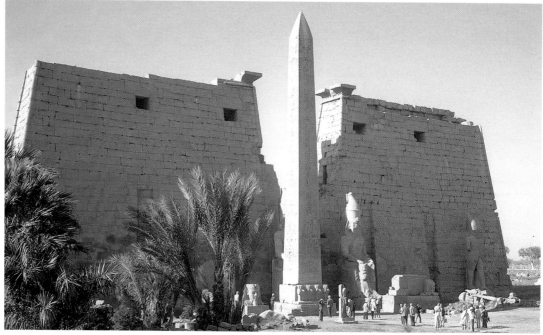

Above: General Horemheb, in his Saqqara tomb, receives rewards for his military triumphs (the 'gold of honour') from Tutankhamun. The royal uraeus was added to the brow of the general after he became king.

Museum of Antiquities, Leiden (H.III.PPP); height 86cm

Right: The great pylon entrance to the temple of Amon-Re at Luxor; built as part of the additions to this temple by Ramesses II, the outer faces of this pylon are decorated with scenes and texts relating to the battle of Qadesh, fought between the armies of Ramesses and the Hittites.

During the reigns of Akhenaten and Tutankhamun the one man who tried to stem the tide was the general Horemheb, but his efforts at first were only partially successful. In about 1323BC, following the short reign of Ay, an elderly relative of the former royal house, Horemheb made himself Pharaoh. His own tenuous claim to the throne was based on his marriage to a sister of Nefertiti. Some historians place him as the last king of the Eighteenth Dynasty, but he could equally well be considered the first of the Nineteenth. His task was to pull all the loose threads together again, and in this he was remarkably successful. In foreign affairs he re-established Egyptian authority in a somewhat reduced Asiatic empire; at home he brought order out of chaos, rebuilt temples, reorganised trade, and rehabilitated the legal system. The effects of the Amarna interlude were eliminated so well that the king-lists of the next generations credited Horemheb with a reign which began immediately after that of Amenophis III.

Having no evident desire to found a dynasty, Horemheb groomed as his successor the man whom he made vizier of Lower Egypt. The latter became Pharaoh in about 1295BC, the first Ramesses, and generally accepted founder of the Nineteenth Dynasty. Fighting and building characterise the early reigns of this dynasty. The army now assumed real importance in the life of the country. It was a strange development. The Egyptians had always been an unwarlike people, happiest when they were allowed to cultivate their fields in peace. The vain claims of great victories repeated in royal inscriptions could have raised but a modest cheer from the mass of ordinary Egyptians.

The military posture was something of a façade. Imperial glory meant very little if it implied service in the army and exposure to the miseries of army life. In writings used in the schools of Egypt during the high days of imperial adventure, the student scribe

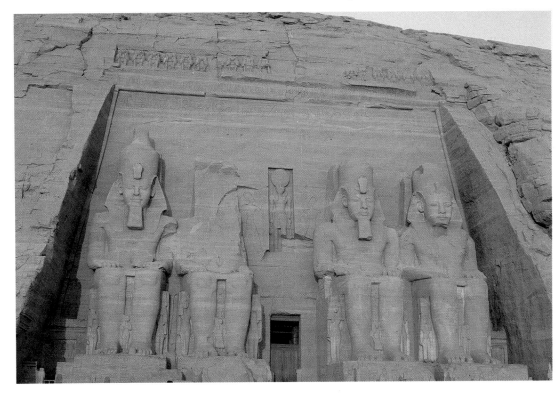

Abu Simbel at dawn, a few years before it was moved as part of the Nubian Rescue Programme. It is the greatest of the many temples and shrines built by Ramesses II in Nubia, to vaunt the fame and divinity of the Pharaoh. Four colossal figures of the King, cut from the living rock, form the façade of this monument.

writes: 'Be a scribe, so that you may be saved from being a soldier.' The ordinary soldier, of course, had little choice, following the flag from necessity.

While the native Egyptian conscript could not be expected to shine in action, the case was very different with the professionals, whether Egyptian or foreign mercenaries, who undoubtedly bore the brunt of the fighting. A high proportion of active soldiers was foreign; Nubians, Palestinians, Syrians and Bedouin were all found serving the Pharaoh, but the best fighting troops were Libyans and the so-called 'Peoples of the Sea' who made sea-borne raids on the Delta.

Infantry and cavalry were organised as separate arms, the latter being considered a cut above the former. Cavalry were employed for initial attacks against infantry and for skirmishing. When the army took to the field in strength it was organised in four divisions named after the great gods Amun, Re, Ptah and Seth. These divisions operated independently under the overall control of the general in charge of the campaign. Their manner of operation can best be seen in the actions before and during the battle of Qadesh, fought between the Egyptians under Ramesses II and the Hittites in about 1274BC. The Hittites, an Indo–European race, had settled in Anatolia, and had threatened the Egyptian Empire in Western Asia since the middle of the Eighteenth Dynasty. The threat materialised early in Ramesses' reign.

A limited expedition into Syria in his fourth year revealed to the Pharaoh the need for prompt and vigorous action against the expanding power of the Hittites. Accordingly, in the following year Ramesses mounted a full-scale campaign. He himself led with the

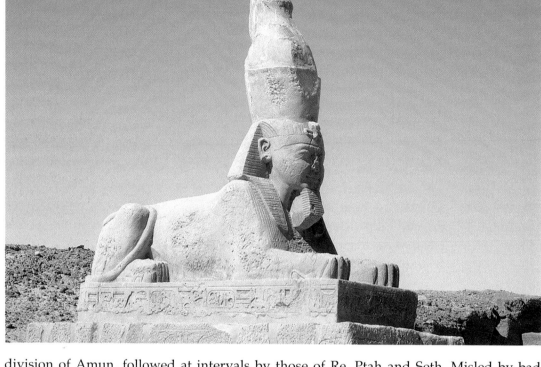

Above: The Hypostyle Hall in the Temple of Karnak, the largest and most impressive of pillared halls. Begun in the reign of King Sethos I, it was completed in that of Ramesses II, his son.

Right: Monumental sphinx wearing the double crown; one of a series forming the processional way leading to the temple of Ramesses II at Wadi es-Sebua in Nubia, another of those temples re-erected on higher ground in the 1960s.

division of Amun, followed at intervals by those of Re, Ptah and Seth. Misled by bad intelligence, and thinking that the Hittites were at Aleppo, he moved to the city of Qadesh on the Orontes where he began to set up camp. Fresh intelligence showed that the Hittites were lying in wait for the Egyptians, and Ramesses had scarcely summoned up the division of Re before the enemy attacked. A rush by Hittite heavy chariots broke the lines of the Re division when they were still on the march, and the demoralised troops fled to the camp established by the Amun division. Their panic communicated itself to the troops of the Amun division, who themselves took to their heels when the Hittites attacked the camp. Ramesses was left practically isolated with just a detachment of cavalry.

If the official boastful record is to be believed, the day was saved by the single-handed efforts of Ramesses with a little moral support from the gods. What seems to have happened is that the coastal task-force turned up in the nick of time, and was able to give the small Egyptian remnant enough support to hold out until the division of Ptah arrived. The Hittites then disengaged and withdrew. By the time the division of Seth arrived the fighting was over. Although Ramesses made much of his success in this battle, it could scarcely be counted a victory. There was nothing left to do except return to Egypt.

In mounting the Qadesh campaign, Ramesses II had resumed the activity of his father and predecessor, Sethos I, in trying to stem the onward movement of the Hittites.

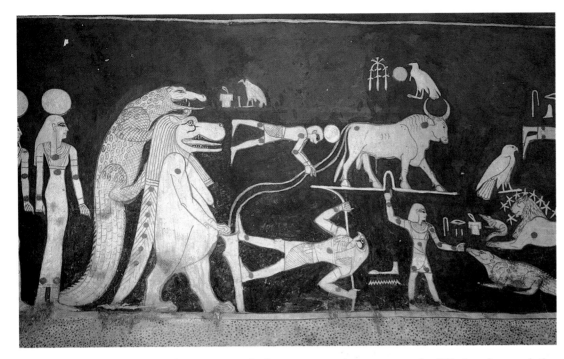

The barrel-vaulted ceiling of the burial chamber in the tomb of King Sethos I in the Valley of the Kings. The painted scenes depict part of the travels of the king through the night sky in the divine boat of the sun-god. Stars and constellations are graphically depicted.

The struggle was one of fluctuation. Sethos won a victory over the Hittites beyond the Orontes; Ramesses was less successful at Qadesh. Subsequent skirmishing between the two sides led to a treaty of peace negotiated in the twenty-first year of Ramesses II. Its provisions were cemented by the marriage of Pharaoh to the daughter of the Hittite king. For the rest of Ramesses' long reign there was peace in Asia, and indeed elsewhere on Egypt's frontiers. There had been troubles of a minor kind in Nubia during the reigns of Sethos I and of Ramesses II, but they had been put down with little difficulty. More ominous were the stirrings in Libya and the raids by the Peoples of the Sea.

When the record is examined it becomes abundantly clear that the reputation enjoyed by Ramesses II of being a mighty warrior and great conqueror is immensely exaggerated. All Egyptian kings, if they had a chance, put up inscriptions glorifying their actions. They never failed to claim success where failure occurred, and they were not beyond inventing a few campaigns to make their achievements look more impressive. But Ramesses outdid them all because he provided himself with more useful wall-space on which he could demonstrate his greatness than any other Pharaoh.

The building boom had started in the reign of Sethos I. At Karnak in the temple of Amon-Re, the greater part of the vast Hypostyle Hall was erected. Across the river in Western Thebes, a fine funerary temple was built and a splendid tomb cut in the Valley of the Kings. The reliefs and paintings in this tomb were the finest ever installed in a royal sepulchre. In character the scenes and texts are wholly conventional, but in style they owe much to the artistic revolution of Akhenaten's reign.

The decoration of Sethos' tomb was, however, eclipsed by that lavished on the great temple he constructed at Abydos. Built to a most original plan, this temple contained

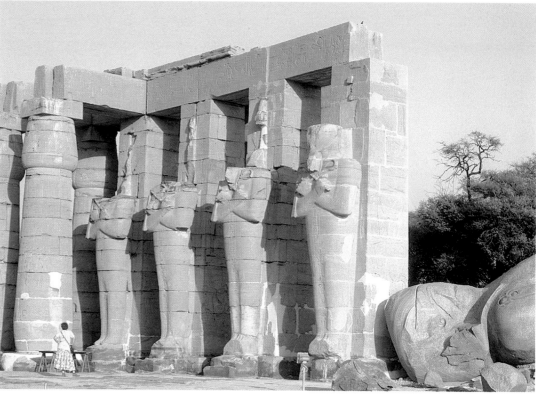

Above: Painted limestone stela made for Kha, a craftsman of the royal workmen's village at Deir el-Medina. Above King Tuthmosis IV makes an offering to Amon-Re and to Queen Ahmes Nefertari, the latter being especially revered in the village; below, Kha makes adoration to Amon-Re and Tuthmosis IV.

British Museum *(EA1515); height 51cm*

Right: The Ramesseum, mortuary temple of Ramesses II; the east side of the Second Court with a colonnade and engaged colossal figures of Osiris, and, on the right, the remains of a vast seated colossal figure of the king, originally a monolith standing over 18m high.

chapels dedicated not only to Osiris, the great local god of Abydos, but also to the other major deities of the land – Isis, Horus, Amun, Ptah, Re-Harakhty (a union of Re and Horus 'of the horizon'), and Sethos himself. The part completed by Sethos remains very well–preserved, and from it the greatness of the conception of the building, and the perfection of its execution, can be fully appreciated. It truly represents the pinnacle of Egyptian temple decoration.

In more senses than one Ramesses II continued where Sethos left off. He completed both the Abydos temple and the Hypostle Hall at Karnak. His own building projects, which must have absorbed a large part of the country's resources, greatly outdid those of Sethos. Throughout Egypt, from the Delta to Elephantine, and south to the Second Cataract, the traveller comes across great temples wholly built by this king, and others greatly enlarged or completed by him. In Karnak and Luxor he made considerable additions to the temple complexes, and in Western Thebes his funerary temple, the Ramesseum, remains a mighty monument to his memory.

Egypt's imperial presence in Nubia was reinforced by a series of temples in which Ramesses was worshipped equally with Amon-Re, Ptah and Re-Harakhty. Of these the most notable was at Abu Simbel, an extraordinary rock-cut temple with mighty colossi carved from the living rock flanking the entrance. The fame of Ramesses pervaded the land, and his vainglorious inscriptions perpetuated his dubious reputation as a conqueror.

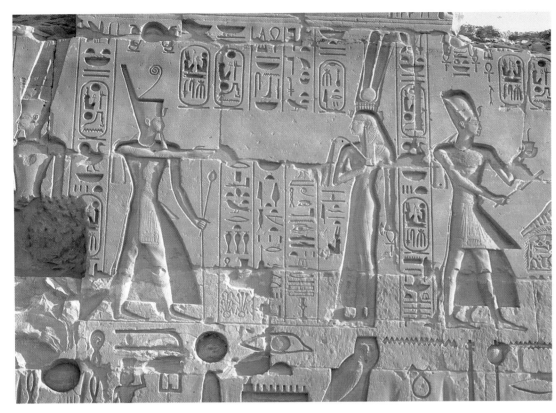

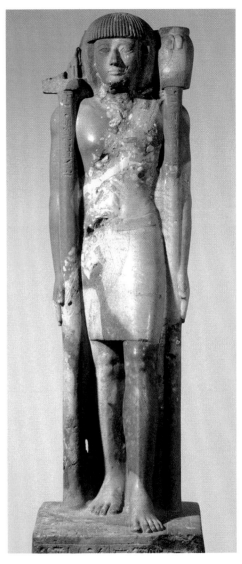

A place that particularly should have been a monument to him and his reign was the new city founded in the eastern Delta to be the northern Residence of Pharaoh. Built on, or near, the site of the Hyksos capital Avaris, it was named Piramesse, which means 'The House of Ramesses'. Here were constructed wonderful palaces, and here his high officials built fine villas. It was here that the army was based, ready for further Asiatic adventures. The beauty and nobility of Piramesse were such that the scholar scribes were given set pieces of purple prose about it to copy out. Remains of a great palace of Ramesses II have been found at a place called Qantir, and it is very likely that this was part of Piramesse. It is, however, ironical that this town of Ramesses, above all others, should have left so few visible remains. The wet Delta lands yield up their secrets very unwillingly. Much of its stonework and many great sculptures were re-used elsewhere in the Delta by later rulers who showed no reluctance whatsoever in usurping the work of the great Ramesses. Pharaohs rarely respected the monuments of their predecessors.

Ramesses II was succeeded by his son Merneptah in about 1213BC. Already quite an old man, he spent his first years carrying out the reorganisation needed after the long reign of his father. It is possible that the Exodus of the Jews took place in his reign; but there is no confirmatory evidence from Egyptian sources for this event. Then, in his fifth year, a coalition composed of various Libyan tribes and groups of the Peoples of the Sea launched a serious assault in the Western Delta. Merneptah's preparations were fortunately to some effect and the pitched battle fought at Piyer provided a resounding

Above: Statue in breccia of the high-priest of Ptah, Khaemwese, son of Ramesses II, and for a time his Crown Prince, who carried out many important works in the Memphite region.
British Museum *(EA947); height 146cm*

Left: A scene from the girdle wall around the main temple of Karnak: Ramesses II faces and greets Queen Nefertari – not his famous principal wife, but Ahmes Nefertari, greatly honoured as the 'mother' of the New Kingdom royal line.

Philistine prisoners captured in battle by the forces of King Ramesses III, depicted on the walls of his mortuary temple at Medinet Habu.

Part of the Papyrus Abbott, bearing a document dated in Year 16 of King Ramesses IX, recording the findings of a commission set up in Thebes to investigate robberies in royal and private tombs in the Theban necropolis.

British Museum *(EA10221); height 42.5cm*

victory for the Egyptians. The intention of the invaders had undoubtedly been to gain a foothold in the Delta and establish colonies, for they had brought their families with them. Although their repulse was only temporary, it took some years before a further assault could be made. It was providential for Egypt that this respite was granted because the last years of the Nineteenth Dynasty were characterised by weakness and confusion. The new dynasty, the Twentieth, founded by Sethnakhte, brought a temporary change in fortune.

In 1184BC Ramesses III became Pharaoh, and his long reign of thirty-two years was to see a remarkable revival in Egypt's greatness. Three great victories laid the foundations of Ramesses' success. In his fifth year the Libyans made another attempt to establish themselves in the Western Delta, but were utterly defeated with great losses. In his eighth year a far more serious threat developed in Asia. A confederation of the Peoples of the Sea with other tribes launched a two-pronged attack on Egypt by land and sea. Two battles were fought, one at sea, probably at one of the mouths of the Nile; once again the Egyptians successfully defended themselves.

Finally, in Ramesses' eleventh year, he was obliged to take the field against the Libyans, again with success. These victories served only to deter large-scale attempts by the Libyans to settle in the Delta. By steady infiltration in small groups they found it a simple matter to establish themselves in fairly large settlements. Like Hyksos before them, these infiltrators were eventually strong enough to gain control.

Scenes of all his victories were carved on the walls of Ramesses III's funerary temple at Medinet Habu in Western Thebes. This temple stood in a large enclosure containing a complex of buildings which included a royal palace and administrative offices for the officials responsible for the great Theban Necropolis area. Many documents written on papyrus in a bold, stylish, hieratic script have survived from this period and from the reigns of other kings of the Twentieth Dynasty, and it is likely that some may have been lodged in the archives at Medinet Habu. The great Harris Papyrus (named after Anthony Harris, its first modern owner), from the early years of Ramesses IV, contains a detailed list of the possessions of the major temples of Egypt and of the gifts made to them by Ramesses III. It provides positive proof of the concentration of wealth in the form of land, slaves and other property, in the hands of the temples. The lists in this papyrus also indicate the wealth of the country in general during Ramesses III's reign. However there were signs of difficulties before he died.

Another document from the official archive tells of a strike by the workmen engaged in the work on the royal tomb. In the time of Tuthmosis I, in the Eighteenth Dynasty, a special community was established at a place now called Deir el-Medina in Western Thebes. Here were to live the skilled workmen who had been selected to form the standing corps whose principal duty was the excavation and decoration of the tomb of the reigning Pharaoh. The community continued to exist as a close-knit group of families who jealously guarded their duties and privileges until the Twenty-first Dynasty when Pharaohs ceased to be buried in the Valley of the Kings.

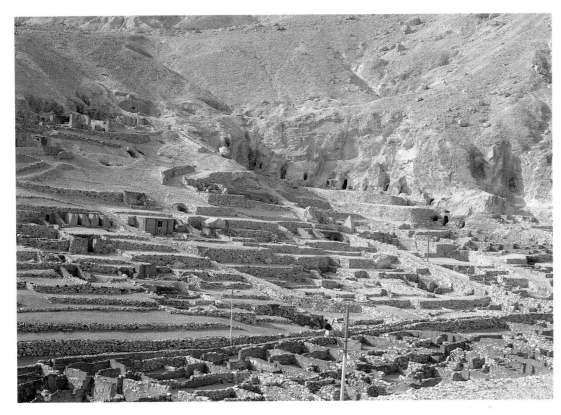

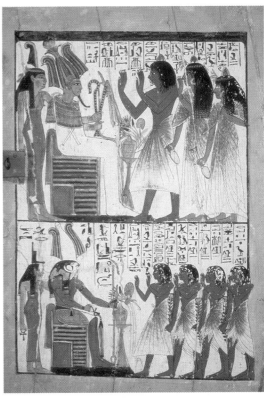

It was a highly privileged, hereditary community, looked after by the State, receiving its rations as part of its payment. It was when the system broke down that trouble began. Thus it happened in Ramesses III's twenty-ninth year that irregularities occurred in the supply of rations. Firstly the workmen downed tools and struck. When their complaints were ignored they rioted and the vizier had to intervene. The trouble was temporarily settled by an issue of half rations. Difficulties of this kind in the provision of supplies may indicate general problems over distribution within the country, or just local problems of supply in the region of the Southern capital of the land. There may also have been a partial famine.

Other documents of the period show that magic, and the exercise of practices based on superstition were common at this time, both at the highest level of government and with simple people like the workmen of Deir el-Medina. The latter were much given to appealing for advice to the deified Amenophis I who was held in great esteem in Western Thebes. Petitions were presented to the statue of the god-king when it was brought in procession at festival times. In the same way high matters of state were decided by application for oracular judgements by the gods, especially by Amon-Re of Karnak. The first recorded use of the oracle was for the confirmation of Tuthmosis III in his right to the throne. In the Twentieth Dynasty the statue of Ramesses II at Abu Simbel was used for the appointment of local officials in Nubia. Many shrines became oracular, and the practice of consulting them steadily increased. As affairs in the Theban area

Above: Painted panel on the outer face of the door of the tomb of Sennedjem at Deir el-Medina. Sennedjem, a workman who served under Sethos I and Ramesses II, is shown above with wife and daughter worshipping Osiris and Maat; below, four sons worship the necropolis deity Ptah-Sokar-Osiris and Isis.
Cairo Museum *(27303); height of door 135cm*

Left: The workmen's village at Deir el-Medina in Western Thebes. Founded in the reign of Tuthmosis I it remained in continuous occupation by the builders of the royal tombs and their families for more than 500 years. Many family tombs were constructed adjacent to the village.

King Ramesses III rides into battle in his chariot attended by his 'pet' lion; one of the many battle scenes on the outer walls of his mortuary temple at Medinet Habu.

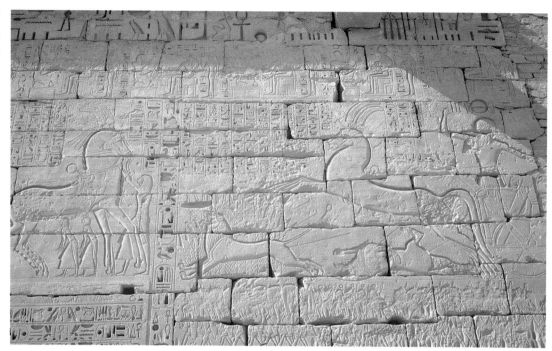

became more and more dominated by the power of the priests of Amon-Re, priestly influence pervaded all aspects of life.

From the death of Ramesses III in about 1153BC until the end of the Twentieth Dynasty eighty years later, eight Pharaohs named Ramesses ruled Egypt. Most of them prepared large tombs for themselves in the Valley of the Kings, and many made additions to the temple of Amon-Re at Karnak. They were, however, very modest monarchs. Slowly the imperial spring, last wound up by Ramesses III, began to unwind. Withdrawal from Asia may have started before the death of the last conquering Pharaoh, but it was certainly completed long before the end of the dynasty.

In the meantime the Libyans continued to infiltrate the Delta. Small principalities were established, and the Pharaoh, unable to expel the intruders, used them as mercenaries. Even at Heracleopolis in Middle Egypt a strong Libyan enclave was consolidated, and marauding bands tried their luck in the Theban area. Several documents record the calling out of the Medjay police to restore order. Other local troubles mentioned in a scribal journal were caused by bands of insurgent Egyptians. The reasons for the troubles are not specified, but a deterioration of living conditions may be surmised.

Inconsistency and confusion render the picture of this period very unsatisfactory. By the end of the dynasty, during the reign of Ramesses XI, the situation was further complicated by the virtual division of rule in Egypt between the Pharaoh, who had retired to Piramesse, his Lower Egyptian vizier, Smendes, whose seat was in Tanis, and the High Priest of Amon-Re, Herihor, who controlled Thebes. Foreigners were not slow to appreciate the opportunity which now presented itself.

*Bronze figure of a lady of high rank; originally gilded
and with inlaid eyes. Twenty-second Dynasty.*
British Museum *(EA43373); height 65cm*

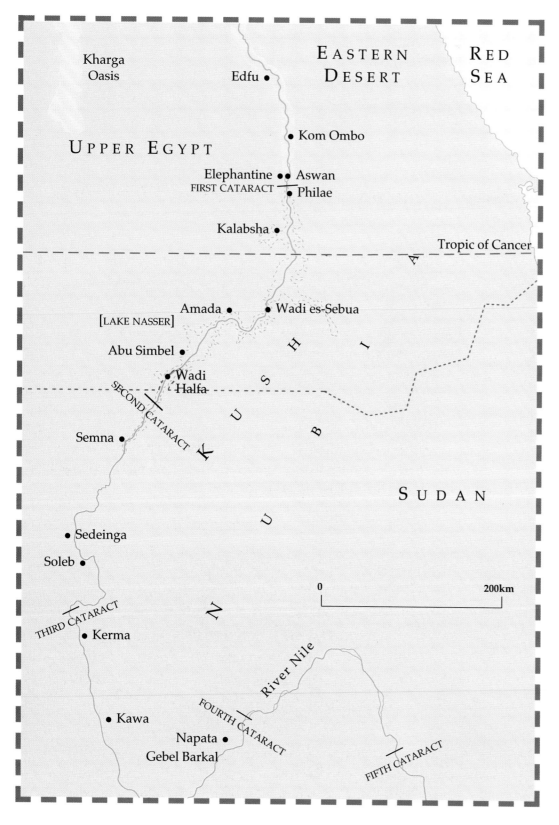

THE LATE PERIOD

Extending to the start of the Roman occupation, the Late Period begins with the Nubian kings of Dynasty XXV (also called Kushite and Napatan) who with the Saïte rulers of Dynasty XXVI presided over a remarkable renaissance in Egypt. The Persians then invaded and nominally retained control of Egypt until the arrival of Alexander the Great. Dynasty XXVII is Persian, but the last three Manethonian dynasties were native Egyptian and virtually independent of Persia.

Note: From the start of Dynasty XXVI dates are absolute. Selected kings only are listed.

Dynasty XXV *c.*747-656BC
Py (Piankhy) *c.*747-716BC
Shabako *c.*716-702BC
Taharqo *c.*690-664BC
Tantamani *c.*664-656BC

Dynasty XXVI *c.*664-525BC
Psammetichus I 664-610BC
Necho II 610-595BC
Psammetichus II 595-589BC
Apries 589-570BC
Amasis 570-526BC
Psammetichus III 526-525BC

Dynasty XXVII 525-404BC
Cambyses 525-522BC

Dynasties XXVIII-XXIX 404-380BC

Dynasty XXX 380-343BC
Nectanebo I 380-362BC
Nectanebo II 360-343BC

9: Disintegration, Renaissance and Collapse

Dynasties XXI–XXX, 1069–343BC

While Herihor was still High Priest of Amon-Re at Thebes, he sent an envoy, Wenamun, to fetch timber for the state barge of the god from the Lebanon. A report on the journey tells how Wenamun called at Tanis to report to Smendes before leaving Egypt, and how he suffered many indignities in the course of his mission at the hands of the Prince of Byblos and others. Two pieces of important information emerge from this report; firstly, that relations between Thebes and Tanis were friendly, and secondly, that Egypt's standing in Asia was at rock-bottom. There is nothing to suggest that Egyptian influence had any impact outside the country during the Twenty-first Dynasty.

After the death of Ramesses XI in about 1069BC, Smendes, the old Lower Egyptian vizier, founded the new Twenty-first Dynasty with its capital at Tanis. At Thebes the

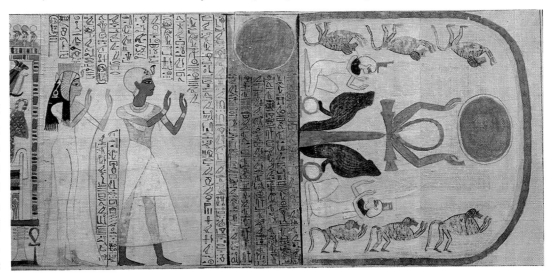

Part of the Book of the Dead *of Herihor and his wife Nodjmet. Herihor, general and high priest of Amun at Thebes, assumed royal titles after the death of Ramesses XI. Here the two semi-royal persons are shown adoring the sun-god Re, represented on the right in an elaborate symbolism, supported by Isis and Nephthys, and worshipped by six baboons.*
British Museum *(EA10541); height 34.6cm*

129

Above: The beginning of a complete papyrus roll written in hieratic with chapters from the Book of the Dead, *for the high priest of Amun Pinudjem II, who is here shown presenting incense and water to Osiris. Unlike his predecessor Herihor, Pinudjem is not depicted with the trappings of royalty.*

British Museum *(EA10793); height 33cm*

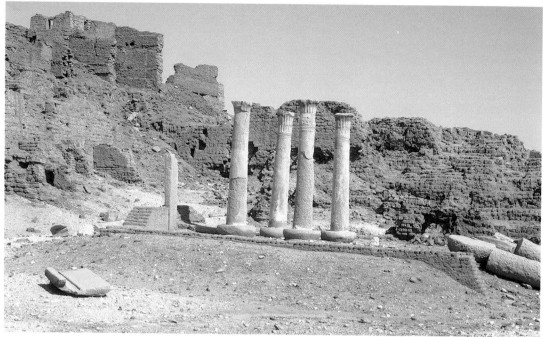

Right: Limestone columns marking the house of Butehamun, scribe of the Tomb and a senior administrative officer in Western Thebes during the late Twentieth and the Twenty-first Dynasties. It is sited in the official quarter within the enclosure of the Medinet Habu temple. Most of the house would have been built of mud-brick.

State of the god Amon-Re, already well-established under Herihor, became virtually an independent realm ruled over by the High Priests of the god, who served in hereditary succession. The friendly relations revealed by Wenamun's report seem to have been maintained throughout the dynasty, and indeed improved from time to time by marriages between the High Priests and daughters of the Tanite Pharaohs.

The real enemy for both sides, forming a common bond between them, was the powerful Libyan principality established in the neighbourhood of Heracleopolis. To protect the Theban territory from attacks from this principality, the High Priest, Pinudjem I, began the construction of a huge fortress at Teudjoi in Middle Egypt. Meanwhile, control of Nubia had been lost, and the Theban territory was reduced to approximately the size of its predecessor in the First Intermediate Period.

Among the domestic affairs which engrossed the High Priests was the condition of the burials of the kings of the New Kingdom. During the last reigns of the Twentieth Dynasty it became known that some of the royal tombs had been broken into and robbed. A commission of enquiry set up to examine the tombs found that some had been violated. Extensive investigations, which were partially successful, led to the apprehending of many of the tomb robbers. Records of some of the resulting legal actions reveal a great deal about Egyptian procedures in the examination of witnesses and the general administration of justice. They also show that there was considerable want and misery in the land, driving simple artisans to desperate acts of desecration. The lively actions of the civil authorities in dealing with this problem did not, however, deter the robbers, and by the early Twenty-first Dynasty most of the royal tombs at Thebes had been broken into. Some spoliation may have been officially arranged.

Gold, silver and precious ointments were the objects of the robberies, not human remains. Many of the pillaged bodies were re-wrapped by the High Priest rulers of Thebes. Those which were so rescued, including many of the truly great rulers of the Eighteenth, Nineteenth and Twentieth Dynasties, were placed in an old tomb near Deir el-Bahri, and in the tomb of King Amenophis II in the Valley of the Kings. In these two places they rested undisturbed until the late nineteenth century when the caches were rediscovered, the former by modern tomb-robbers, the latter by archaeologists.

The circumstances under which the Twenty-second Dynasty succeeded the Twenty-first are obscure. From about 945BC the northern part of Egypt was ruled by a king of a new royal house whose origin was Libyan. This king, Sheshonq I, may have been elevated to the highest position by a coalition of Libyan princelings, or he may have moved by himself to fill a vacuum after the death of Psusennes II, the last king of the preceding dynasty. The new line sprang from Bubastis in the south-eastern Delta, but Tanis continued to be used as the capital. Although Libyan in origin, the new kings were content to continue the old Pharaonic traditions, and, like the Hyksos, were assiduous in

A view into the Valley of the Kings, the royal burial ground at Thebes for more than 500 years. It is dominated by the pyramid-shaped peak, El-Qurn, a sacred 'presence' overseeing the Valley and its precious burials.

Colossal statue of Ramesses II wearing the double crown and holding the symbols of royalty, with a wife or daughter at much smaller scale standing between his feet. This figure was first usurped by Ramesses VI, and then by Pinudjem I, high priest of Amun in the early Twenty-first Dynasty, who also assumed royal titles. It has been reassembled from fragments and placed in the first court of Karnak Temple.

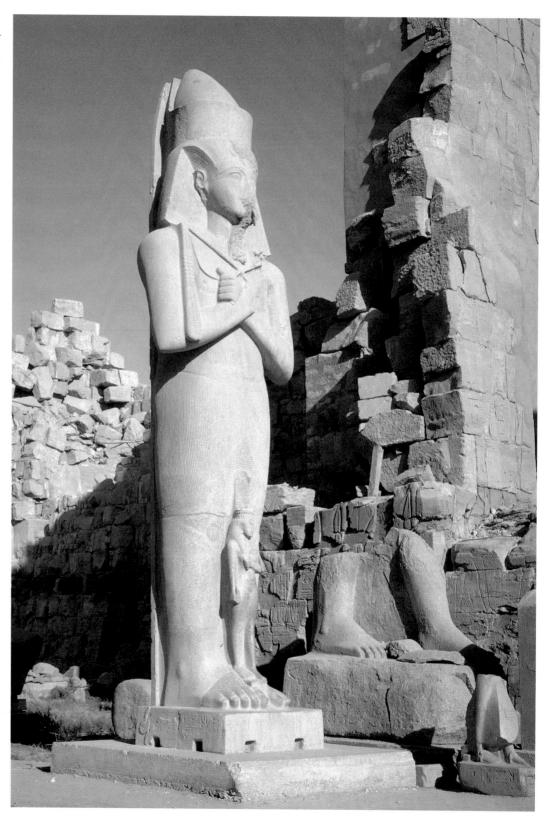

fostering a truly Egyptian image of themselves. The division of the land continued, but Sheshonq ensured that he would have some say in the affairs of the divine state of Amon-Re at Thebes by naming his own son as the new High Priest. The practice was followed by later Pharaohs of the dynasty.

Late in his reign Sheshonq began a large building programme in the temple of Amon-Re at Karnak, of which only the great gate was completed in his lifetime. This Bubastite Portal bears some record of a campaign conducted by Sheshonq against Palestine, in the course of which he carried off treasures from the temple in Jerusalem. The biblical account of the affair, in which the Pharaoh is named Shishak, suggests that the campaign may have been launched in support of Jeroboam, a pretender to the throne of Judah, who had fled in exile to Egypt. Another text on the Bubastite Portal, inscribed by the High Priest Osorkon, the eldest son of Takelothis II, provides an idea of the troubled conditions which prevailed in Egypt throughout this period.

As the dynasty advanced the Theban state of Amon-Re acquired even more formal independence. The High Priests were now not only the religious heads of the southern state, but also the chief officers of the administration and the army. Because of the constant threat from insurgent elements the High Priest frequently took up residence at the fortress of Teudjoi. Prince Osorkon, however, found to his cost that absence from Thebes did not make for peace in the capital. Twice during the reign of Takelothis II he was obliged to put down serious civil disturbances. A further outbreak of trouble led to his loss of office. Later, in the reign of a new king, Sheshonq III, Osorkon retrieved his position as High Priest, and he was still in office in that king's twenty-ninth year.

The disturbed state of the country can only be partially surmised from brief statements contained in texts like that of Osorkon. The Pharaohs of what may be termed the legitimate line ruled and lived in Tanis; they were also buried at Tanis in rather mean sepulchres with modest funerary equipment. Their control, however, was very imperfect, and a rival dynasty (the Twenty-third by Manetho's reckoning) established itself at Leontopolis in the Delta under a ruler called Petubastis. The lack of a strong central authority led to the disintegration of the country into small units. It is impossible to say how many principalities existed contemporaneously at this time, but the names of many ephemeral rulers have survived. It is probable that the land was in a state of flux for almost 100 years. Consequently the period between the Twentieth and the Twenty-fifth Dynasties is now usually termed the Third Intermediate Period.

The ultimate rescue of Egypt from its chaotic state was effected by a conqueror who came from a most unexpected direction. Napata in Nubia, the town near the Fourth Cataract of the Nile founded by Tuthmosis III in the Eighteenth Dynasty, had become the capital of a native state, the rulers of which were passionately devoted to the worship of Amun. For reasons which remain obscure, but which may have included an element of pro-Amun evangelism, the ruler of Napata intervened in Thebes in about 740BC. It used to be thought that the Nubian king who took the initiative was Kashta, but it is now generally believed that it was actually his son Py (Piankhy). An early act in

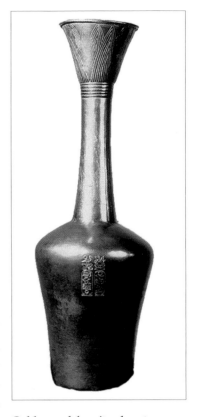

Gold vessel for ritual water, inscribed for King Psusennes I of the Twenty-first Dynasty; from the unrobbed tomb of the king in the temple enclosure at Tanis in the Delta, capital city of the kings of that dynasty.
Cairo Museum *(85892); height 38cm*

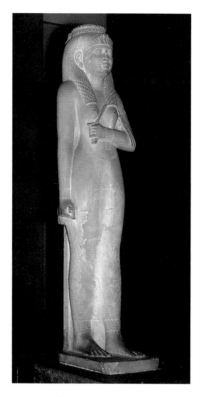

Above: Alabaster statue of Amenirdis, sister of Py, the Nubian founder of the Twenty-fifth Dynasty. He arranged for her to be adopted by the incumbent God's Wife of Amun at Thebes, so ensuring that in due course she would become the priestess ruler of the Theban principality. Found in Karnak.
Cairo Museum *(565); height 170cm*

Right: Great alabaster table used in the Twenty-sixth Dynasty for the embalming of the sacred Apis bull at Memphis. After mummification was completed the interment took place in the catacomb at Saqqara, now called the Serapeum.

Py's campaign was the adoption of his sister Amenirdis as heir by the influential God's Wife of Amun. The office of God's Wife of Amun was held by a woman of the highest rank, who became in most senses the ruler of the priestly state of Amun at Thebes. Py made his major move against Egypt in his twentieth year (about 726BC).

His invading army had little difficulty in reducing most of the land of Egypt. Of the opposing princelings the most energetic was Tefnakhte, who had established a dynasty in the Delta which was later dignified by being numbered Twenty-fourth. Tefnakhte was forced to yield to Py, but was allowed to continue ruling in a reduced domain. Py, it seems, had no desire to control Egypt from Thebes, and he retired to Napata for the remainder of his reign. Shabako, who succeeded him in 716BC, finally conquered the whole country, slaying Tefnakhte's successor, Bocchoris.

Under the Kushite (Nubian or Napatan) Pharaohs of the Twenty-fifth Dynasty a kind of renaissance began which was to continue, with one temporary set-back, for almost 200 years. They seem to have chosen Memphis as their capital, although the evidence on this point is not conclusive. What is certain, however, is that they spent much time in the north of Egypt, and did much to foster the worship of Ptah and the traditions of his cult in Memphis. It is probable that peaceful conditions in the Delta were maintained only with difficulty. In Thebes rule was in the hands of the God's Wife who now, in terms of power, eclipsed the High Priest of Amon-Re.

In the stimulating climate engendered by the new dynasty the arts flourished, particularly those of relief-carving and sculpture. For centuries the work produced by

Egyptian artists had been coarse and heavy. The reliefs in a great temple like that of Ramesses III at Medinet Habu were crudely finished; the scenes in tombs lacked the beauty of line and mastery of composition found in the tombs of the earlier New Kingdom; sculpture was mostly undistinguished, devoid of inspiration, and competent only in the most formal sense. Although the inherent conservatism of Egyptian art somehow enabled artists to produce fair, if commonplace, work during the uninspiring centuries of decline, scarcely anything of real merit, in stone sculpture at least, was produced from the mid-Twentieth Dynasty until the Twenty-fifth Dynasty. Some fine objects were found in the Tanite tombs of the kings of the Twenty-first and Twenty-second Dynasties, particularly metal vessels and coffins, and jewellery; at the same time splendid cast bronze figures and fine glazed composition pieces were also made.

Mortuary chapels of God's Wives of Amun of the Twenty-fifth and Twenty-sixth Dynasties, built in the precinct of the temple of Medinet Habu. Left is that of Amenirdis I; right, that of Nitocris, Shepenupet II and Mehytenuskhet (wife of King Psammetichus I and mother of Nitocris).

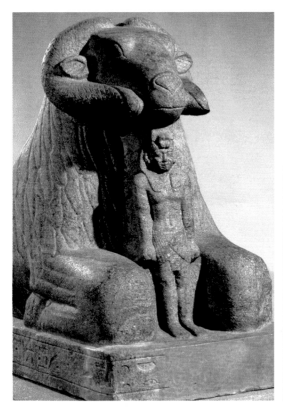

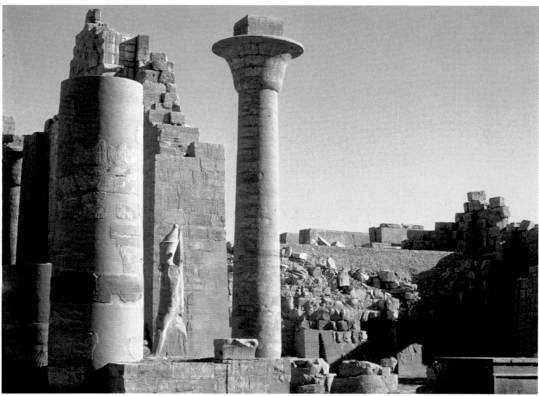

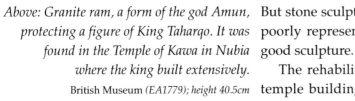

*Above: Granite ram, a form of the god Amun,
protecting a figure of King Taharqo. It was
found in the Temple of Kawa in Nubia
where the king built extensively.*

British Museum *(EA1779); height 40.5cm*

*Right: View of the front court of the Temple of
Karnak showing the surviving parts of a great
kiosk built in front of the Hypostyle Hall by
King Taharqo, and restored by later Pharaohs.
Only one of the ten monumental papyrus
columns could be reconstructed.*

But stone sculpture, always the glory and the index of achievement in Egyptian art, was poorly represented. The right kind of circumstances was essential for the making of good sculpture.

The rehabilitation of the State of Amon-Re of Thebes was accompanied by some temple building at Karnak, especially by the Pharaoh Taharqo. In addition, greater opportunities were available to nobles and senior officials for the placing of personal sculptures in temples, through which they could participate in the offerings to the gods. The sculptural forms which predominated for private votive purposes usually possessed suitable surfaces for the reception of inscriptions. The most favoured forms were the squatting figure, the block statue, in which the subject is shown seated on the ground with knees drawn up close to the body, and the kneeling figure, often with a shrine held in front of the body.

The change in emphasis in statuary which followed from its greater use for votive purposes resulted in another significant development: the idealised representations of subjects became less common. Attempts were made to render the head of a subject in a more realistic, but not necessarily life-like, way. There can be little doubt that these early efforts at a kind of portraiture, significantly developed in the Twenty-sixth Dynasty, had a great effect ultimately on classical portrait sculpture. Within the standard conventions the body was also treated with great sensitivity. The artistic dividends of this period are at last achieving adequate appreciation.

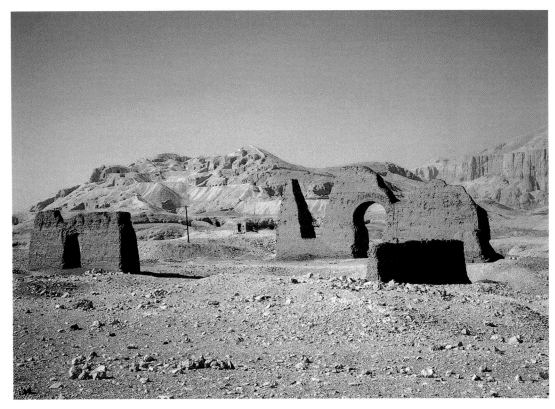

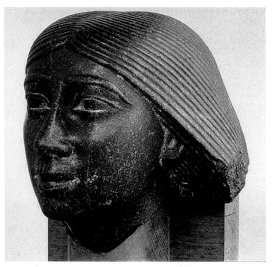

Above: Granite head of an unnamed but important official, found in the Temple of Mut in Karnak. It is based on sculptures of the Fifth Dynasty, reinterpreted in the Twenty-fifth Dynasty, and carved with greater realism than its Old Kingdom prototypes.

British Museum *(EA67969); height 17.5cm*

Disaster unhappily struck the resourceful régime of the Twenty-fifth Dynasty in the last years of Taharqo. Esarhaddon, the conquering Assyrian king, made a determined assault on Egypt, and in 671BC. temporarily installed himself in Memphis. About two years later Taharqo succeeded in reasserting his authority in the north, but in 667BC the Assyrians returned, this time under Ashurbanipal. When Tantamani succeeded Taharqo in 664BC he had a limited success against the Assyrians, but eventually succumbed to Ashurbanipal who had managed to reach Thebes. Tantamani withdrew to Napata and never returned to Egypt. So ended the Napatan excursion into Egyptian affairs, which had lasted about seventy-five years.

Left: Remains of the mud-brick pylon and other structures above the tomb of Mentuemhat, mayor of Thebes in the seventh century BC. It was constructed in an open area in front of the Deir el-Bahri temples on a lavish scale and decorated with fine reliefs which drew some of their inspiration from tombs of earlier periods.

Meanwhile at Thebes the Assyrians had found the God's Wife Shepenupet II in control, ably assisted by Mentuemhat, mayor of the city, whose influence was immense. Between them they managed to maintain a fairly stable régime in the southern part of the country. They apparently offered no resistance to the Assyrians, and Ashurbanipal carried off a great quantity of booty to Nineveh (near Mosul in modern Iraq). He also took away as captives a number of princelings who had established themselves in small principalities in the Delta and Middle Egypt.

Among these princelings was Necho who came from Saïs in the Delta. In some way he ingratiated himself with Ashurbanipal and was allowed to return to Saïs. The Assyrians controlled Egypt through local rulers like Necho, but do not seem to have intervened actively themselves. Taking advantage of this state of loose control, the son of

Monumental inscription recording part of the history of the campaign in Nubia by King Psammetichus II in 591BC. The text is laid out mostly in vertical columns after the manner of the Old Kingdom, and in accordance with the antiquarianism of the Saïte Period. It now stands by the Temple of Kalabsha, near the High Dam south of Aswan.

Necho, Psammetichus, the local ruler at Athribis in the southern Delta, began to assert his influence over his neighbours. With the help of Ionian and Carian mercenaries he won control of most of the northern part of Egypt. In 654BC. he reunited the whole land by securing the adoption of his daughter, Nitocris, by Shepenupet II at Thebes.

Under the kings of the new Twenty-sixth or Saïte Dynasty, the renaissance of the previous dynasty picked up strength, and a wonderful period of prosperity began, affecting all aspects of life. Not the least reason for this prosperity was the growing influx of foreigners into Egypt. In the neighbourhood of Memphis there were many settlements of foreigners, in particular Carians. As far south as Elephantine there was a large and flourishing Jewish colony. Among the most influential immigrants were the Greeks. They came principally to trade, although they were subsequently much used as mercenaries. The most important Greek settlement was at Naucratis in the Delta, not far from Saïs. It was founded by Psammetichus I, but its real importance dated from about 550BC, in the reign of Amasis, who enacted that Greeks were allowed to trade freely only from Naucratis. It was also the only pre-Ptolemaic city in Egypt to strike its own coinage.

Pride in the revival of Egyptian power was reflected in an unusual interest in earlier periods of the country's history. This antiquarianism can be seen in religion and in artistic forms, and also in a kind of curiosity in the past which was generally rare in the ancient world. Some famous structures were restored; others were investigated to provide material for reproduction. Temple and tomb reliefs of earlier times were copied, as were the religious texts found in the ancient tombs, including close adaptations of the *Pyramid Texts*, otherwise found only in the royal sepulchres of the Old Kingdom. Similarly the Saïte nobles aped their distant ancestors by assuming titles and dignities held in such profusion by royal officials in the Fifth and Sixth Dynasties. In sculpture, too, old types of statuary were revived, not only those of Old Kingdom times, but also others from the times of the Middle and New Kingdoms.

The success of the Saïte Pharaohs in domestic matters encouraged and enabled them to take a greater interest in foreign affairs than any group of Egyptian rulers for several centuries before them. To this end, as well as for sound commercial reasons, Necho II developed a navy and an active maritime policy. Initial excursions by land into Asia were successful, as in 606–605BC when Necho II defeated Josiah, King of Judah, at Megiddo. But a clash with the Babylonians became inevitable. In 605BC an Egyptian army was decisively beaten at Carchemish by Nebuchadrezzar (the Biblical Nebuchadnezzar).

Psammetichus II turned his attention to Nubia and sent south a great expedition, the outcome of which was the decisive checking of Kushite northerly ambitions. Apries, who succeeded him, enjoyed some small triumphs in Syria, but failed badly in an effort to help the Libyans eliminate a Greek colony at Cyrene. This disaster ruined him. He was succeeded by Amasis who seems not to have been directly of the royal line. In a long and sparsely documented reign Amasis concentrated on home affairs, promoting trade and restoring temples. His diplomatic master-stroke in confining Greek trading

activity to Naucratis was, it seems, characteristic of his political skill. After forty-four years he died, only just in time to avoid the calamity which overtook Egypt in the first year of his successor, Psammetichus III.

During the reign of Amasis supreme power in Western Asia had passed into the hands of the Persians, whose victories brought them ever closer to Egypt. In 525BC their armies under Cambyses defeated an Egyptian army at Pelusium in the north-eastern corner of the Delta. The Persian kings of the Twenty-seventh Dynasty controlled Egypt for over a century, treating the land as a *satrapy* (province) of their empire. As administrators the Persians earned a great reputation for their work in re-codifying the laws of Egypt, and in undertaking great buildings and important public works.

The initial stretch of an avenue of sphinxes which once led from the Temple of Luxor to the Temple of Karnak, now mostly destroyed or buried beneath the town of Luxor. The sphinxes here represent King Nectanebo I of the Thirtieth Dynasty.

Above: Perfume bottle in the form of a hedgehog, made of faience in a style commonly called Naucratite, after the Greek city of Naucratis in the Delta. It is now known that such pieces were made not only at Naucratis, but at many other places in the Eastern Mediterranean.

Private collection; *length 6.8cm*

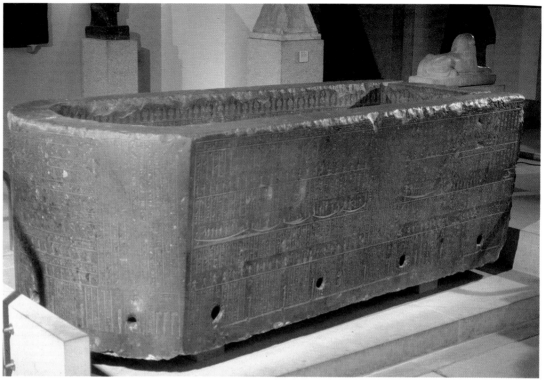

Right: Breccia sarcophagus of King Nectanebo II, last native ruler of Egypt in antiquity; inscribed with parts of The Book of what is in the Underworld. *Found in Alexandria, it was once thought to be the sarcophagus of Alexander the Great.*

British Museum *(EA10); length 314cm*

There was, however, much unrest in the land, the sketchy records of the period containing many references to uprisings and plots, in which the native Egyptians were often assisted by Greeks. The Twenty-eighth, Twenty-ninth and Thirtieth Dynasties were all of a somewhat ephemeral character, and their rulers seem never to have been wholly free from Persian interference. As a distant satrapy Egypt avoided direct Persian rule, and for short periods the so-called native Pharaohs were undoubtedly able to conduct themselves with some pretence of royalty. Nectanebo II, the last king of the Thirtieth Dynasty, in fact managed to survive for seventeen years, and even to construct temples. In the end he was obliged to flee into exile in Nubia when Artaxerxes Ochus made certain of Egypt by a determined campaign in 343BC.

Bronze figure of the cat-goddess Bastet,
attended by kittens.
British Museum *(EA25565); height 27cm*

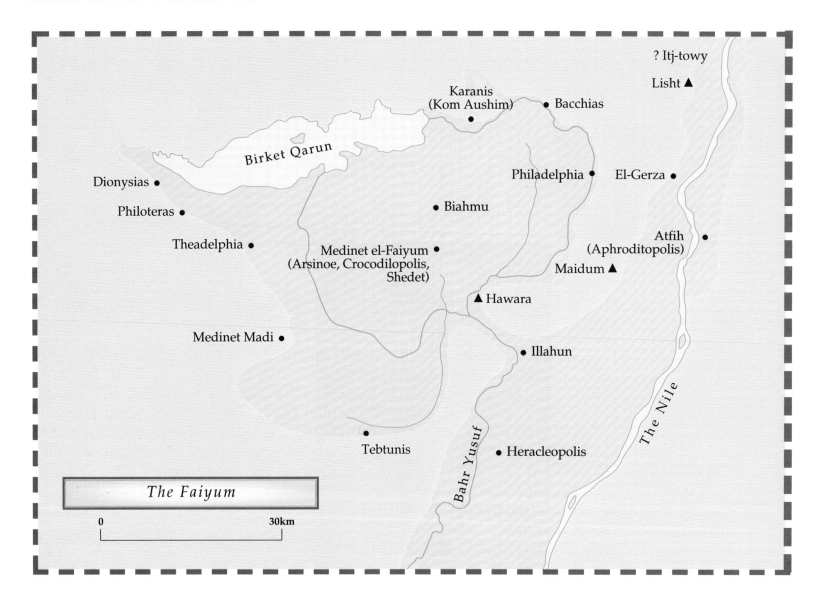

? Itj-towy

Lisht ▲

Karanis
(Kom Aushim)

● Bacchias

Birket Qarun

Dionysias ●

Philadelphia ● El-Gerza ●

Philoteras ●

● Biahmu

Theadelphia ●

Atfih ●
(Aphroditopolis)

Medinet el-Faiyum ●
(Arsinoe, Crocodilopolis,
Shedet)

Maidum ▲

▲ Hawara

Medinet Madi ●

● Illahun

Bahr Yusuf

The Nile

Tebtunis ●

● Heracleopolis

The Faiyum

0 30km

THE PTOLEMAIC PERIOD

The reassertion of power by the Persians after the death of the last native Pharaoh, Nectanebo II, did not last long. Alexander's arrival in Egypt in 332BC marked the end of the country's independence. After his death Egypt remained a province of the Macedonian empire and the Macedonian king was acknowledged as Pharaoh. Eventually Ptolemy, the Macedonian satrap of Egypt, declared himself Pharaoh instituting the Ptolemaic Dynasty, which ruled Egypt as a quasi-Greek state very successfully until the country was absorbed into the Roman Empire under Augustus.

Note: Selected rulers only are listed.

Persian kings 343-332BC

Macedonian kings 332-305BC
Alexander the Great 332-323BC
Philip Arrhidaeus 323-317BC
Alexander IV 317-311BC

The Ptolemies 305-30BC
Ptolemy I Soter 305-282BC
Ptolemy II Philadelphus 282-246BC
Ptolemy III Euergetes 246-222BC
Ptolemy IV Philopater 222-205BC
Ptolemy V Epiphanes 205-180BC
Ptolemy VI Philometor 180-145BC
Ptolemy IX Soter II 116-107BC
Ptolemy XII Auletes 80-51BC
Cleopatra VII Philopator 51-30BC

10: The King's Estate
Ptolemaic Egypt to the Roman Conquest, 332–30BC

For ten years the Persians held sway in Egypt. It was a troubled period in which the native Egyptians scarcely tolerated their foreign rulers. The writer of the *Demotic Chronicle* describes the condition of the land in terms which recall accounts of Egypt during the First Intermediate Period. It is probably true that the Egyptians greeted the arrival of Alexander the Great in 332BC with joy. He came fresh from his triumphs over the Persians in Asia Minor, and in Egypt he seems to have acted in an exemplary manner. In Memphis he made sacrifices to the Apis bull and to other Egyptian gods; he held games in the Greek fashion, and then he paid a visit to the famous temple of Amun at Siwa to the east of the Delta. Here the priests in charge of the

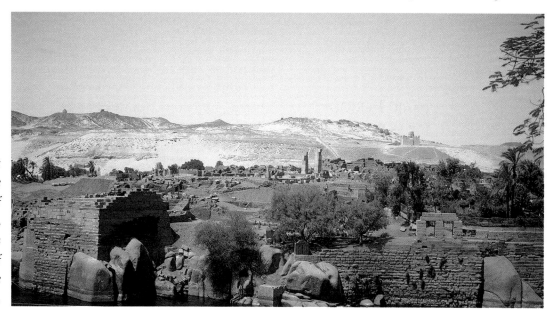

View of Elephantine from Aswan: in the right foreground the ancient Nilometer, to the left the Roman quay. Above, in the centre, the temple of Khnum, ram-headed god of the Cataract Region, here marked by the granite gateway which is inscribed for Alexander IV of Macedon, son of Alexander the Great, who may never have visited Egypt; he died in 311BC.

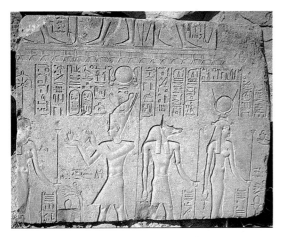

Above: Granite block from the temple of Isis at Behbeit el-Hagar in the Delta, begun in the Thirtieth Dynasty, but completed by Ptolemy II Philadelphus a century later. Here Ptolemy (left) offers incense to Seshat, goddess of writing; on the right, Isis and Anubis receive similar offerings from the king whose figure is lost.

Right: Remains of a temple in the town of Karanis (Kom Aushim) dedicated to the local crocodile gods Pnepheros and Petesuchos. Karanis is the best preserved of the many towns founded by the Greeks in and around the Faiyum.

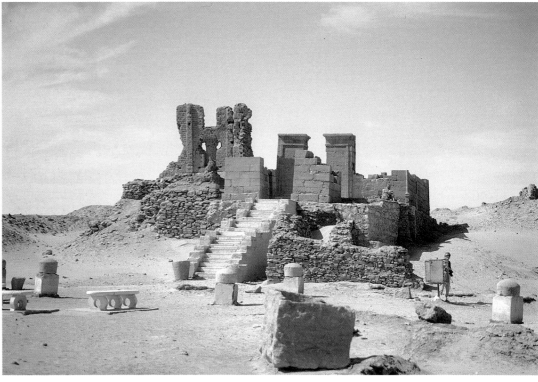

oracle clearly did their best in the Egyptian tradition to answer the questions he posed. It is certain that his treatment in Egypt helped him to formulate his conception of the divine king. He had perhaps not been fully briefed by his advisers about the traditional nature of the Egyptian kingship. The Pharaoh was always divine; Alexander, the new Pharaoh, and accepted as such by the Egyptians, became at once divine. During his short stay in Egypt he also founded the city of Alexandria, his most lasting monument in the country.

In the confusion which followed Alexander's death in 323BC Egypt fell under the control of Ptolemy Lagus, one of the dead king's bodyguards. With commendable foresight he carried off the royal body and buried it at Memphis. It was later removed to a great, and so far undiscovered, mausoleum in Alexandria. In the lifetimes of Alexander's brother and of his young son, Alexander, Ptolemy Lagus ruled Egypt as a satrapy, but in 304BC, after young Alexander's death, he declared himself Pharaoh, taking the epithet Soter (Saviour), and founding the Ptolemaic Dynasty. He and his immediate successors were immensely energetic rulers who established a strong, prosperous, and, at first, enlightened administration.

The Ptolemies, however, were not content to become Pharaohs in the traditional form. They had something new and of great benefit to contribute to the country. Although they were by race Macedonians, they had been educated as Greeks, and their court, first at Memphis and later at Alexandria, was Greek in culture and in outlook. Greek became the official language – not Macedonian Greek, but the *koine*, a widely spoken form of the

language which had developed in the Eastern Mediterranean world from Attic Greek. The Hellenistic influence was spread not only through the administration by the appointment of senior Greek officials to all high offices, but also by the settlement of Greek soldiers in all parts of Egypt. Thus small Greek enclaves were to be found throughout Egypt, containing privileged persons, owning land by grant from the king, free from the regular post-inundation conscription, but liable for military service. One wholly Greek city was founded in Middle Egypt by Ptolemy Soter; it was called Ptolemais.

During the Ptolemaic Period policy was much advanced by the intelligent use of land. Since time immemorial the whole of Egypt had been considered the king's estate, but in later periods the emphasis on ownership had become blurred. In Ptolemaic times the concepts of ownership were tightened up, and the idea of the king's estate became one which was thoroughly exploited. The mass of detail on land-ownership which suddenly becomes available is obtained from the many papyri which have survived from this period. Some are written in demotic, the latest and most cursive form of the Egyptian script, but most are in Greek.

Such documents provide much information about land; about the tenants who worked the land that was actually retained for the king's private estate; about the temple lands, administered on behalf of the temples by royal agents; about land relinquished to private persons which became, in effect, privately owned; and about land granted to mercenaries. The cultivated area of the country was much increased, and large tracts of poor land improved. Egypt was possibly never better organised agriculturally in antiquity. In addition, vines were planted widely, and the culture of olive trees was encouraged. Stock on farms was also improved, and new animals like the camel were introduced.

By using the old system of nomes as the basis of local administration, employing Greeks in the offices of nomarchs and of *strategos*, the Ptolemaic Pharaohs kept a close control over all aspects of Egyptian life. The nomarch was employed chiefly as a local financial officer, while the *strategos* became the most important provincial officer. Initially the latter was appointed to be in charge of the troops and militia in the nome, but as time passed he acquired many other administrative and financial functions. There was much more to administer because Egypt, the king's estate, was run on business lines.

The introduction of a properly based monetary system greatly facilitated the organisation of the business life and agriculture of the country. Barter, which had been the essence of trade in Egypt for thousands of years, was inexact and clumsy, and quite unsuitable for a developed economy. Even banks were now established, through which paper transactions could be made. It was to be, however, a very long time before barter was eliminated from business life, even at a high level.

The revenue from the king's estate was further enhanced by the use of royal monopolies on a whole series of important commodities. Banking, oil-production, and linen-production were among the principal monopolies, but similar control was

Bronze figure of an ichneumon ('Pharaoh's rat') the top of a ritual staff. Its haunts were in the marshes of the Delta, and it had associations with several Egyptian deities, particularly Uadjet, the cobra goddess, protectress of the King of Lower Egypt; also with the Sun-god Re.

British Museum *(EA29601); height 18.3cm*

One of the tombs of Ptolemaic and Roman times at Tuna el-Gebel in Middle Egypt, the necropolis area for the city of Hermopolis (Ashmunein), cult centre of Thoth, whom the Greeks knew as Hermes. The architecture of the tombs is eclectic, but mostly based on traditional Egyptian temple building.

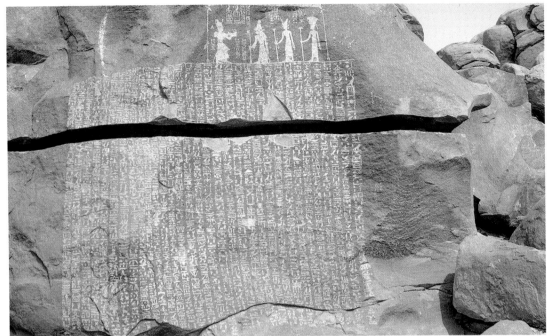

exercised over other products, such as salt, perfume, beer and wine. The king granted monopolies to specified agents who exercised them on their own behalf after payment of a substantial premium to the state.

Agents and middlemen flourished in Ptolemaic Egypt. Apart from tax-collection, banking, and the administration of monopolies, they were also deeply involved in foreign trade and the organisation of ports. The Greek genius for business, which had been recognised in Egypt for centuries, and had obliged Amasis to confine Greek trading activities to Naucratis, now had unlimited opportunities. With trade came much else, and Alexandria, the Ptolemaic capital and chief port, also became a centre of culture and learning. Planned on a generous scale, unburdened by ancient buildings, the city was a remarkable expression of the prosperity and grandeur of Ptolemaic Egypt. There were wide streets, great squares and fine buildings. Its citizen body was cosmopolitan, un-Egyptian, outward-looking. From the sea its symbol was the lighthouse on Pharos; on land its symbols were many – sentimentally, the tomb of Alexander, politically, the royal palace, and culturally, the Museum and Library.

The Library developed as an adjunct to the Museum, which was founded as a kind of university where scholars could live, teach, and carry on their researches. The congenial atmosphere of this extraordinary institution drew learned men from all parts of the Greek world. Apart from experimental work in the natural sciences, the Alexandrian scholars purged the texts of the great writings of Greek literature, producing versions free from the corruptions of time and the errors of oral transmission. It is not surprising that the ruins of the Ptolemaic and Roman communities in Egypt have yielded so many copies of Greek literary works written on papyrus.

Above: Schist stauette of the priest of Khonspakhered, Unnefer, shown holding a figure of the god. This deity, 'Khons-the-child', was worshipped specially in a temple within the precinct of the Karnak Temple. This finely carved figure is of early Ptolemaic date.
British Museum (EA55254); *height 56.5cm*

Left: The 'Famine' stela carved on a smoothed rock face on the Island of Siheil, south of Aswan. It carries a fantasy text dated to Year 18 of King Djoser of the Third Dynasty, but composed in the Ptolemaic Period. It deals with the steps taken by Djoser to alleviate the effects of serious famine in Egypt by placating the gods of the Cataract Region.

Above: One of the bays in the Serapeum at Saqqara containing a granite sarcophagus for a mummified Apis bull. This great subterranean system of corridors and burial bays remained in use until the Ptolemaic Period.

Right: A relief scene in the Temple of Kom Ombo in Upper Egypt. Doubly dedicated to the gods Haroeris (Horus-the-Elder) and Sobk, this temple was begun in the Ptolemaic Period. Here Haroeris offers multiple Sed-festivals to Ptolemy VIII Euergetes II; to the right Sobk receives the king (not shown) into his presence.

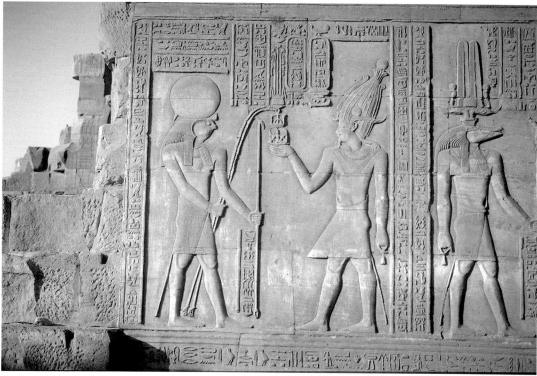

In all that has been said so far about Ptolemaic Egypt, there has been little to suggest that much was done to conciliate the native population. The Pharaoh was Macedonian-Greek; the administration was run by Greeks; the official language was Greek; the capital was no longer an Egyptian city; and Greek culture was rapidly gaining ground. Yet, in spite of the dominance of things Greek, the régime was entirely Egyptian in the sense that it was of the country, and owed no loyalty to any other land. The Ptolemies and the Greeks who had come with them were not the representatives of an external imperial power. They had come as settlers, intending to stay and to put down roots. But the nature of the culture they brought with them was, for them, so superior to what they found that they had no hesitation in imposing it on Egypt. There is nothing, however, to suggest that positive steps were taken to suppress aspects of Egyptian life which were thought to be inferior.

Evidence provided by demotic documents of the Ptolemaic Period shows that Egyptians did not suffer particular restraints in either their private lives or in the exercise of their business interests. On the lowest levels there can have been little change from the old days; the peasants were certainly not obliged to learn Greek. The situation has some parallels with that of Norman Britain. As the Frenchness of the ruling classes was a kind of veneer on the surface of a Saxon country, so the Hellenisation of Egypt was superficial and confined to the upper levels of society.

The early Ptolemies were not lacking in political sagacity. If they had read the second book of Herodotus' *History* they would surely have understood the importance in the

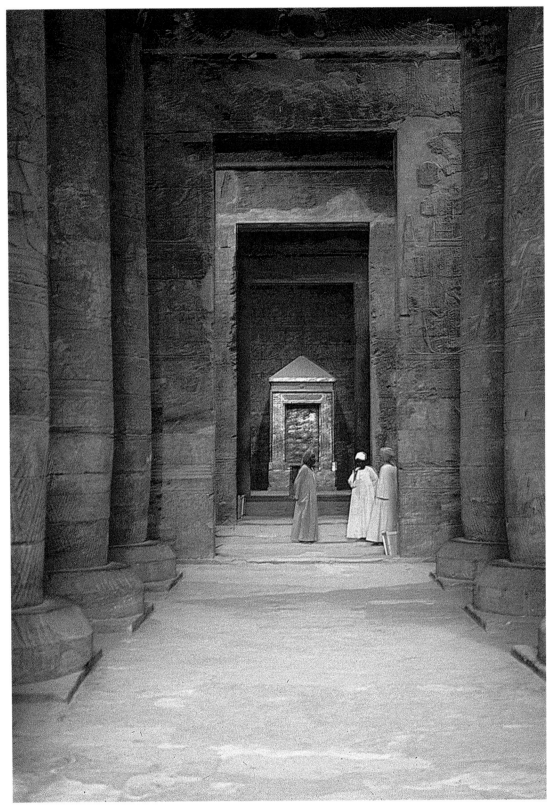

Above: The Rosetta Stone, key monument in the history of the decipherment of the ancient Egyptian scripts. The text records a decree passed in 196BC by a gathering of Egyptian priests in Memphis, honouring Ptolemy V Epiphanes for his good works towards the temples of Egypt.

British Museum *(EA24); height 114cm*

Left: View along the central axis of the Edfu Temple into the sanctuary in which the god of the temple was daily worshipped. The image of Horus as a falcon stood in the monolithic shrine in the sanctuary which was made in the reign of Nectanebo II of the Thirtieth Dynasty, but preserved for use in the present temple, built wholly in the Ptolemaic Period.

Above: Bronze figure of the Apis bull, incarnation of the god Ptah of Memphis, much revered in the Late Period and the Ptolemaic Period. This figure was dedicated by Petiese. On its brow is a triangular mark inlaid in silver.

British Museum *(EA37448); height 17.7cm*

Right: Colossal granite figure of the falcon Horus, wearing the double royal crown, standing in front of the first pillared hall in the Edfu Temple. An actual living falcon was kept in the temple to represent the god, and to be presented to the populace at the time of great festivals.

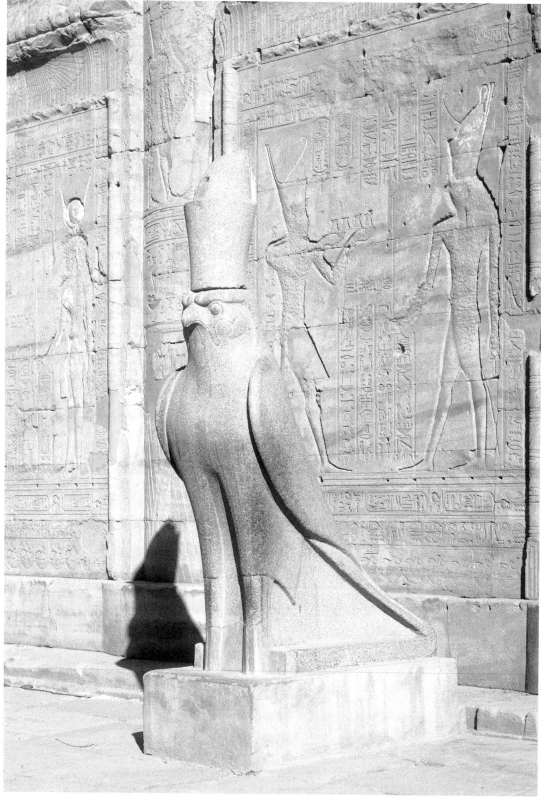

life of the land of the strange tangle of cults and inconsistent beliefs. They therefore assumed all the trappings and titles of the Pharaoh, writing their names in hieroglyphs in cartouches. As Pharaoh, Ptolemy was divine; he alone could sacrifice to the gods; from time to time it was politic for him to perform the rituals himself. Like the Pharaohs of Egypt's great periods, the prosperous Ptolemies built temples in the Egyptian style, decorated with reliefs and inscriptions of a traditional kind. In these reliefs they showed themselves as Pharaohs, dressed as Pharaohs, and performing religious ceremonies of untold antiquity.

Such scenes cannot be wholly pretence, for the inscriptions on the Rosetta Stone give the text of a decree passed by a synod of Egyptian priests meeting at Memphis in 196BC, honouring Ptolemy V Epiphanes for his great benefactions and good services to the temples of Egypt. It is interesting and significant that the decree was inscribed first in hieroglyphics, the Egyptian script used at that time only for religious inscriptions and very formal texts; secondly, in demotic, the regular writing used for Egyptian documents of all kinds; and thirdly, in Greek. It was the fortunate discovery of this bilingual inscription that led to the decipherment of hieroglyphics and of demotic.

Although Alexandria was the greatest creation of the Ptolemies, the modern visitor has to look very hard to find the smallest vestige to recall its heyday. It is ironical that the most impressive physical monument of the period should be a temple in the Egyptian style far to the south of Alexandria in the provincial city of Edfu, known to the Egyptians as Tbo, and to the Greeks as Apollonopolis Magna. The Greek god Apollo was here equated with Horus, the falcon deity, who was worshipped at Edfu as a solar god. Ptolemy III Euergetes began to build a great temple dedicated to Horus in 237BC. Ptolemy XII Auletes performed the dedication ceremony in 71BC, and the great doors of the pylon were installed in the same reign in 57BC.

The main structure of the temple remains intact. The outer faces of the great pylon carry impressive reliefs showing Ptolemy XII smiting his enemies. Apart from these fanciful but grandiloquent reliefs, the decoration of the temple is entirely devoted to ritual scenes in which the king is shown performing ceremonies in and around the temple, offering to the gods and engaging in the re-enactment of significant myths. Wherever a royal figure appears it is labelled with the name of the Ptolemy who happened to be ruling when the scene was carved.

In the extent of the representations they contain, the temple of Edfu and other temples built at the same time or in the early Roman Period, are more complete than any temple of the Dynastic Period. Their building and decoration were singular acts of piety by rulers who could have felt little real devotion to the gods worshipped in them.

Diplomacy in the handling of the Egyptians through religion by the Ptolemies went far back to the arrival of Alexander in Memphis, when he made offerings to the Apis bull in the Temple of Ptah. This living symbol of divine creativity had developed many additional aspects by the time the Macedonian came to Egypt. Most important was his association with Osiris, the divinity of the after-life. The living Apis was consulted as an

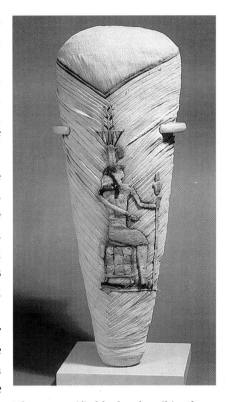

The mummified body of an ibis, the bird sacred to the god Thoth; from a catacomb of ibis burials at Saqqara. It is embellished with a seated figure of the god Nefertum, son of Ptah and of lioness-headed Sakhmet, the sacred triad of Memphis.

British Museum *(EA67149); height 47cm*

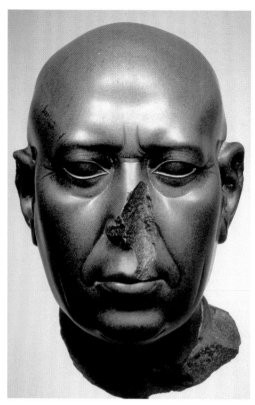

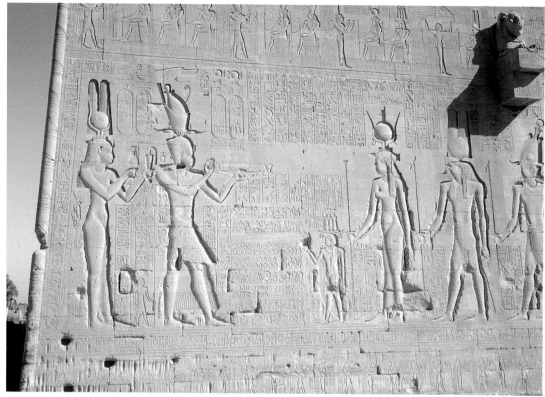

Above: The Berlin Green Head, a powerful portrait in green schist of an unidentified Egyptian official, dating to the first century BC or even a little earlier in the Ptolemaic Period.

Egyptian Museum, Berlin *(12500); height 21.5cm*

Right: Scene carved on the rear wall of the Temple of Dendera, showing Cleopatra VII as an Egyptian queen, preceded by Caesarion, her son by Julius Caesar. They present ritual objects and incense to some of the gods honoured in the temple: Horsamtowy (Horus-who-unites-the-Two-Lands) shown small, Isis, Horsamtowy shown large, Osiris-Unnefer.

oracle in the city of Memphis; the dead Apis, or Osiris-Apis, was called on for intercession in the Memphite Necropolis, where lay the bodies of the deceased bulls in the underground catacomb now called erroneously the Serapeum.

The cult of the Apis was very different from the other animal cults which flourished in Egypt at this time. The latter represented a development in popular religion which was scarcely evident in more ancient times. Cemeteries of mummified dogs, cats, ibises, baboons, and even crocodiles, testify to the widespread popularity of this form of devotion. But there was only one sacred Apis-bull, and he was very special. He became even more so when his cult was adopted by the Ptolemies and transformed into the worship of Sarapis, a name derived from Osiris-Apis. The creation of this new god by Ptolemy I was a master stroke. The god was Egyptian, but he was represented as a Greek divinity – a mixture of Zeus, Dionysus and Pluto. The Serapeum at Alexandria, the cathedral of the cult, was by all accounts a remarkable building. By one of those unaccountable processes of chance, Sarapis was a success, and his worship not only appealed to Egyptians and Greeks alike, but also to foreigners. Subsequently the cult spread rapidly throughout the Roman Empire.

In spite of the consideration given by the Ptolemies to the native cults of Egypt, the relegation of Egyptians to subordinate positions in the running of the country was a recipe for trouble. It first seriously manifested itself during the reign of Ptolemy IV Philopator (221–205BC), a ruler with an unenviable reputation for weakness and vice.

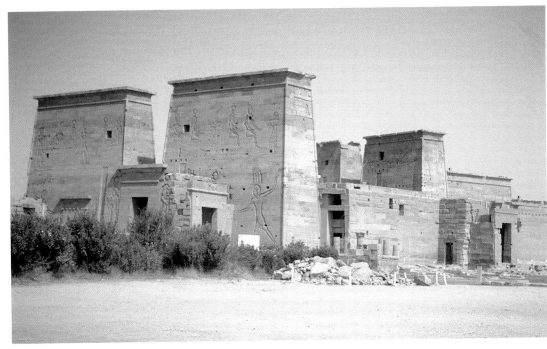

The temple of Isis south of Aswan. Built on Philae Island, it was moved in the 1970s and reconstructed on the adjacent island of Agilkia to raise it above the waters of the lake between the old and new dams. Built on an ancient site in the Ptolemaic Period, it continued as a cult centre for many centuries.

The excesses of his chief agent, an unprincipled Alexandrian called Sosibius, alienated Greek as well as Egyptian support. Unrest of all kinds developed, and would surely have led to serious uprisings but for a threat to Egypt by Antiochus, King of Syria. The emergency brought the country together. Sosibius succeeded in gathering a large army of mercenaries, settled veterans and native troops, and he defeated the forces of Antiochus at Raphia on the borders of Egypt and Palestine in 217BC.

One unexpected result of this victory was the unusual confidence it gave the Egyptians. The veterans of the battle, disbanded and dispersed throughout the land, encouraged the disaffected Egyptians with the belief that they were capable of tackling the forces of the Pharaoh on their own terms. The minor revolts that broke out throughout Egypt were, however, more successful than they should have been because dynastic squabbles distracted the central authority from its main duty of maintaining law and order.

The decline of Ptolemaic power was slow and painful. Yet the independence of Egypt as a sovereign state was protracted beyond its expectation because the power of Rome in the Eastern Mediterranean buttressed the shaky régime against its natural enemy, the Syrian state. Commercial relations between Egypt and Rome had begun as early as the reign of Ptolemy II Philadelphus, but the extent to which Rome actively supported the Ptolemaic command is not evident until the reign of Ptolemy VI Philometor. Antiochus Epiphanes of Syria, having already annexed Egypt's Asiatic territories, succeeded in 170BC in seizing the throne of the Ptolemies. Rome was at this time engrossed in the Third Macedonian War and so unable to frustrate Antiochus' purpose, but in 168BC her envoy presented an ultimatum to the Syrian king. Antiochus was obliged to withdraw

Basalt bust of a distinguished Roman of the first century BC. *The style is Roman, the stone is Egyptian; said to have been found in the Delta. At one time thought to be a portrait of Octavian or of Mark Antony, it is now less certainly identified.*

National Trust (Kingston Lacy House); *height 57cm*

and Philometor was reinstated, but thereafter the independence of Egypt continued, albeit by kind permission of Rome.

Within Egypt civil disorders continued, with disastrous results both for the economy and relations between Greeks and Egyptians. One particularly serious rising in 88–85 BC aimed at securing independence for Thebes and southern Egypt. It ended with the destruction of a large proportion of the ancient city, a calamity from which it never recovered.

Rome's involvement in Egyptian affairs increased markedly during the reign of Cleopatra VII, the last of the Ptolemies, who came to the throne of Egypt at the age of seventeen or eighteen in 51BC. The reputation of this extraordinary woman has been much influenced by distortions of emphasis in the writings of ancient propagandists and in works of imaginative literature. To the Romans she was Julius Caesar's mistress; to the Greeks of Egypt she was a traitor; to the native Egyptians she was yet another foreigner masquerading as their Pharaoh. Yet, under her, Egypt for a while looked like regaining some of its ancient glory. In fact, through Caesar she came within an ace of acquiring a vast empire. The legacy of her affair with Caesar, their son Caesarion, was one of the main reasons for her final failure. Caesarion would have remained a threat to Rome and to Octavian if he had lived – a rallying point for disaffection.

Cleopatra's involvement in the fatal adventures of Mark Antony provided the opportunity for the final resolution of the Egyptian problem. In 31BC, at the battle of Actium, the Egyptian hopes were frustrated. In the following year Antony was defeated on land and committed suicide. A last attempt by Cleopatra to escape ignominy proved unsuccessful. Octavian, it seems, was determined to take her to Rome to decorate his triumph. She in turn avoided this final humiliation by submitting to the bites of two snakes.

Key to Hieroglyphs

The hieroglyphic quotations reproduced on the title page of this book and at the head of each chapter, are taken, or adapted, from appropriate inscriptions, funerary compositions and literary texts. For reasons of convenience and consistency they are all reproduced in a standard style of hieroglyphic writing to be read from left to right. The originals are in some cases carved on stone in horizontal or vertical lines, or written in hieratic script on papyrus or a wooden writing board (the Carnarvon Tablet). Most of the originals are to be read from right to left.

Title page:
'His Majesty commanded to be set up all the splendid things which His Majesty had done in Egypt and in all foreign lands.'

Text adapted from Eighteenth Dynasty monumental inscriptions.

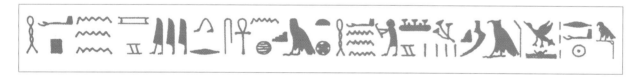

Chapter 1:
'Hapy, who is come to make Egypt live, to flood the fields which Re has created.'

Words from the Hymn to Hapy, the Nile in inundation; from the version in Papyrus Sallier II. British Museum *(EA10182).*

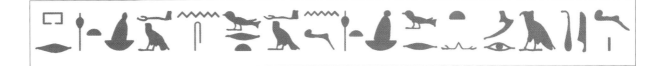

Chapter 2:

'The White Crown goes forth. She has swallowed the Great. White Crown's tongue has swallowed the Great. The tongue was not seen.'

The triumph of the White Crown of Upper Egypt, as expressed in the *Pyramid Texts*, spell 239.

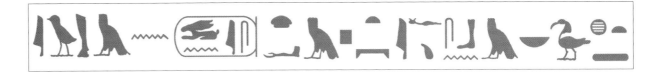

Chapter 3:

'Unas has repeated his rising in heaven. He is crowned as Lord of the Horizon.'

From the Pyramid of Unas, the *Pyramid Texts*, spell 274.

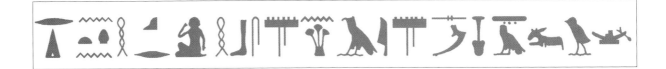

Chapter 4:

'I gave bread to the hungry man, clothing to the naked, and brought the stranded to land.'

A common claim in the 'biographies' of Sixth Dynasty officials; e.g. T.G.H. James, *The Mastaba of Khentika called Ikhekhi*, p.40f.

Chapter 5:
'His Majesty placed me as mayor of Menat-Khufu. My administration was excellent to
His Majesty's mind.'

From the biographical text of Khnumhotpe at Beni Hasan, see P.E. Newberry, *Beni Hasan* I, pl.44, 1.7.

Chapter 6:
'I sailed north as a champion to drive out the Aamu (Asiatics) by the command of Amun.'

Kamose engages the Hyksos in battle, from the *Carnarvon Tablet*, 1.10.

Chapter 7:
'I set Your Majesty's war-cry throughout the Nine Bows (foreign enemies), the great ones of all
foreign lands held together in your grasp.'

From the *Poetical Stela* of King Tuthmosis III, 1.4. Cairo Museum *(34010)*.

Chapter 8:
'Set your heart on being a scribe. You call to one and a thousand answer you.'

On the advantages of being a scribe, from Papyrus Lansing. British Museum, *(EA9999)*, p.8, ll.1-2.

Chapter 9:
'Do not attack by night in the manner of chess-players. Fight when you can be seen. Challenge him to battle from a distance.'

From the instructions of King Py to his army on being sent to Egypt, in his great stela.
Cairo Museum *(48862)* ll.9-10.

Chapter 10:
'[They shall write] this decree on a stela of hard stone in the script of the god's words (hieroglyphics), in the script of documents (hieratic), and in the writing of the Aegeans (the Greek script).'

From the Rosetta Stone, l.14 of the hieroglyphic text. British Museum *(EA 24).*

Reading List

C. Aldred & others: *Les Pharaons. Le Temps des Pyramides*, Paris, 1978; *L'Empire des Conquérants*, Paris, 1979; *L'Égypte du crépuscule*, Paris, 1981.

J. Baines & J. Malek: *Atlas of Ancient Egypt*, Oxford, 1980.

J. von Beckerath: *Handbuch der Ägyptishen Königsnamen*, Munich and Berlin, 1984.

A. K. Bowman: *Egypt after the Pharaohs*, London, 1985.

A. H. Gardiner: *Egypt of the Pharaohs*, Oxford, 1961.

N. Grimal: *A History of Ancient Egypt*, Oxford, 1993.

W. C. Hayes: *The Scepter of Egypt*, 2 volumes, New York, 1953, 1959.

W. Helck & E. Otto: *Lexikon der Ägyptologie*, 7 volumes, Wiesbaden, 1972-91.

E. Hornung: *Conceptions of God in Ancient Egypt*, Cornell, 1986.

T. G.H. James: *Pharaoh's People*, London, 1984.

H. Kees: *Ancient Egypt. A cultural topography*, London, 1961.

B. J. Kemp: *Ancient Egypt. Anatomy of a Civilisation*, London & New York, 1989.

K. A. Kitchen: *The Third Intermediate Period in Egypt*, 2nd ed., Warminster, 1986.

M. Lichtheim: *Ancient Egyptian Literature*, 3 volumes, Berkeley, Los Angeles & London, 1973-80.

S. Quirke: *Ancient Egyptian Religion*, London, 1992.

S. Quirke: *Who were the Pharaohs?*, London, 1990.

S. Quirke & J. Spencer (eds.): *The British Museum Book of Ancient Egypt*, London, 1992.

B. Trigger & others: *Ancient Egypt. A Social History*, Cambridge, 1983.

P. Vernus & J. Yoyotte: *Dictionnaire des Pharaons*, Paris, 1996.

D. Welsby: *The Kingdom of Kush: The Napatan and Meroitic Empires*, London, 1996.

Acknowledgements

Chronology is always a problem in the writing of ancient Egyptian history. To establish the sequence of the dynasties in an acceptable timescale requires the deployment of arguments beyond the possibilities of a brief history of the kind offered in this volume. I have therefore based my datings on those used in two publications which are widely available and in which chronology is established on the findings of current orthodox scholarship: J. Baines & J. Malek, *Atlas of Ancient Egypt* , and S. Quirke & A.J. Spencer, *The British Museum Book of Ancient Egypt.*

I am particularly grateful to those colleagues and institutions who have generously given permission for the publication of photographs of objects in their collections: those on the cover and pages 17, 19, 23, 25, 31, 33, 35, 36, 46, 53, 68, 69, 73, 82, 83, 86, 89, 94, 105, 111, 123, 127, 136, 140, 141, 145, 149, 150 and 151 are reproduced courtesy of the Trustees of the British Museum; on pages 38, 111 and 152, by courtesy of the Ägyptisches Museum, Berlin; on page 28, by courtesy of the Ashmolean Museum, University of Oxford; on page 57, by courtesy of the Saqqara Kagemni Expedition, photographer Paolo Scremin, assistant Yvonne Harpur (Oxford Expedition to Egypt); on page 113, by courtesy of the Petrie Museum of Egyptian Archaeology, University College London; on pages 20, 39, 51 and 67, by courtesy of the Phoebe A. Hearst Museum of Anthropology, University of California at Berkeley; on page 118, by courtesy of the Rijksmuseum van Oudheden, Leiden; on pages 115 and 154 by courtesy of the National Trust (Kingston Lacy House). I am also grateful to many Directors of the Egyptian Museum in Cairo for allowing me over the years to photograph objects in that supreme collection, some of which are reproduced here on pages 28, 70, 94, 96, 103, 114, 125, 133 and 134. The remaining illustrations are reproduced from the author's own photographs.

I am also indebted to my publishers for turning what was originally conceived as a rather slight book into this splendidly illustrated and produced volume, the design of which is the result of the imaginative and expert attention of Caroline Reeves. In my editor, Camilla Reid, I was unusually fortunate in having someone whose sympathetic pedantry was quite a match for my own.

INDEX

Note: In modern Arabic place-names beginning with El-, the El- is ignored in indexing; thus El-Amarna is indexed as Amarna.

After studying the Classics and Egyptology at Oxford University, T.G.H. James entered the British Museum, and remained on the staff from 1951 to 1988, being Keeper of Egyptian Antiquities from 1974.
He has paid many visits to Egypt, to participate in excavations and epigraphic expeditions for the Egypt Exploration Society, and to accompany visiting groups.

His principal scholarly interests have been in the fields of texts, history, and material objects; and more recently in the history of Egyptology. He is author of a number of specialist books, and of popular works, such as *Pharaoh's People* (1982), *Egyptian Painting* (1983), *Ancient Egypt: The Land and its Legacy* (1988), *Egypt: The Living Past* (1992). His most recent work is *Howard Carter, The Path to Tutankhamun* (1992).

He is married, with one son, and lives in London.